ATLAS OF

FORBIDDEN PLACES

JONGLEZ PUBLISHING

Content

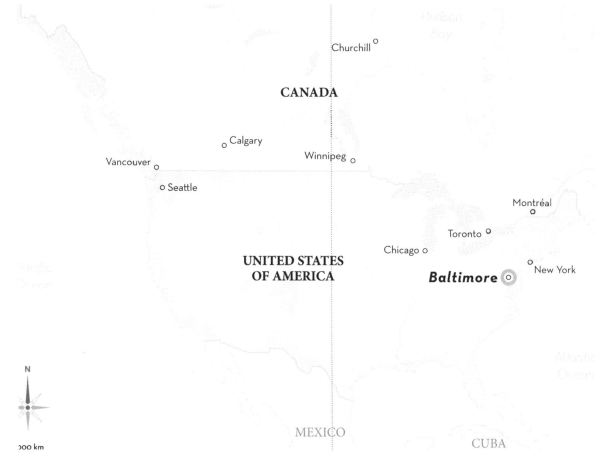

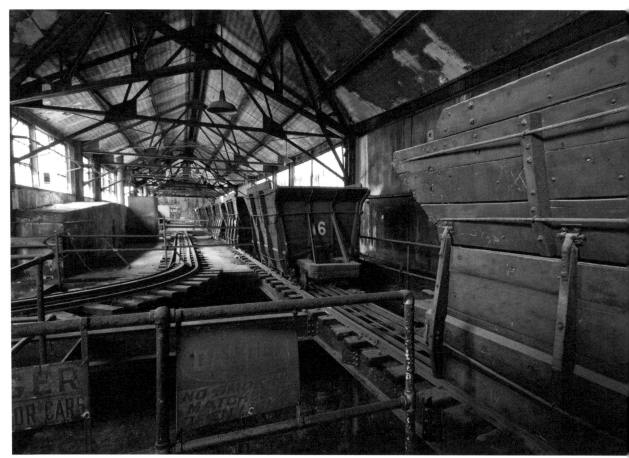

Twelve Monkeys Power Plant · Baltimore, United States

Baltimore, Maryland. Westport.

Demolished. Cleared, levelled. Deserted. As if a virus had spread there, had contaminated the immense premises of the power plant to make them disappear.

Of this steel and concrete giant, nothing remains. Nothing other than the railway network that criss-crossed the site so that the silos could be loaded with coal.

It seems there were turbines bigger than cars. Alternators, thundering steam.

At its construction, in 1906, its colossal size made this power plant the largest ever built. All that, gone forever.

You might suspect corrosion as the problem, but no. Rust could not achieve such a work of destruction so quickly and so completely.

When Terry Gilliam used this abandoned site in 1995 as the location for his film *Twelve Monkeys*, the walls were still standing. The damage came later.

Were people the cause? The agent behind its extinction? The fact is that by 2008, this metal monster was no more.

One day in this very place a hotel or theme park is bound to be built, fronting the waters of Baltimore Bay. Will passers-by recall that here stood a power plant, the pride of Baltimore Gas and Electricity?

There's not much chance of that. Unless we could go back in time to throw light on what really happened …

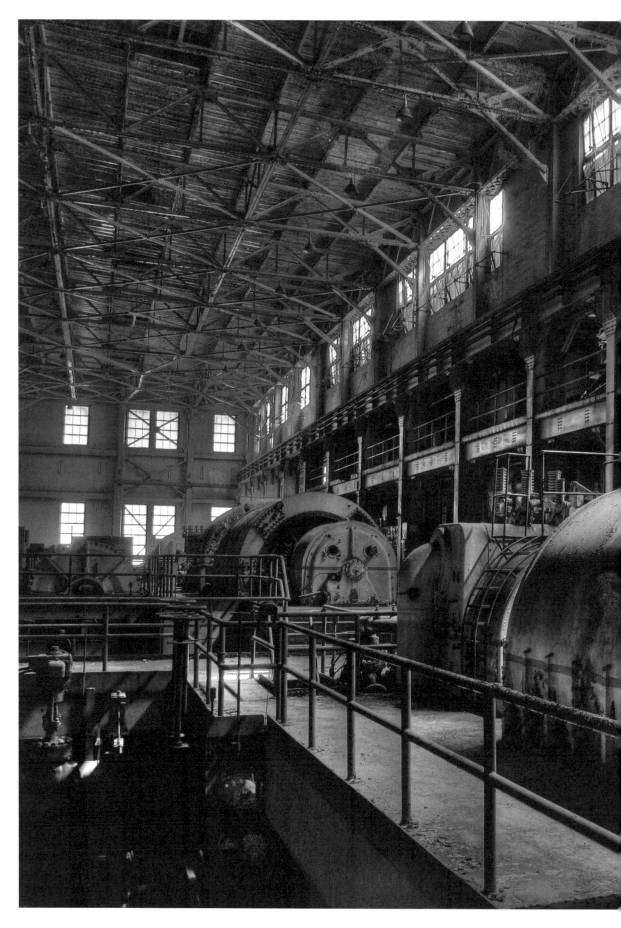

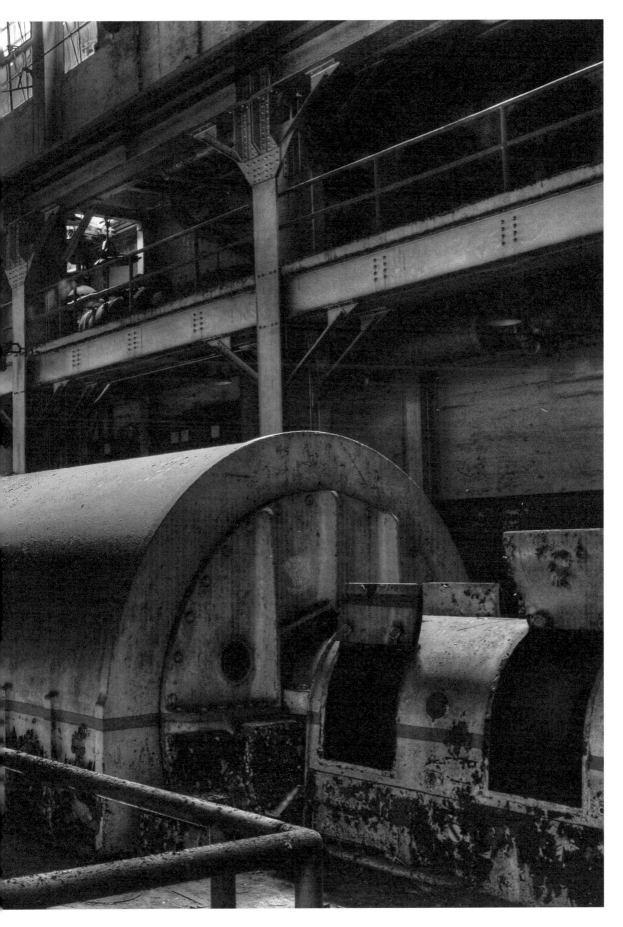

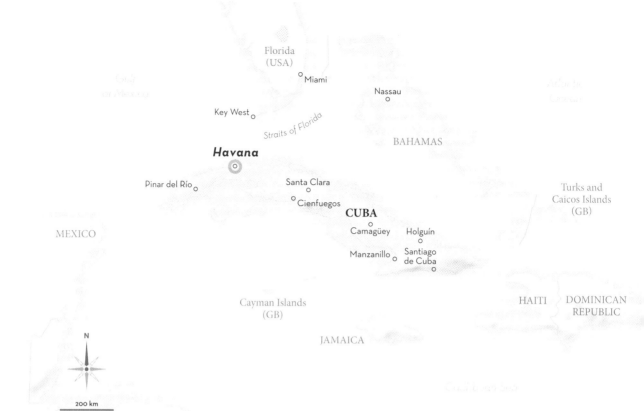

Florida
(USA)

○ Miami

Nassau
○

Key West ○

Straits of Florida

BAHAMAS

Havana
◎

Pinar del Río ○

Santa Clara
○
○ Cienfuegos

CUBA
○
Camagüey

Holguín
○

Turks and
Caicos Islands
(GB)

MEXICO

Manzanillo ○

Santiago
de Cuba
○

Cayman Islands
(GB)

HAITI DOMINICAN
REPUBLIC

JAMAICA

N

200 km

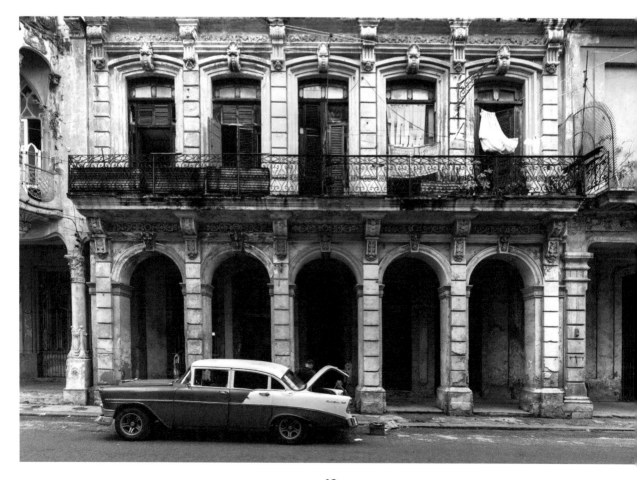

Abandoned Buildings
in Havana · Cuba

In the heart of the Cuban capital, as elsewhere, the 1959 revolution led to numerous expropriations, sometimes forcing even wealthy property owners into exile.

Several requisitioned buildings continued to be used, however. Some palaces became official buildings, their magnificent halls used for numerous meetings of the Communist Party (see p. 14-15). Others were simply abandoned and are now more or less in ruins (see p. 12, top photo).

Many hotels have suffered the same fate: Though some are now being refurbished at great expense to attract tourists, others are veritable wrecks, like some of the buildings in the Vedado neighbourhood (see p. 13, bottom photo). Transformed into residential buildings, the lack of maintenance combined with the humid climate have led to their rapid deterioration; the lower floors are sometimes still inhabited despite their dilapidated state.

The risk to the local population is far from negligible: The last ten years have seen a series of tragic accidents, some of which resulted in the death of residents when the buildings collapsed on them.

Renovation is one of the city's main concerns but the US embargo, as well as corruption, remain major obstacles: This is why the rehabilitation of the old town, financed by UNESCO, saw part of its funds cut off after the departure of the organisation's representatives.

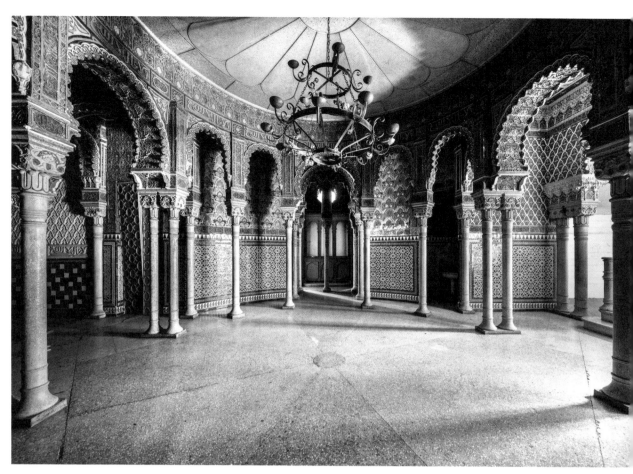

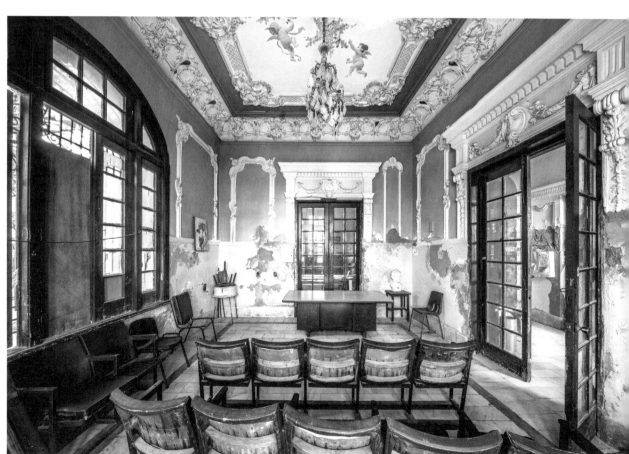

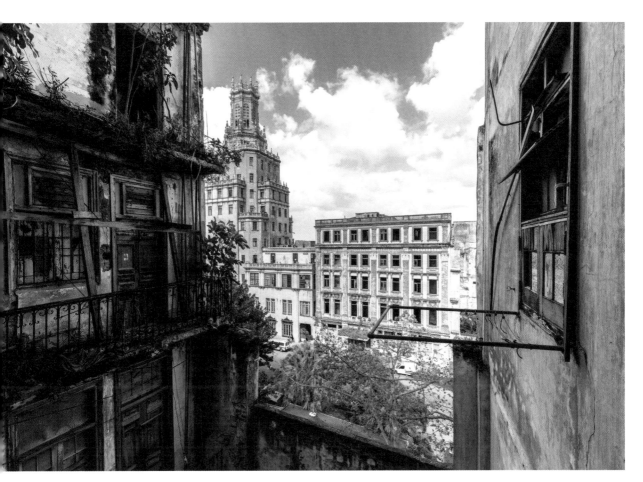

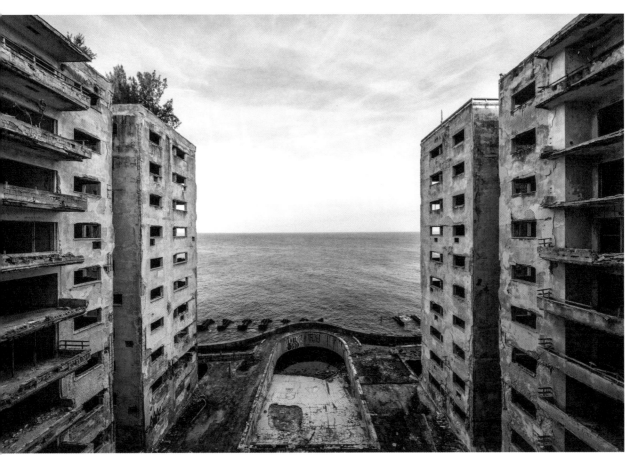

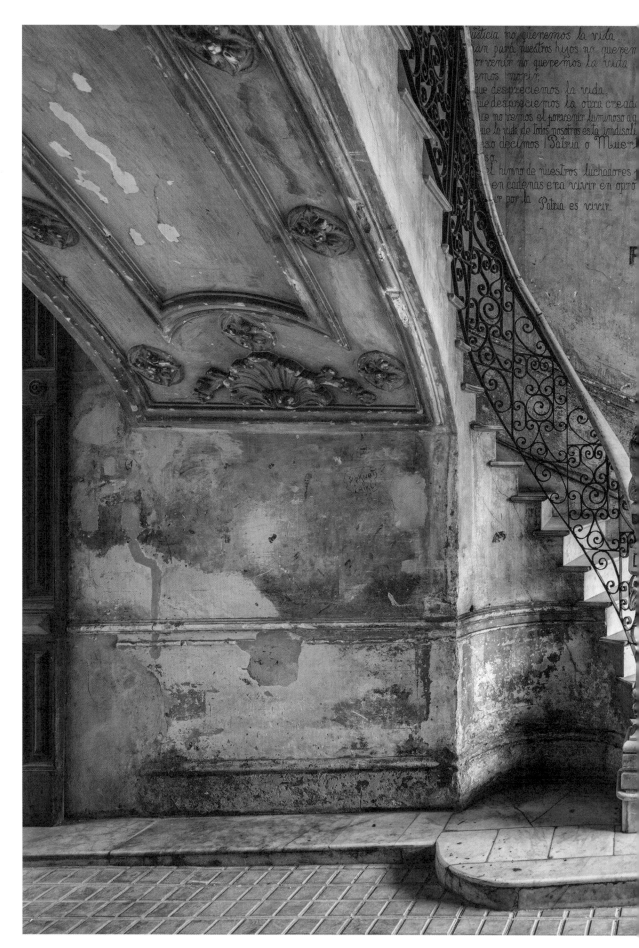

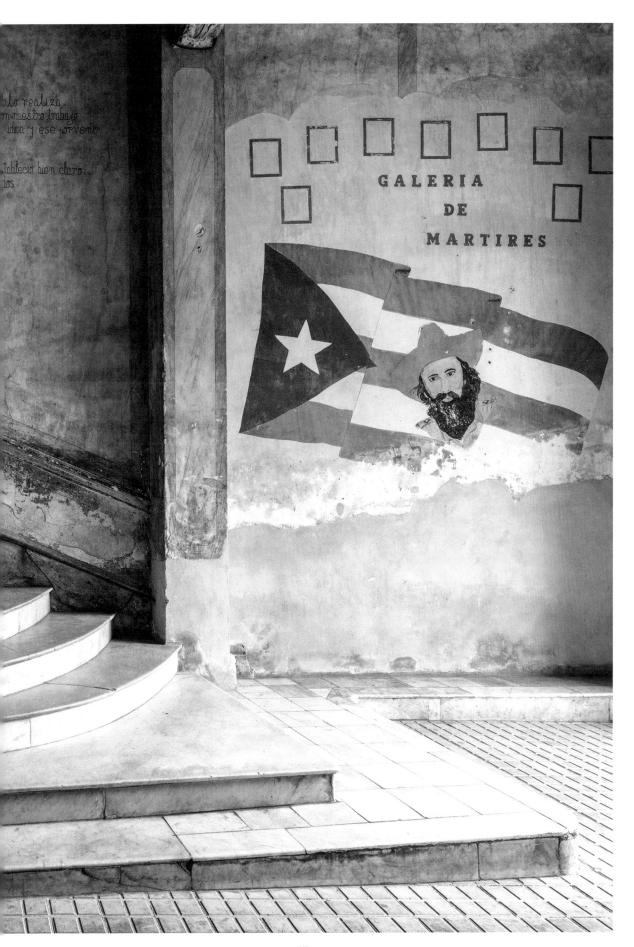

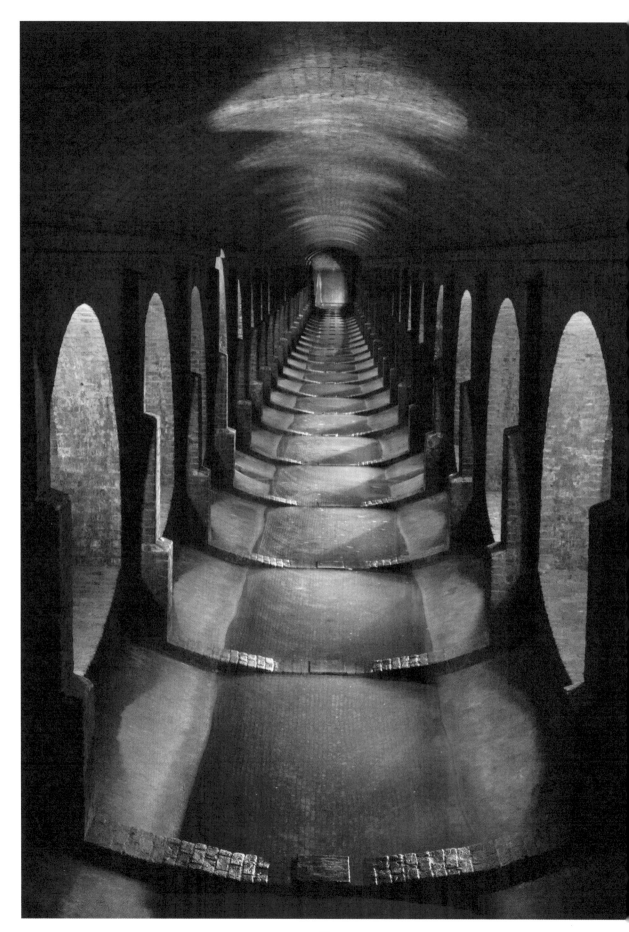

Subterranean Reservoirs and Cisterns · London, United Kingdom

London is well known to have one of the UK's largest underground networks, from sewers and culverts, tube and service tunnels, cable runs and infrastructure, bunkers and cellars to the more secretive government- and intelligence-owned areas. This hidden city calls to the curious and adventurous among us, who, once the sun has set, slip silently across the public/private divide into ladder-lined shafts and tunnel entrances, clicking on head torches before vanishing into the darkness.

There is something quite visceral, thrilling and secretive about exploring deep below the everyday plane of human existence, the people above oblivious to the hidden world below their feet. It is logical that such a world exists in the porous and rain-soaked limestone hills of England, but the discovery that an equally vast network of hidden and varied underground spaces exists below urban centres can be quite surprising.

Cisterns, designed for the collection and storage of water, feature watertight linings in their construction. They are generally enclosed under a roof or underground to prevent sunlight causing the growth of algae. And they are often found in areas where water is scarce or needed for agricultural irrigation.

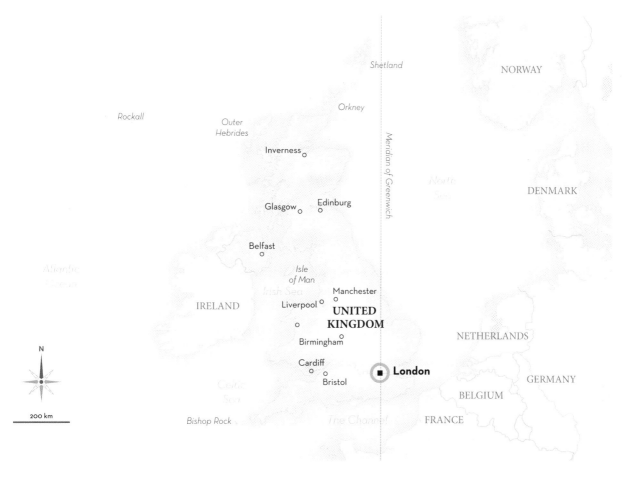

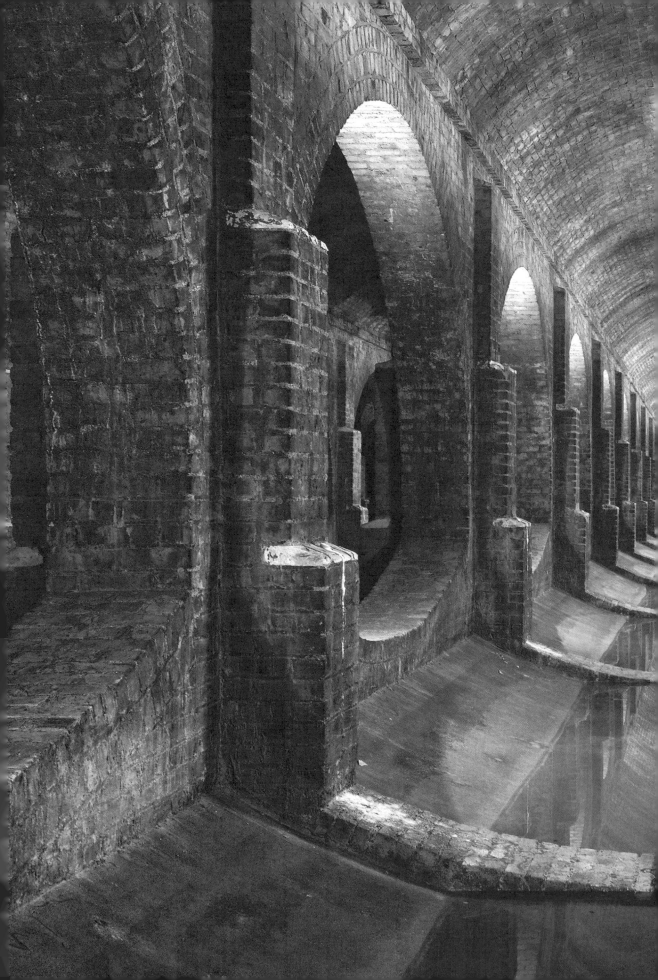

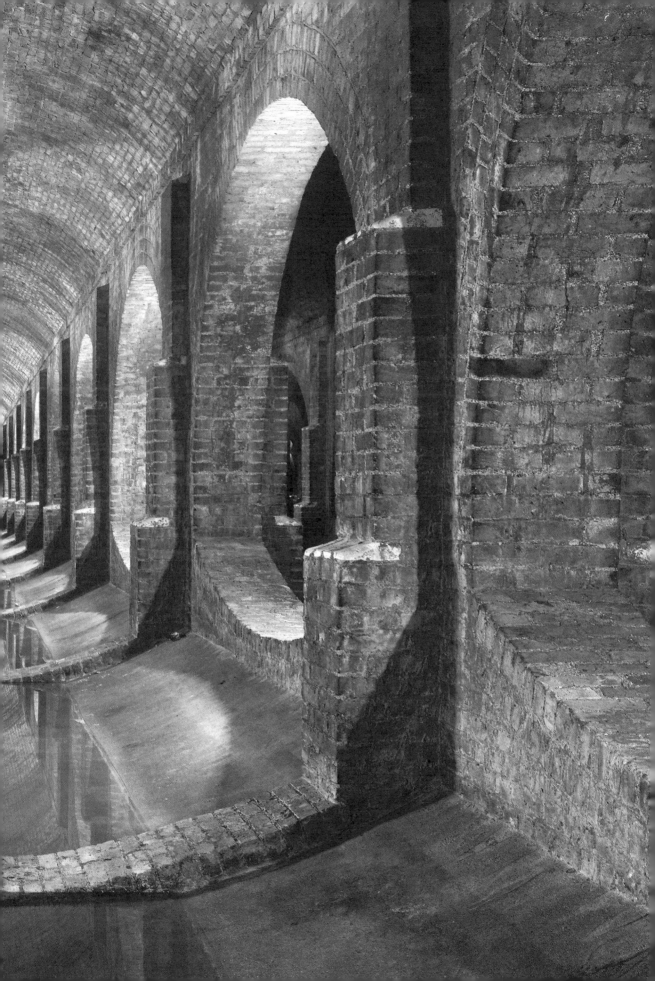

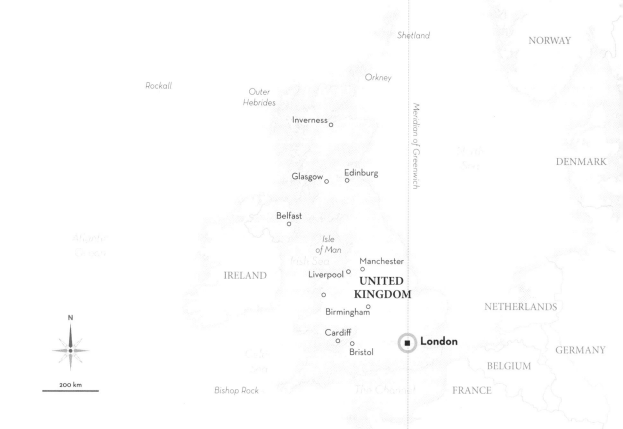

Shetland

NORWAY

Rockall

Orkney

Outer
Hebrides

DENMARK

Inverness

Glasgow Edinburg

IRELAND

Belfast

Isle
of Man

Manchester
Liverpool

UNITED
KINGDOM

NETHERLANDS

N

Birmingham

Cardiff

London

GERMANY

BELGIUM

200 km

Bristol

Bishop Rock

FRANCE

Meridian of Greenwich

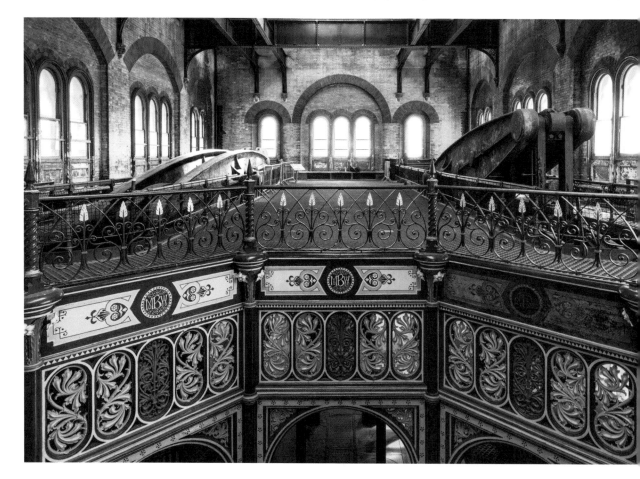

Crossness Pumping Station · London, United Kingdom

There aren't many opportunities to make a trip to a sewage farm, but Crossness Pumping Station – opened in 1856 by Edward, Prince of Wales – offers the chance. The obsolete pumping station is located in the middle of the Crossness Sewage Treatment Works, which is still very much operational: If you miss the shuttle service from the station, simply follow your nose.

The pumping station was part of legendary engineer Joseph Bazalgette's innovative sewage system for London. By the mid-19th century, London's exploding population meant the Thames had effectively become an open sewer. The contaminated water caused cholera outbreaks that killed over 30,000 Londoners. Plans to address this were finally put into action following the 'Great Stink' of 1858, when an unusually warm summer and clogged-up River Thames made the House of Commons unusable. Bazalgette built 1,100 miles of brick-lined, underground sewers that diverted untreated sewage downstream.

Crossness was the business end of the southern half of the system (a similar station at Beckton performs the same function for North London). Sewage arrived at the site and was pumped up into a 17-foot-deep reservoir, which could hold 27 million gallons of waste. The reservoir gates were opened twice a day, and the contents were swept out to sea on the Thames' ebb tide. Eventually, only liquid waste was disposed of in this way; the prosaically named 'sludge boats' dumped solid, untreated waste beyond the mouth of the river until 1998.

Crossness Pumping Station is an incredible place. The Beam Engine House, home to four steam-driven pumping engines, contains some of the most spectacular ornamental ironwork in the capital. At the heart of the building is the Octagon, an exuberant framework for the engines made of brightly coloured iron columns and screens. This is characteristic of the Victorians' love of Gothic adornment in the unlikeliest places. The building was abandoned in the 1950s after it became obsolete.

Ongoing restoration work, largely by unpaid volunteers, began in 1987.

The scale of the engineering is unnerving: the four engines (each weirdly named after a member of the royal family) are the largest rotative beam engines in the world. They have 52-ton flywheels and 47-ton beams, and were capable of pumping around 20 milk lorries of sewage a minute into the reservoir. Only one – the 'Prince Consort' – is currently restored, but the Crossness Engines Trust is now focused on bringing 'Victoria' back to her former glory.

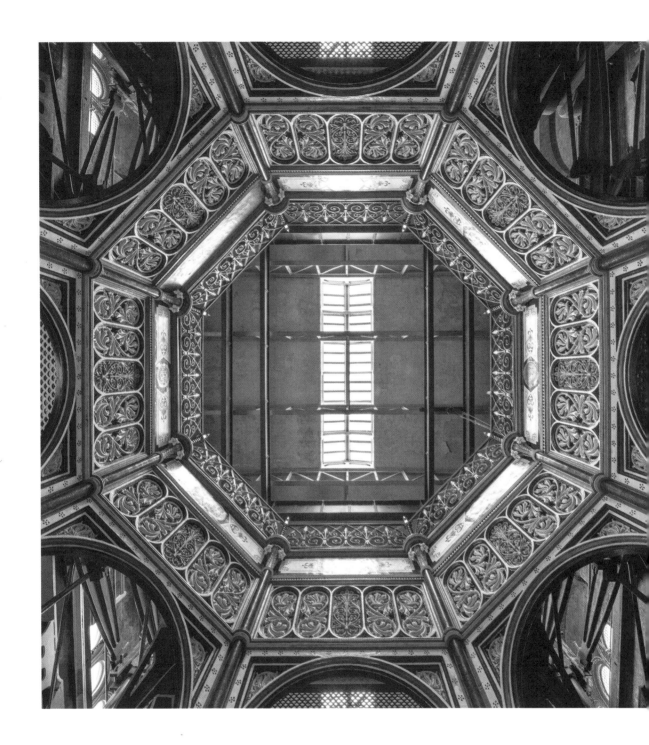

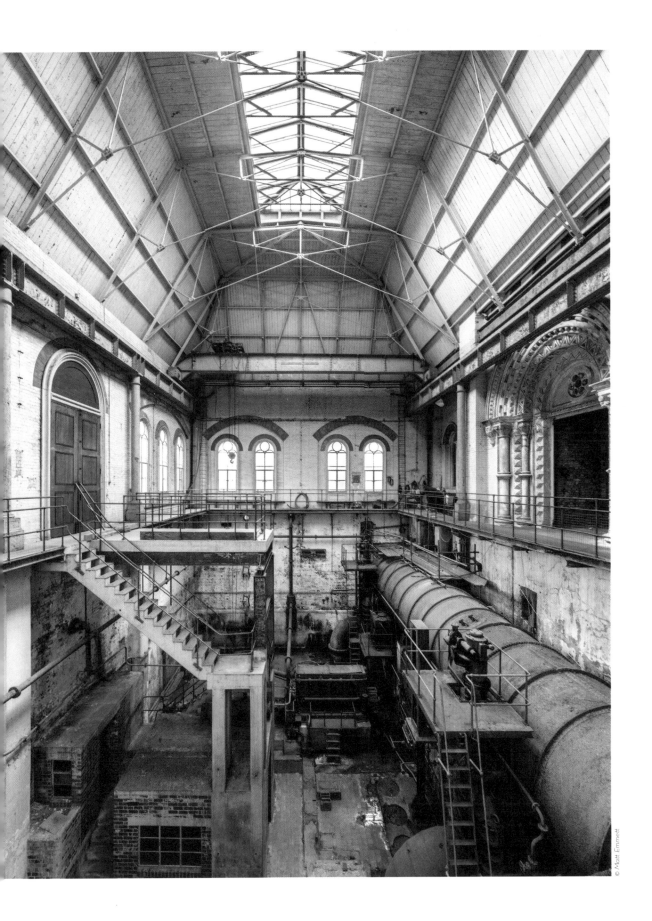

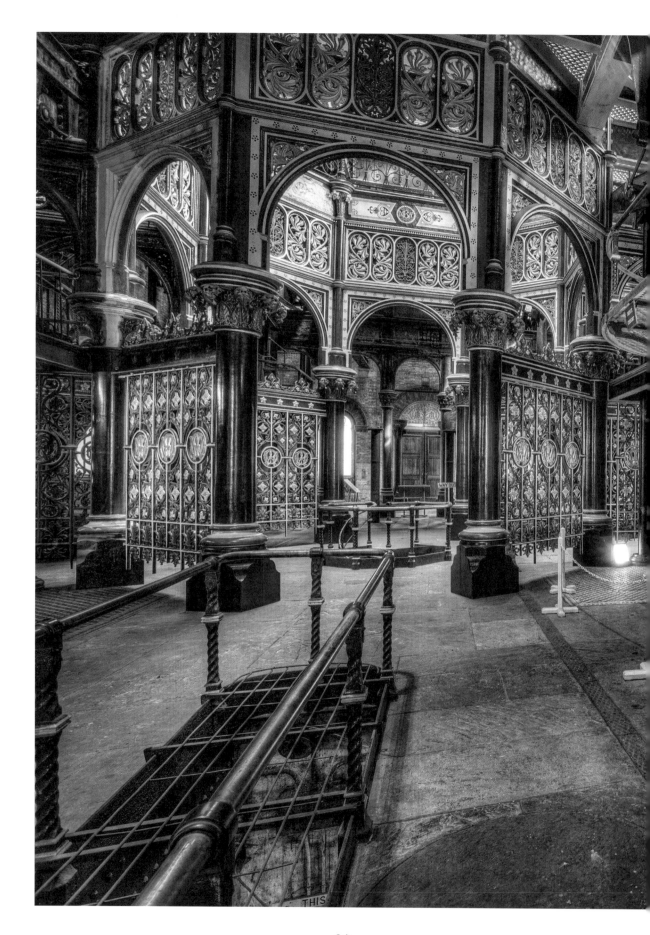

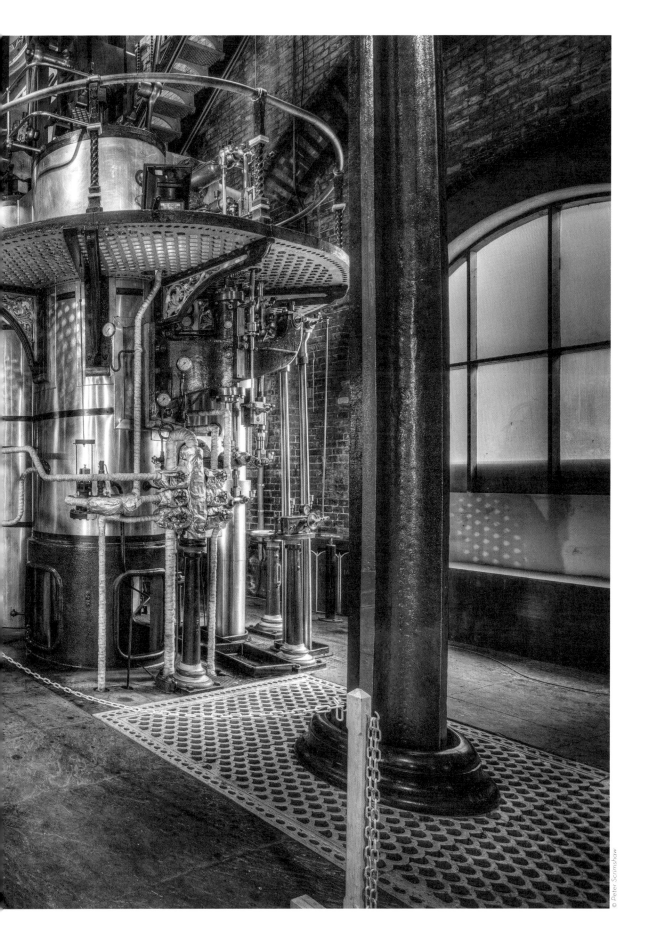

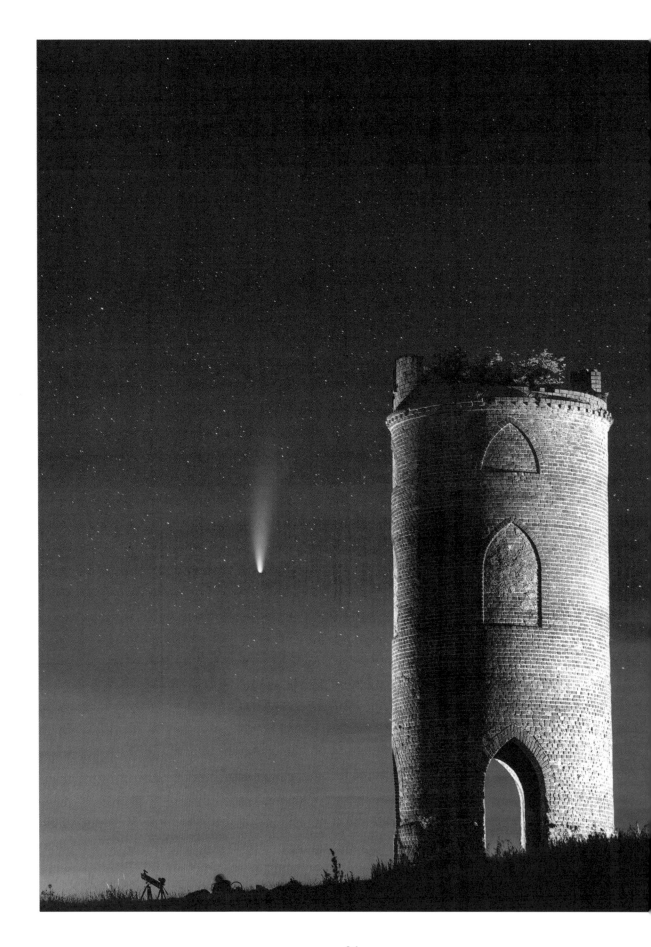

Wilders Folly ·
Reading, United Kingdom

On the outskirts of Reading sits an almost 300 year-old brick tower. Originally built as a symbol of the love between two local people, Reverend Henry Wilder and Joan Thoyts. The line of sight between the two family homes was obscured by a hill at Sulham Woods, so Reverend Wilder had the tower built on the hill where it could be seen from both houses. The couple were eventually married and the tower still stands as a lasting testament to their love. These days the tower is a dilapidated ruin that silently stands guard on the outskirts of the town.

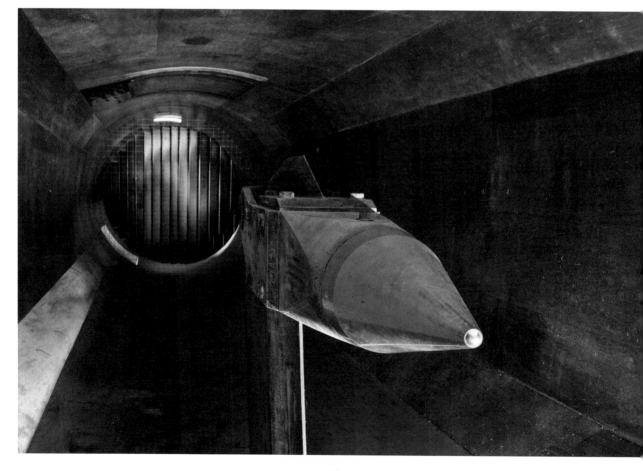

Royal Aircraft Establishment · Farnborough, United Kingdom

The wind tunnels at Farnborough were a precursor site to the NGTE (National Gas Turbine Establishment) and were therefore designed with a much broader set of test criteria than the latter: Scale models of whole aircraft, wing and tail sections, bomb casings, missiles and other vehicles such as cars and boats could be tested for their aerodynamic properties.

In the Low Speed (subsonic) 24' Tunnel within the Q121 building, entire prototype planes could be suspended within the airflow and tested for flightworthiness without endangering the life of a test pilot.

The military presence in this area dates back to 1905, and it came into its own during the First World War, when experimental aircraft were built and tested before being put into service on the battlefields of Belgium and northern France.

With the construction of the first building housing aerodynamic test tunnels in 1917, the site was designated as a key research location for the design of new aircraft. All manufacturing was then relocated so that the engineers could devote themselves solely to advancing research in this emerging specialist field.

Now known as the Royal Aircraft Establishment, the RAE worked on many aircraft concepts that were highly secret projects at the time. Many of their engineers went on to found companies whose names are now well known, such as Rolls Royce and the de Havilland Aircraft Company.

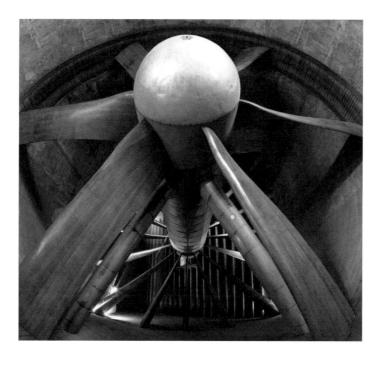

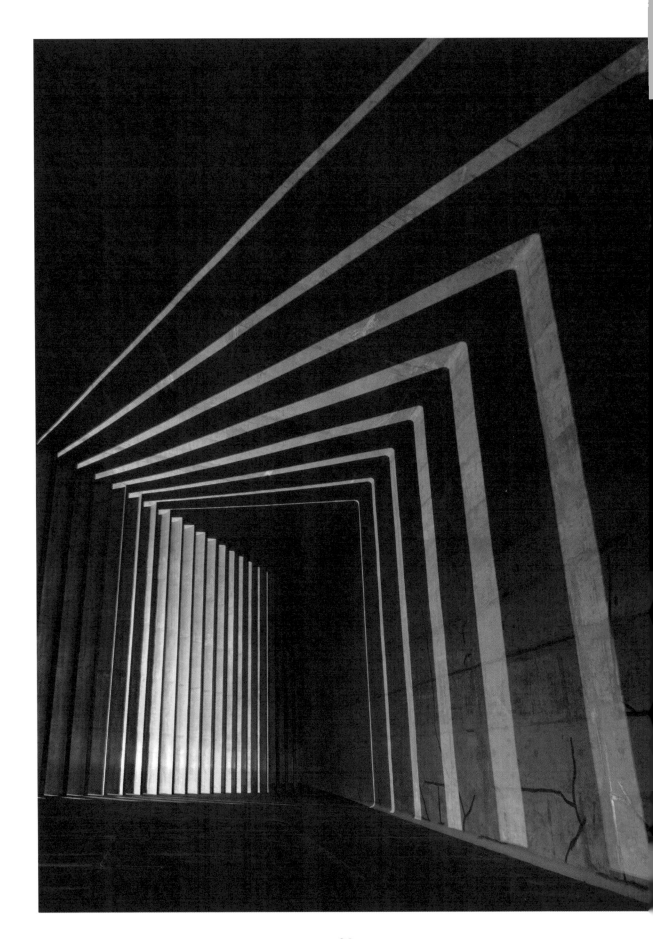

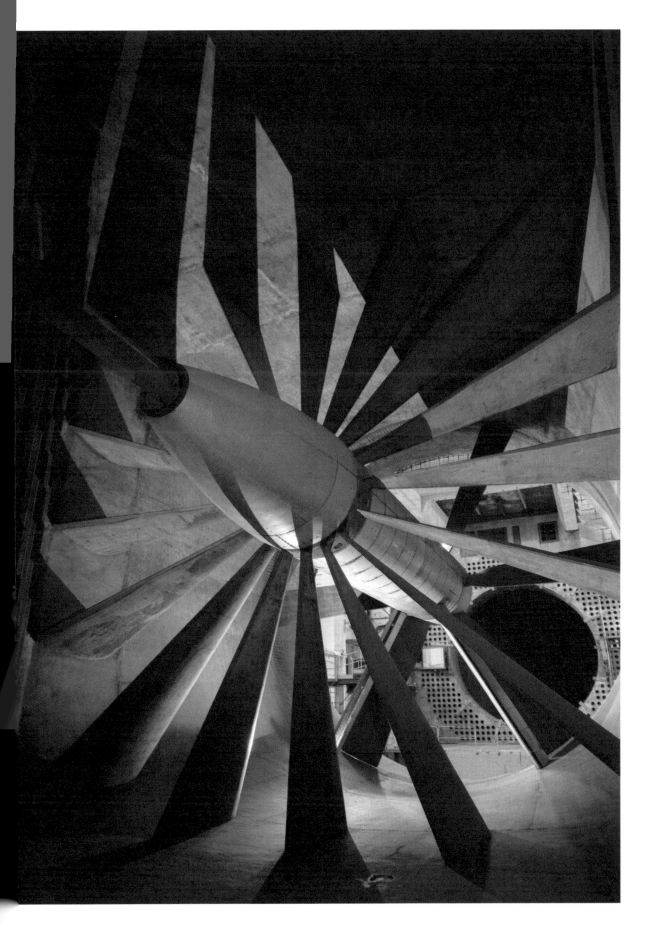

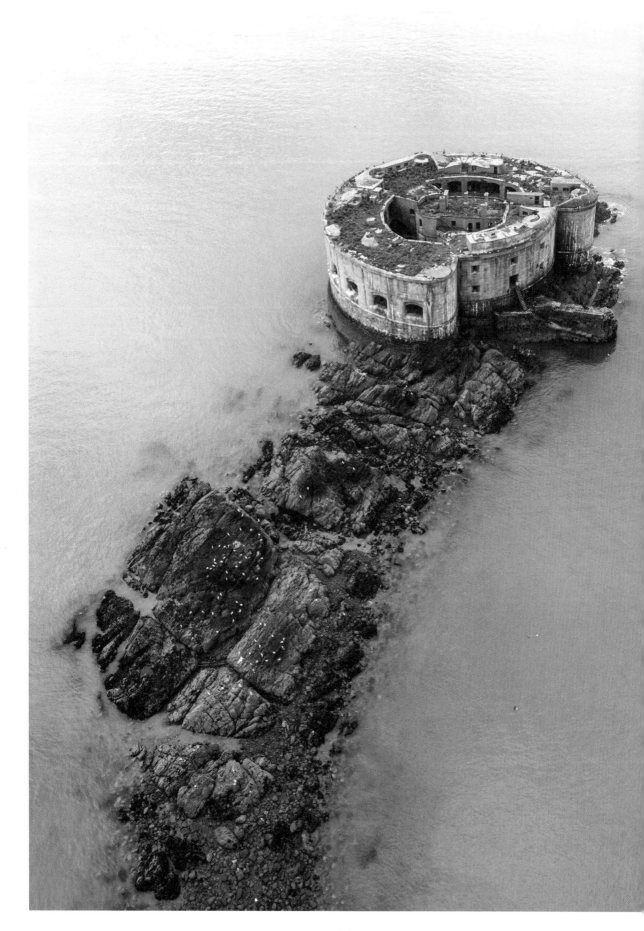

Stack Rock Fort · South Wales, United Kingdom

A sturdy stone-constructed defensive battery perched on a rocky island near Milford Haven in Pembrokeshire. It was built in two stages: The first structure was a Martello Fort built at the mouth of the inlet that led to the strategic Pembroke Dock. Despite a resounding British victory over the French and Spanish fleets at The Battle of Trafalgar in 1805, by the mid 1800's the French fleet was back at full strength and a worsening relationship with France's new president, Louis Napoleon (nephew to Napoleon I) led to renewed fears of a French invasion. In 1859 a Royal commission headed by Lord Palmerston, was formed to make recommendations on the strengthening of Britain's coastal defences. Along with many other sites across the country, Stack Rock Fort was then upgraded to the much larger ring structure we can see today. The new design featured 54 heavy guns protected by large granite casemates and embrasures, sleeping room for 154 soldiers and cost £82,000. The wider project was Britain's most expensive military upgrade during peacetime and was never used in conflict.

Today the fort is an isolated and quiet ruin, an abode for sea birds and ferns and the occasional tourist visit that can be arranged via the site's owner.

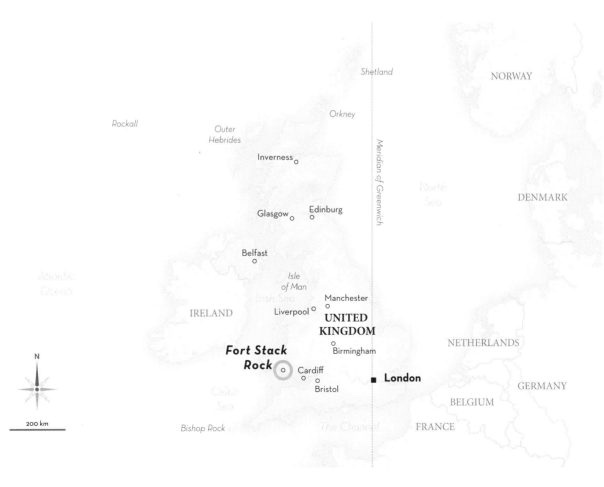

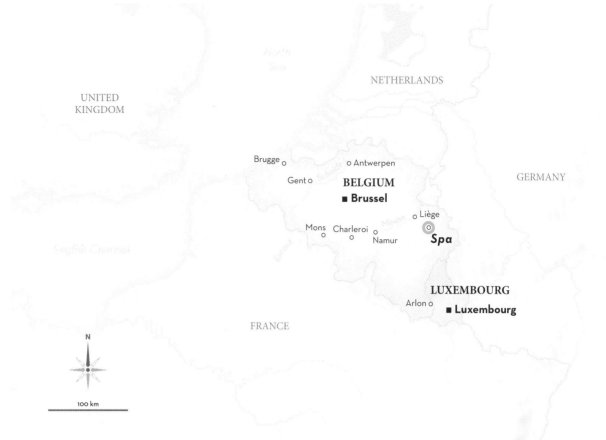

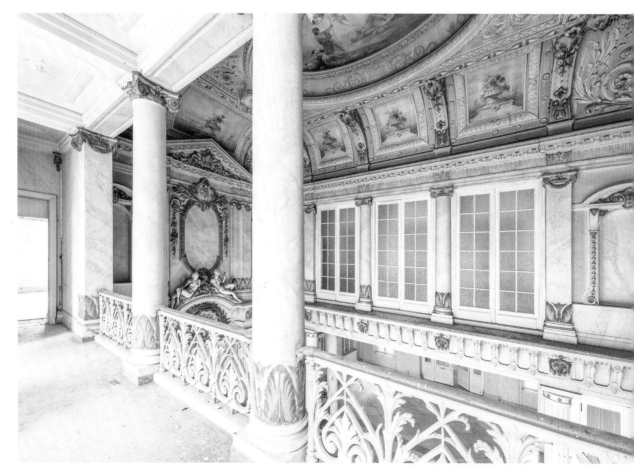

Alla Italia Thermal Spa · Liège Province, Belgium

Built in a Neo-Renaissance French style, this thermal spa, located in the city centre, is the last of three that were built between 1828 and 1868. In their heyday, these thermal spas carried out up to 170,000 treatments per year. Replaced by a more modern installation in 2003, they closed their doors for good after 135 years of service. In 2016, they were listed as part of the 'exceptional heritage' in the Walloon region and became a UNESCO World Heritage site in 2021.

Going through the different changing rooms and bathing rooms that are spread out over the building's three floors, we can see that everything has already been dismantled and taken. Not a single copper bathtub. No more furniture. The highlight of this visit is undoubtedly in the atrium. Despite feeling outdated – chipped gilt moulding, grimy stucco and plasterwork, faded paint – the luxury is still eye-catching. A collection of Neo-Renaissance architecture on a postage stamp.

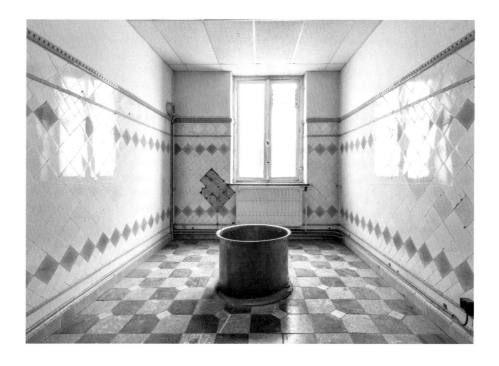

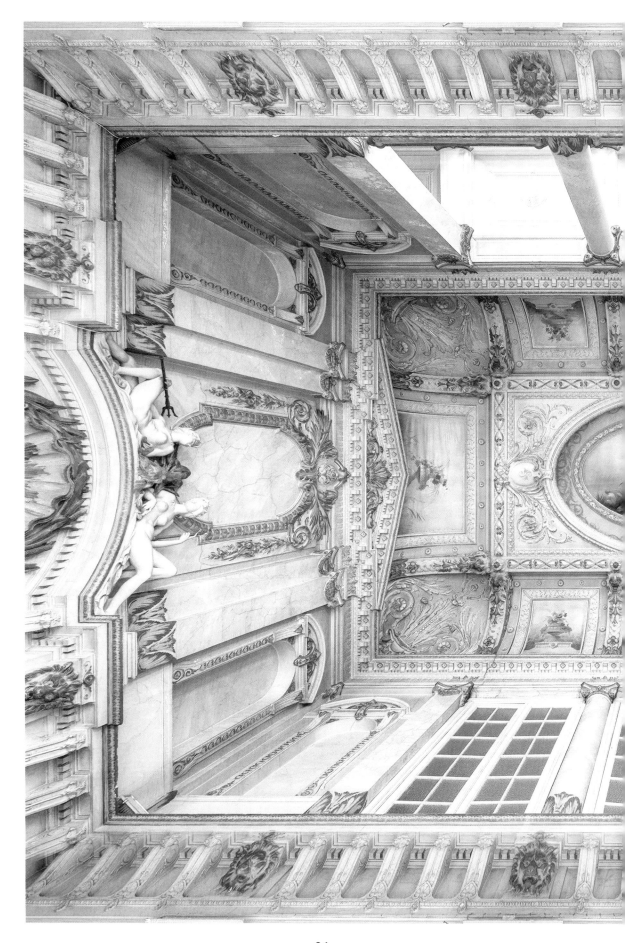

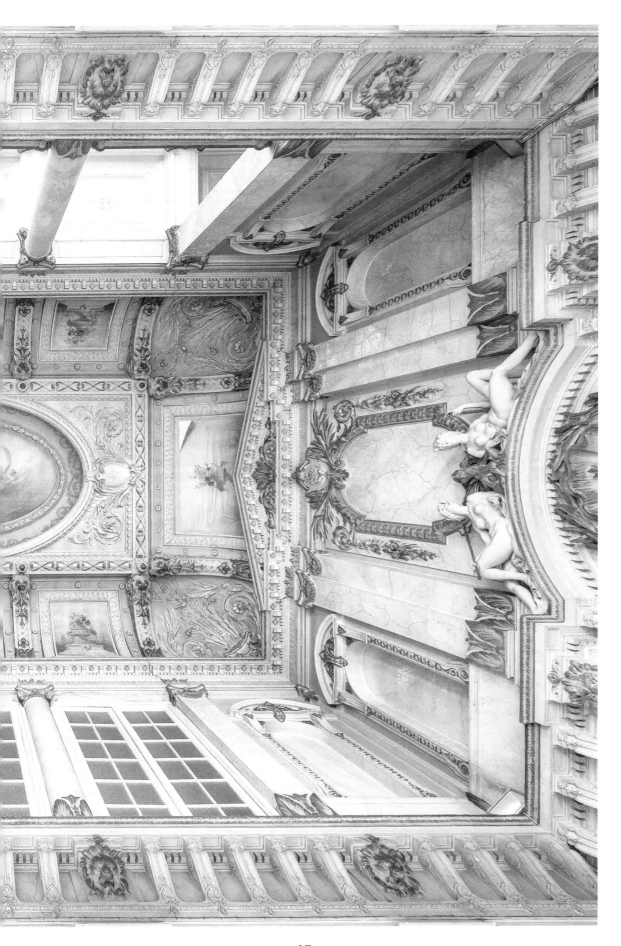

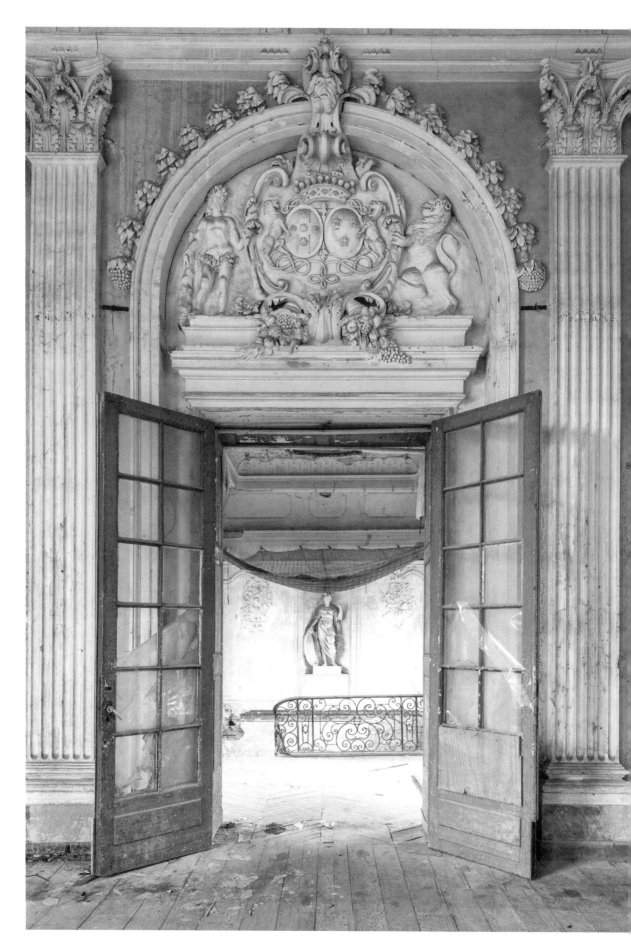

Lucky Castle ·
Liège Province, Belgium

Construction began on this building in 1864, and when it opened in 1870, it was originally a casino, a theatre, and a concert hall. It welcomed wealthy tourists who came to the town for its thermal baths. It quickly became a popular meeting and entertainment venue, hosting many famous artists, theatrical performances, and classical music concerts. Over time, the building was used for multiple purposes, including a cinema and a dance hall. After suffering significant damage during the Second World War, it was restored for the first time in 1950 and once more became an entertainment and concert hall. Throughout the years, the building was used for other purposes: a military hospital, a Protestant church, a school, an orphanage, a municipal museum, and even the headquarters of local organisations. It was added to the Walloon Heritage Institute's safeguarding list in 1999.

The exterior's simplicity, with its bricks and blue stones, contrasts with the richness of the interior which is overflowing with decor. There are stucco walls, paintings on the ceiling, marble fireplaces, mirrors – this ornamentation is present throughout the five rooms on the first floor, including in a majestic ball room. Architects, stucco workers, painters; great artists had made this place possible.

Contrary to what the title of this book suggests, this site isn't abandoned. The concept of abandoned is relative. Forgotten by time, fallen prey to degradation, this building is still monitored and is gradually being restored with the help of a preservation society. It's often open to the public during Heritage Days, and the public can come admire one of the oldest gaming rooms in Europe.

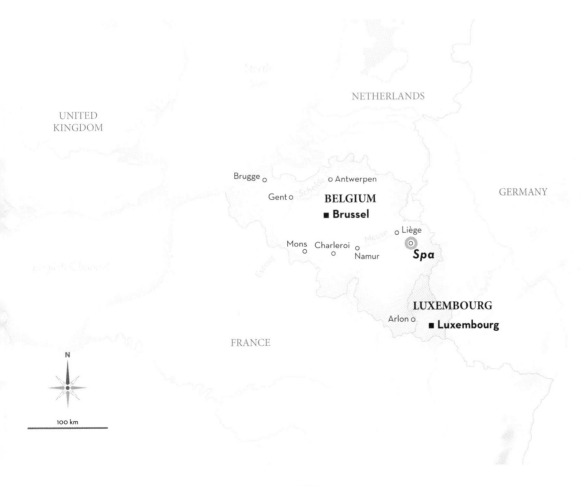

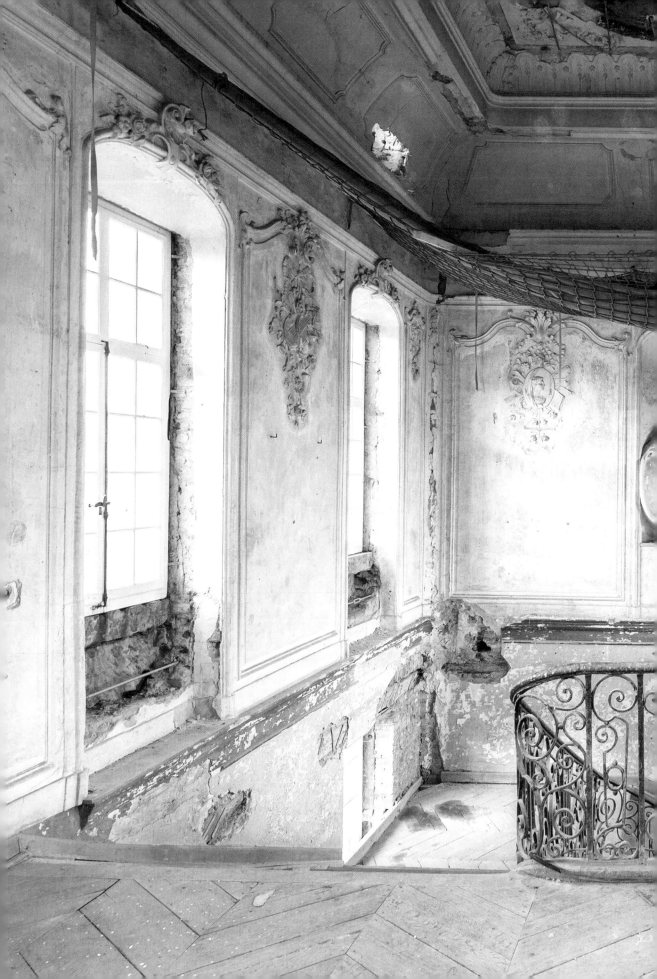

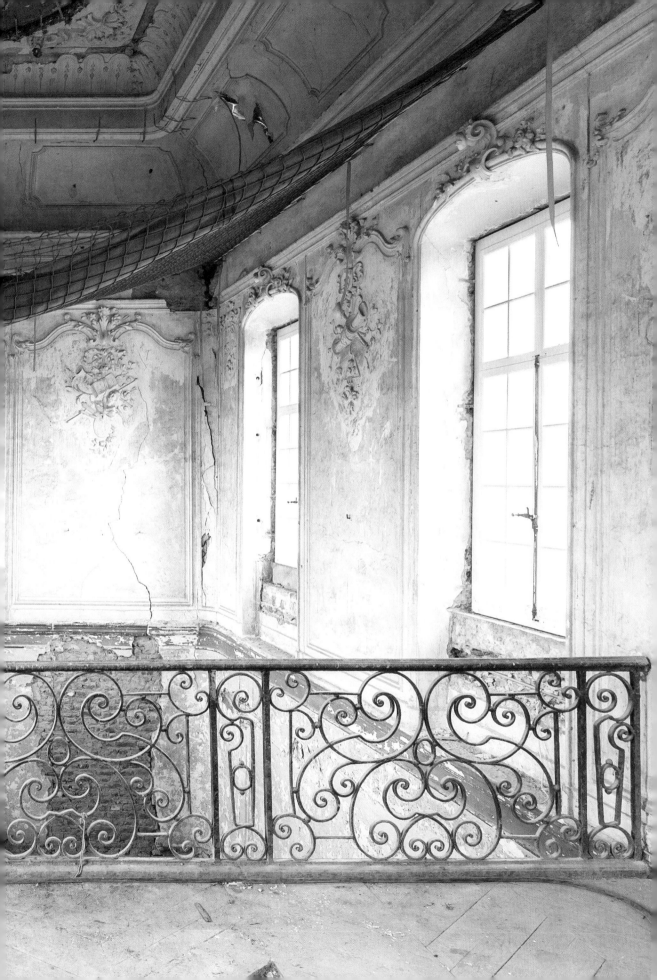

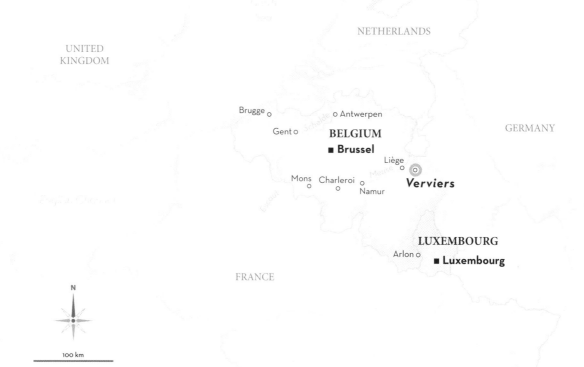

NETHERLANDS

UNITED
KINGDOM

GERMANY

Brugge o o Antwerpen

Gent o **BELGIUM**

■ **Brussel**

Liège
o

Mons Charleroi *Verviers*
o o o
 o
 Namur

LUXEMBOURG

Arlon o ■ **Luxembourg**

FRANCE

N

100 km

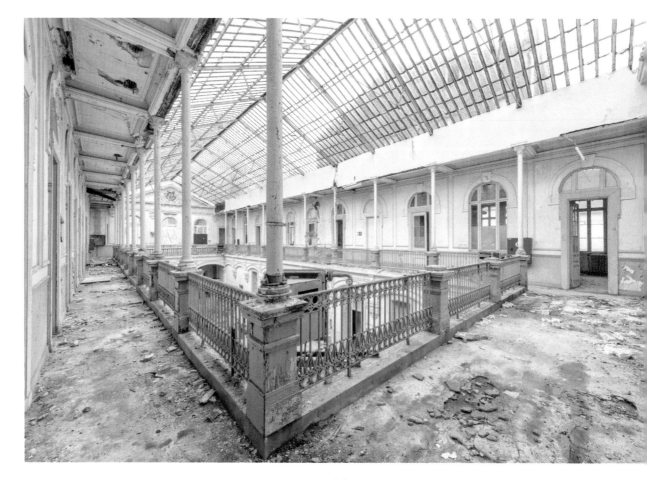

Maidens School ·
Liège Province, Belgium

Built by two Brussels architects, this building opened in 1876. It then became home to 'the school for young girls', a middle school for girls that had been founded in 1865. After being taken over by the state in 1925, it then became a high school. In 1946 it was named Lycée Royal. Before closing its doors in 1998, the building was also home to a nurse training college. A large company bought it in 2001 and it was listed as a heritage site, but it remained abandoned until 2019.

Its architecture and luminosity make it a remarkable building. One can easily picture the excitement that must have reigned over breaktime, but also the strict discipline that must have been administered once the bell rang. When these photos were taken, the entire building had water leaks, and the beautiful glass roof was no longer waterproof or secure like the original. On rainy days, the ground would be completely flooded, which gave photographers a beautiful mirror-like reflection from that perspective. The vegetation was overgrown in all four corners of the courtyard.

Furniture that had been thrown from the first floor was in pieces on the ground. All of the classroom windows were broken, and plaster moulding from the balconies was strewn about. Graffiti tags had appeared, but the light's magic had remained intact.

A programme of works was performed in 2019 to avoid the risk of collapse. The roofs and the glass ceiling were boarded up. The doors and the window frames were completely dismantled so they could be restored to their original form. Finally, in September 2022, the Société Publique de Gestion de l'Eau (The Public Water Management Company) installed its new offices in the completely renovated nurse training college.

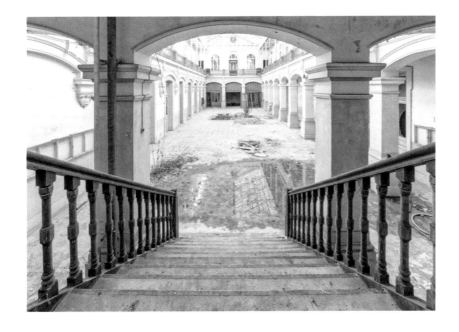

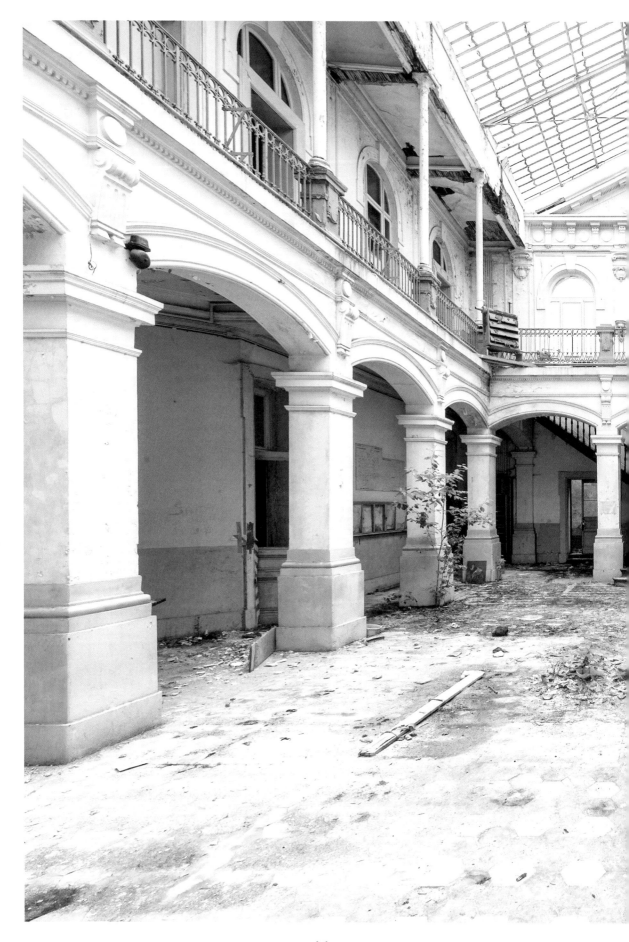

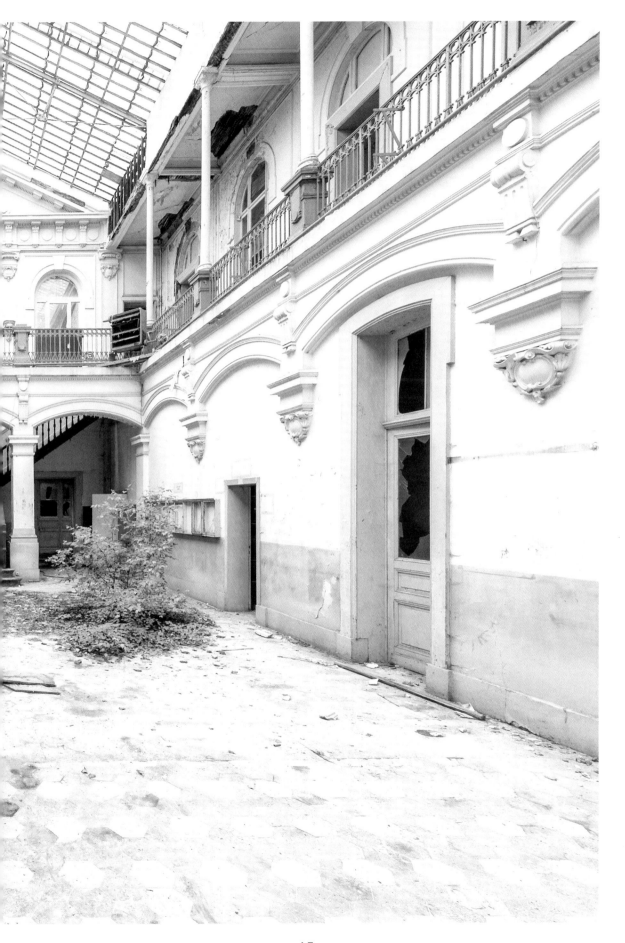

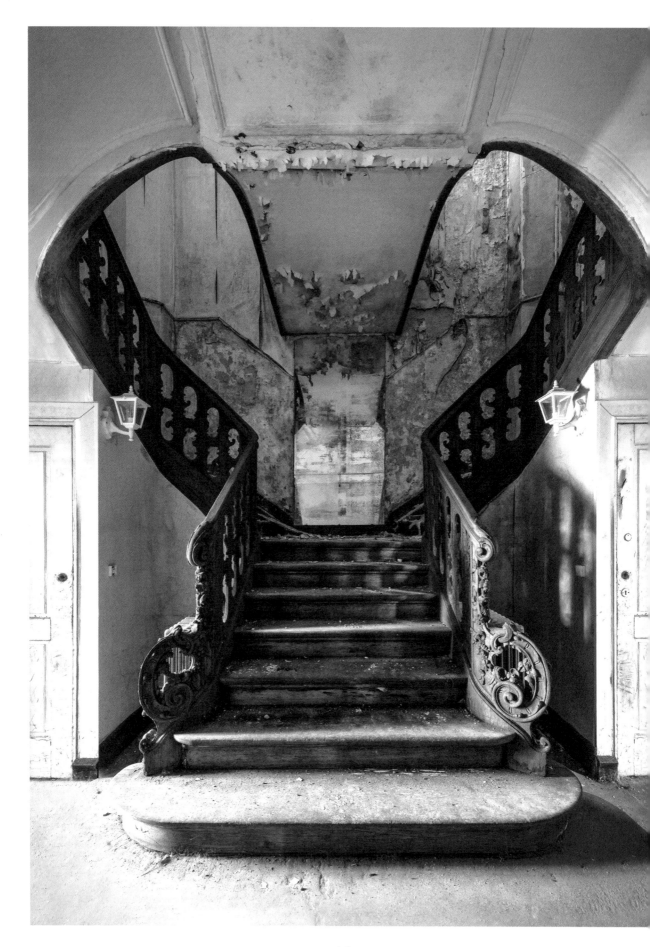

Flood Castle · Liège Province, Belgium

In the 17th century, on the grounds of a 12th-century Cistercian abbey, a palatial abbey was built from one of the cloister's wings. It was gradually transformed into a castle. In 1795, the abbey was demolished, along with the religious community that had been driven out by the French revolutionary powers. The castle was sold in 1935 to an insurance co-op, which set up a tuberculosis preventorium for teenagers. Although it had been listed as a historical monument, the castle was gradually abandoned and is in a particularly troubling state today.

The castle is completely empty. A wooden Louis XVI staircase stands at the end of a hallway, making anyone wonder if it is being held up by its own wooden structure or by the frozen dampness within it. Despite being listed, it seems completely hopeless. The steps and the ground are littered with debris that have fallen from the ceiling. How long will it be before everything makes its way to the ground?

Upstairs, there is a strange hallway whose wooden floor ripples dangerously beneath the feet. Some of the doors open up into empty rooms where brambles are hibernating for the winter, other doors lead to washrooms that are frozen in time with the cold and dust of the decaying walls. A thin film of sculpted ice fractals lines the windows, allowing light to pass through, though you can no longer see outside.

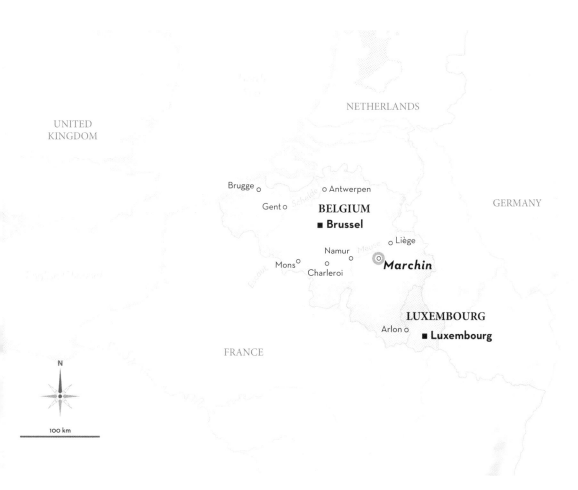

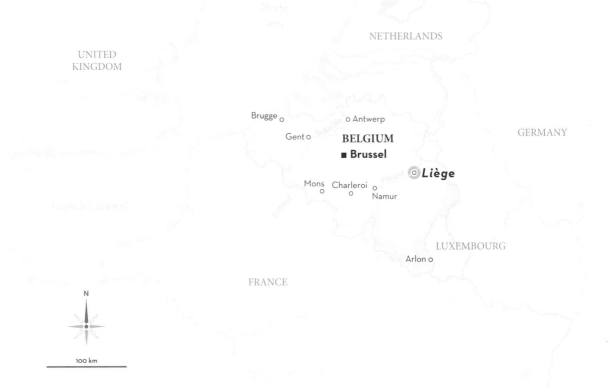

Top Grunge MIG ·
Liège Province, Belgium

A former MiG (Russian aircraft) of the Polish Army has been acquired and transported to the back of this property by a rich, eccentric bourgeois man who certainly wanted to impress his friends during country excursions. Time has passed, vegetation has grown around it, and the owner has probably tired of his toy. Although it has been taken over by ferns, it is no less impressive. The flight instruments are all there. One can even sit behind the controls of the plane that is secured to the ground.

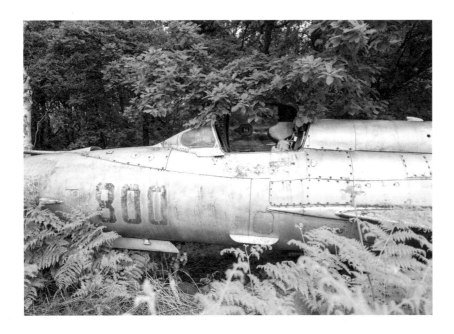

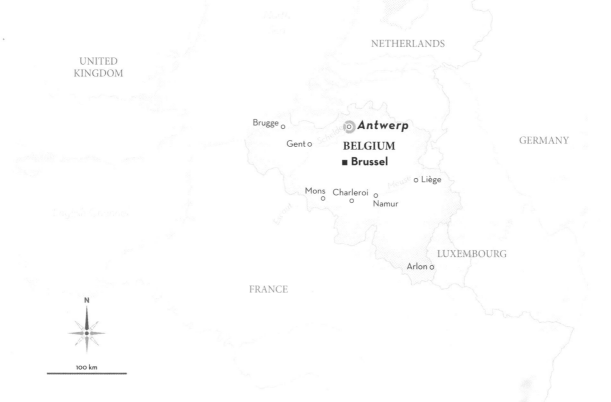

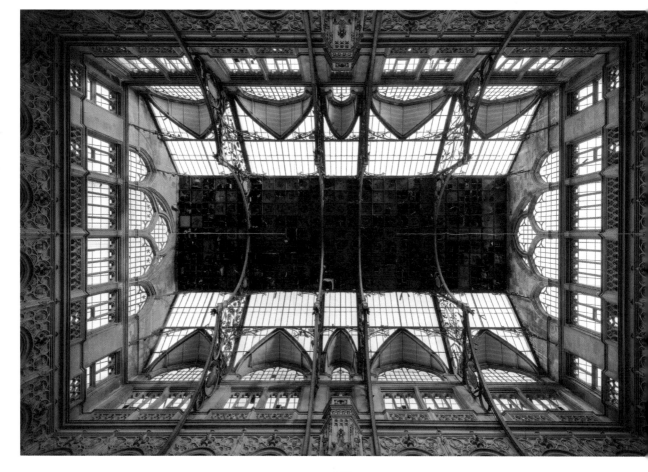

The Commodities Exchange ·
Antwerp Province, Belgium

In 1531, the Handelsbeurs of Antwerp was built: A Neo-Gothic architectural gem that was the first stock exchange in history. Other buildings all over Europe were modelled after it. It closed its doors in 1997 after stock market activities were transferred to Brussels. The old commodities exchange were a legendary place in forgotten Belgium before finally being restored in 2019 after 20 years of slumber. It is now a shopping centre that's open to the public and located in the city centre.

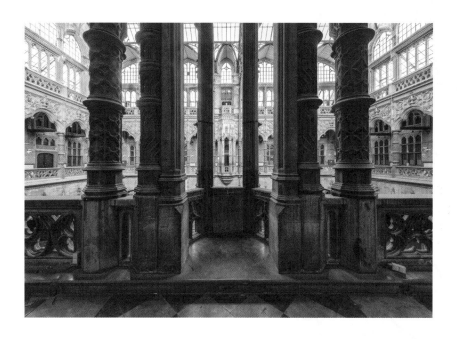

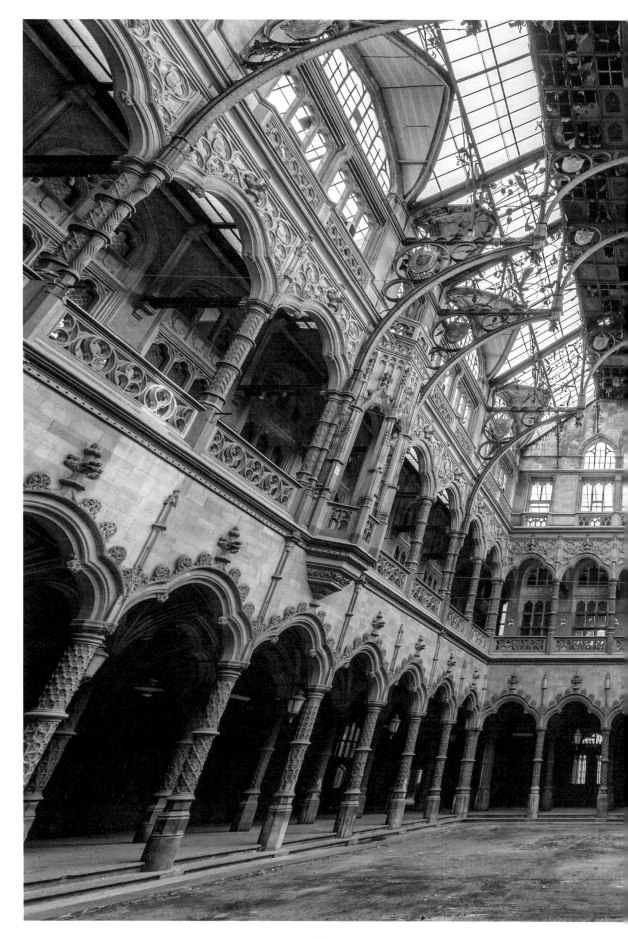

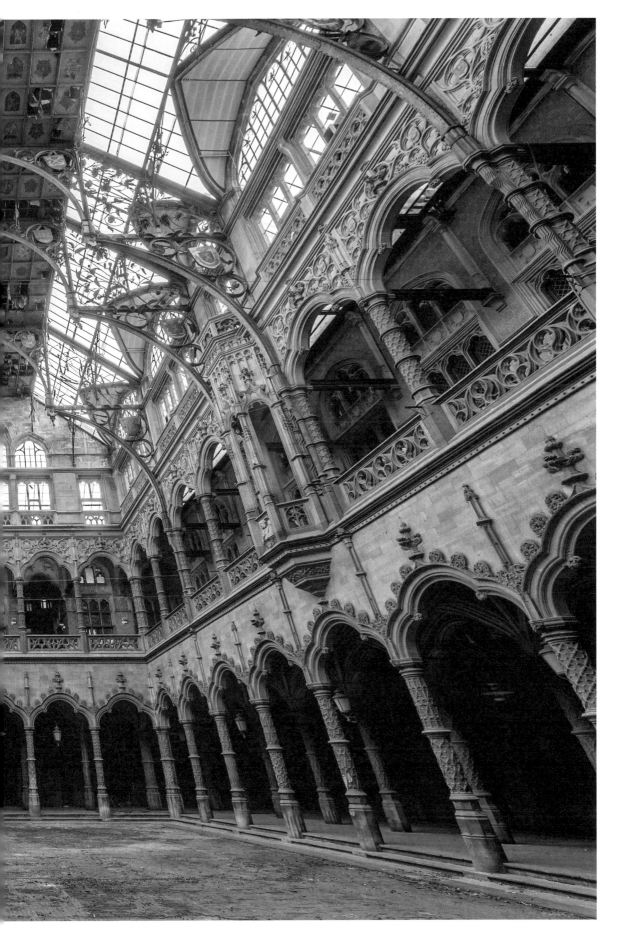

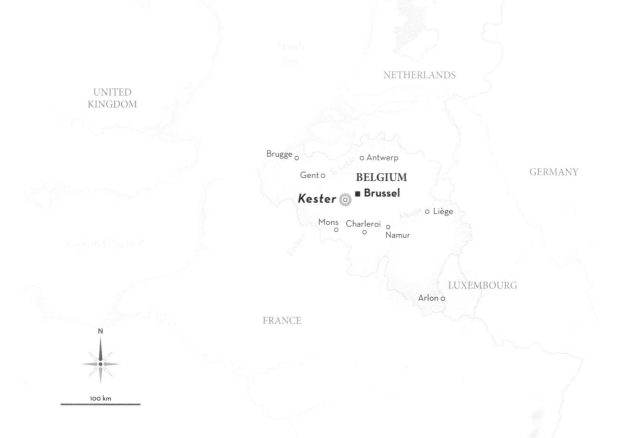

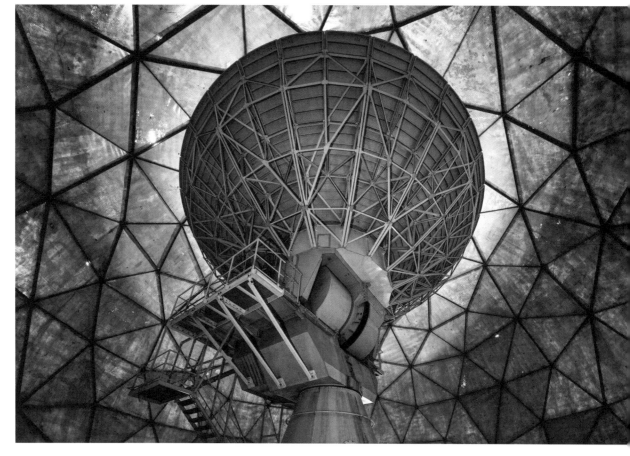

Satellite Communication Station · Kester, Belgium

In the small village of Kester, located in the countryside just outside of Brussels, stood an unusual building: an abandoned ex-military radome, one of those 'golf ball-like' geodesic structures beyond the fence lines of communication bases.

Construction of this NATO installation, codenamed 'Zone Braams', began in 1969. It was operational by 1971 and manned by a small contingent of mostly US military personnel up until its closure in late 2012 (it has been demolished since).

It was one of several stations dotted around Europe designed to maintain secure military communications between NATO member states.

Within a high perimeter fence there were two structures; the large dome mounted atop the westernmost of these. The buildings were at one stage filled with electronic monitoring equipment but had been completely stripped out save for the large antenna within the dome. The dome was constructed using a rigid geodesic frame covered in a fabric made from PTFE, a 'Teflon-like' material that does not interfere with the antenna signals while protecting it from the weather and keeping it hidden from view.

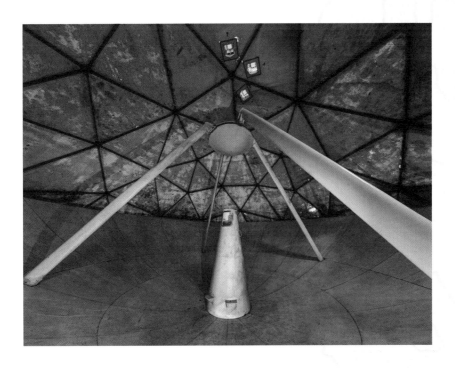

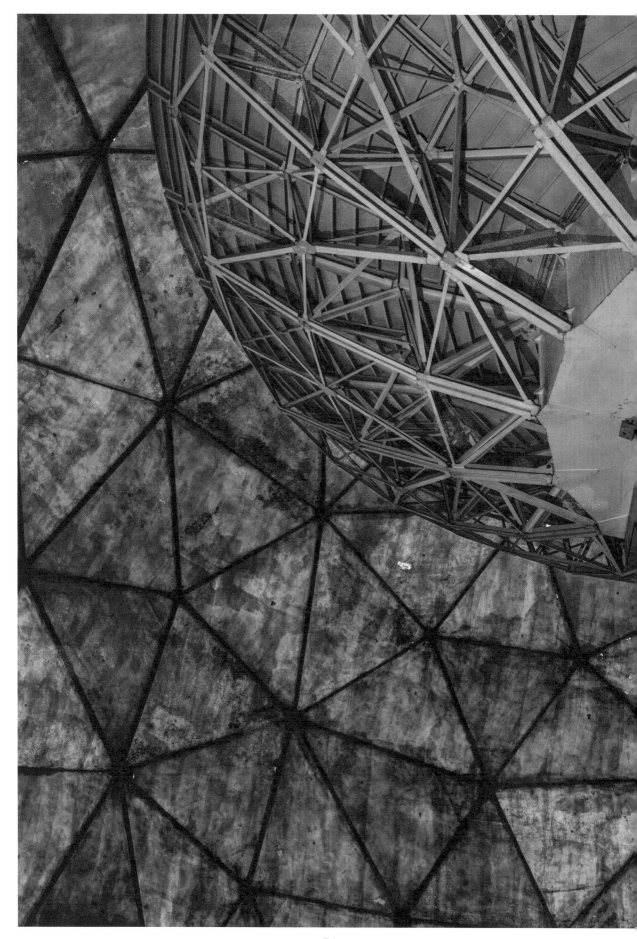

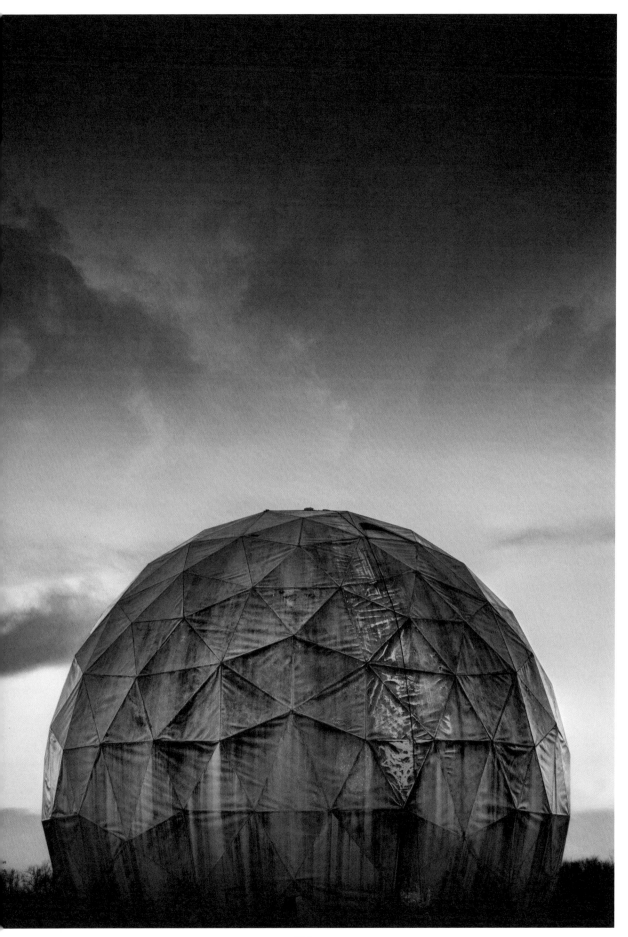

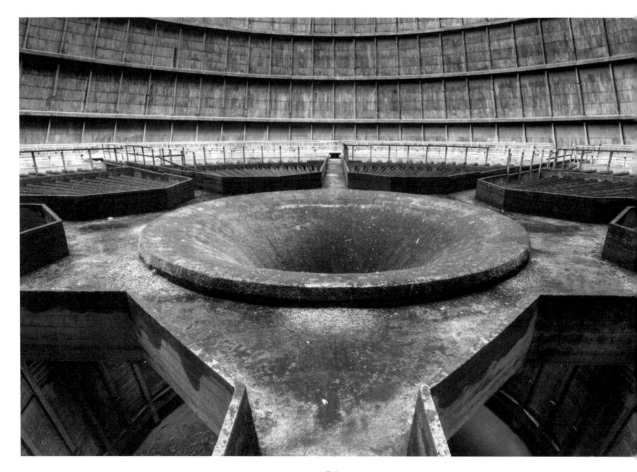

Cooling Tower · Monceau-sur-Sambre, Belgium

This location, one of the Northern European classics, has remained a hot favorite almost constantly. This could be because it is easily accessible, situated in a busy industrial town in central Belgium and provides an exciting and truly sensory experience.

The location is a large cooling tower next to a looming derelict power plant. A busy canal and lock separate the plant from the tower, with the services that pump the hot water to the tower crossing the canal on a dedicated bridge. The purpose of cooling towers is to cool and re-circulate water that is boiled to generate the steam that drives the turbines within the station. The water is pumped upwards to spray nozzles or into troughs that spread the supply across the full width of the tower. It then trickles down through a series of containers and drops into the pond. During its descent the water will have lost much of its heat through evaporation as steam. This then rises up and out of the top of the tower.

Cooled water can then be pumped back to the power station to be reused.

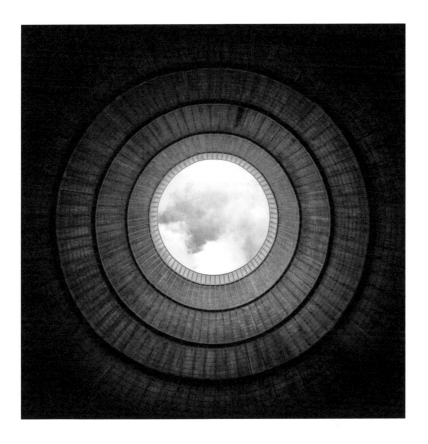

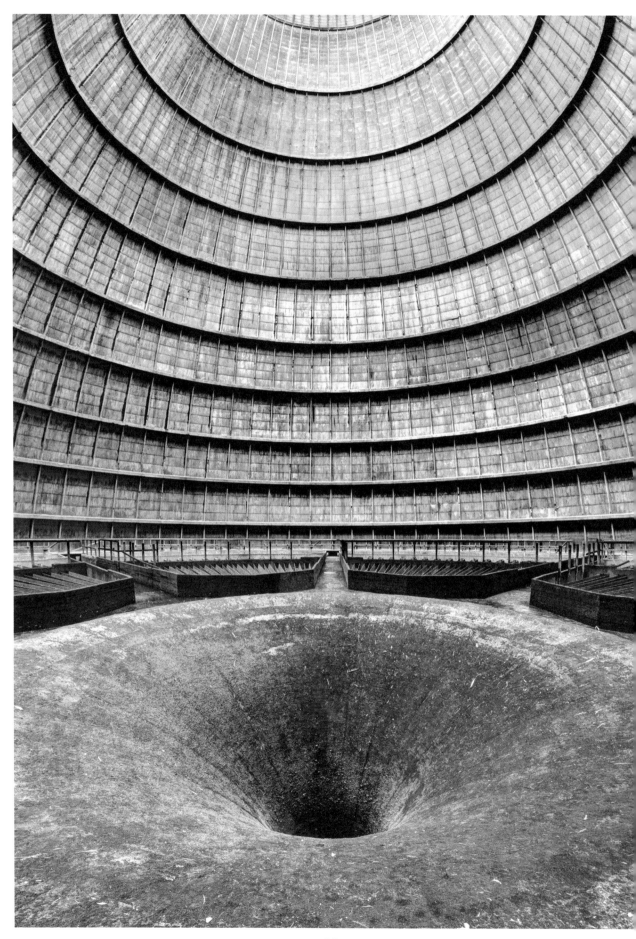

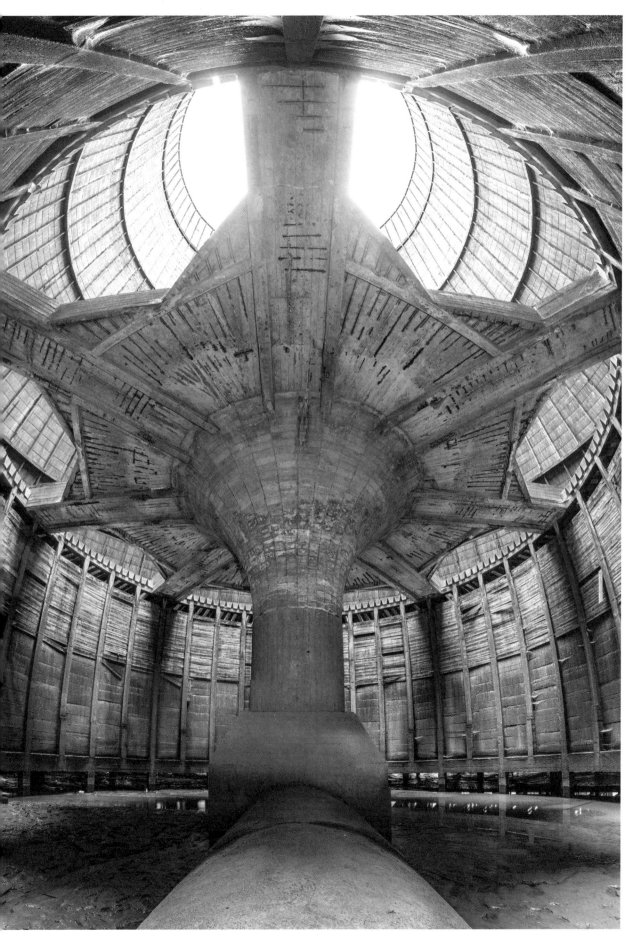

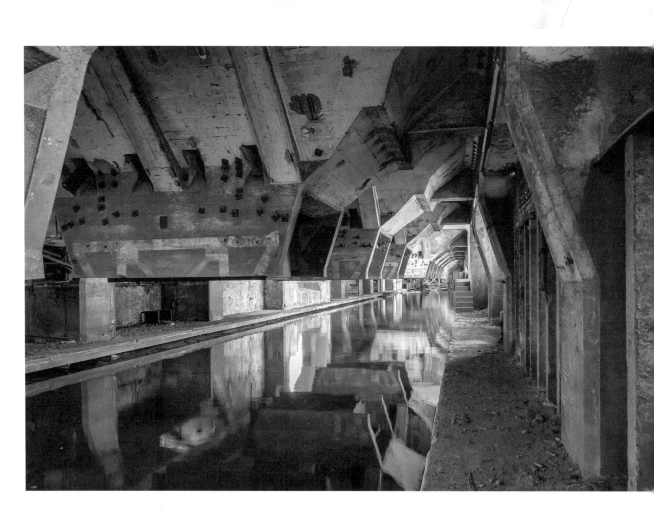

Crimson Earth · Luxembourg

Built in 1907, this ore accumulator is one of the only vestiges that remains from a huge iron and steel site that has been abandoned since 1977. After managing to avoid bulldozers for a long time, it seems that its demolition is imminent (if it hasn't already happened). However, certain steel portal structures will be preserved and relocated in the future. Just for the record, a chase scene in the movie *The Crimson Rivers 2* was shot there.

The site is located on the edge of an industrial plot, along a railway line that has fallen into disuse. It's well known to photographers and relatively easy to access. Still, it's a dangerous site, especially if you're trying to access the upper levels.

After stepping on a kind of rickety walkway, you can reach a tunnel that is about 500 feet long, separated in the middle by a pool of stagnant water running its entire length. On either side, two narrow towpaths make it possible to walk on the right bank or the left. The water is crystal clear and reflects the machinery that is still in the tunnel like a mirror. It is a real visual treat.

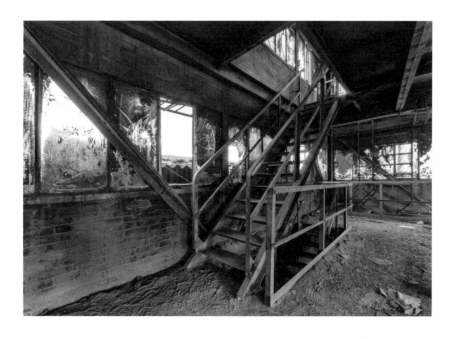

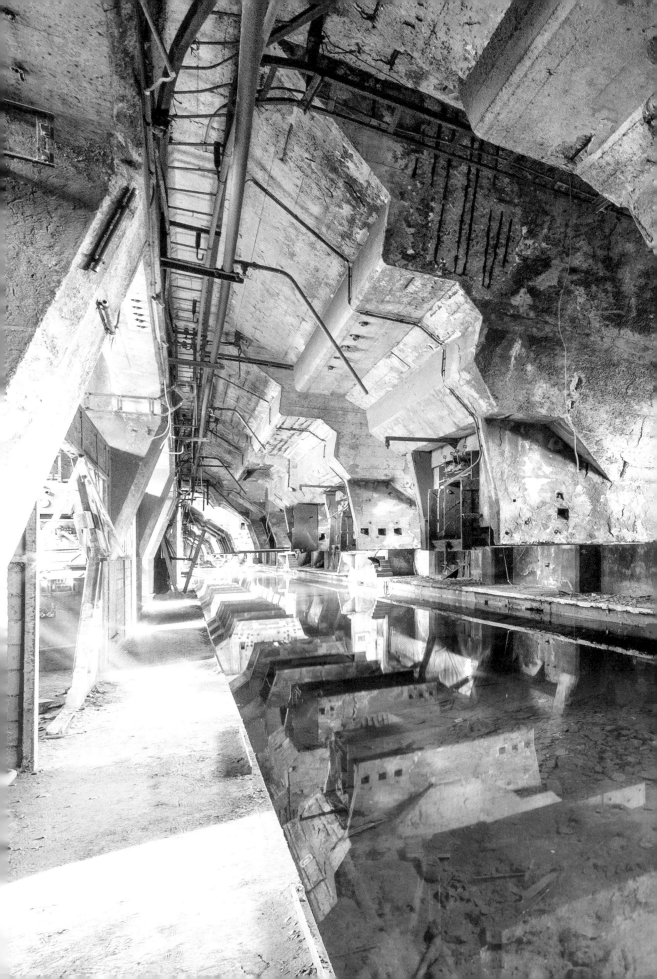

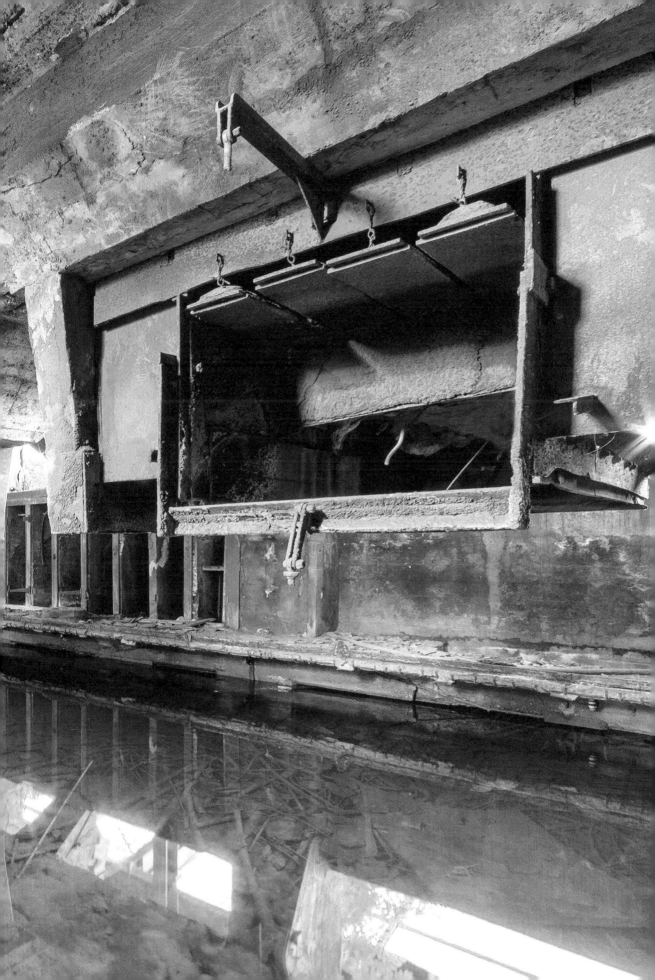

UNITED-KINGDOM

North
Sea

NETHERLAND

BELGIUM

GERMANY

Lille

Amiens

LUX.

English Channel

Reims

Metz

Cherbourg

Nancy

Strasbourg

Brest

Paris

Gometz-la-Ville

Rennes

Orléans

Belfort

Dijon

Besançon

SWITZERLAND

Nantes

FRANCE

Poitiers

Atlantic
Ocean

Limoges

Clermont-
Ferrand

Lyon

ITALY

Bordeaux

Nice

MONACO

Toulouse

Montpellier

Marseille

Perpignan

Ajaccio

SPAIN

Mediterranean
Sea

N

100 km

A Hovertrain 'Made in France' · France

Some 25 years before the TGV (France's high-speed train) was invented, the Aérotrain, or hovertrain, was the remarkable technological innovation and design of its time.

During tests in February 1966, the 01 prototype of the Aérotrain, mounted on an air cushion, reached 200 km/h. Two years later, an experimental monorail test track entirely dedicated to this new type of transport was built south of Paris by the French engineer Jean Bertin at Gometz-la-Ville. The Aérotrain was designed to be part of a future Paris-Orléans route connecting the two cities in just 20 minutes. In 1969, tests of the 02 prototype were carried out on the track, where the train's engine and rockets managed speeds of 422 km/h. From 1969 to 1974, this track was used mainly for the I80-250 and I80-HV prototypes, the latter reaching the world speed record for guided transport of 430.4 km/h, on 5 March 1974.

Despite keen interest in this invention, which aroused the enthusiasm of some 20 countries, including the United States, the project was finally abandoned in favour of the high-speed train (the current TGV), which pushed the business of the visionary Bertin into bankruptcy. Capable of equivalent speeds, the TGV had the double advantage of running on electricity rather than hydrocarbons, and on the existing rail network. However, it did not reach a speed of 380 km/h until 1981, and 551.3 km/h in 1990.

About 20 years ago, Thierry Farges, a mechanics enthusiast mainly interested in preserving military vehicles from the D-Day landings, narrowly managed to salvage the I80-250 and I80-HV prototypes that were destined for scrap from the grassy car park of the former Bertin company. They were restored by Farges, who can't stop talking about the air-cushion technology and propulsion performance.

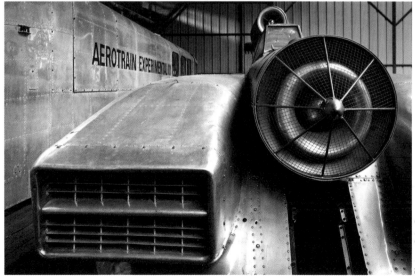

Photos © Robin Brinaert

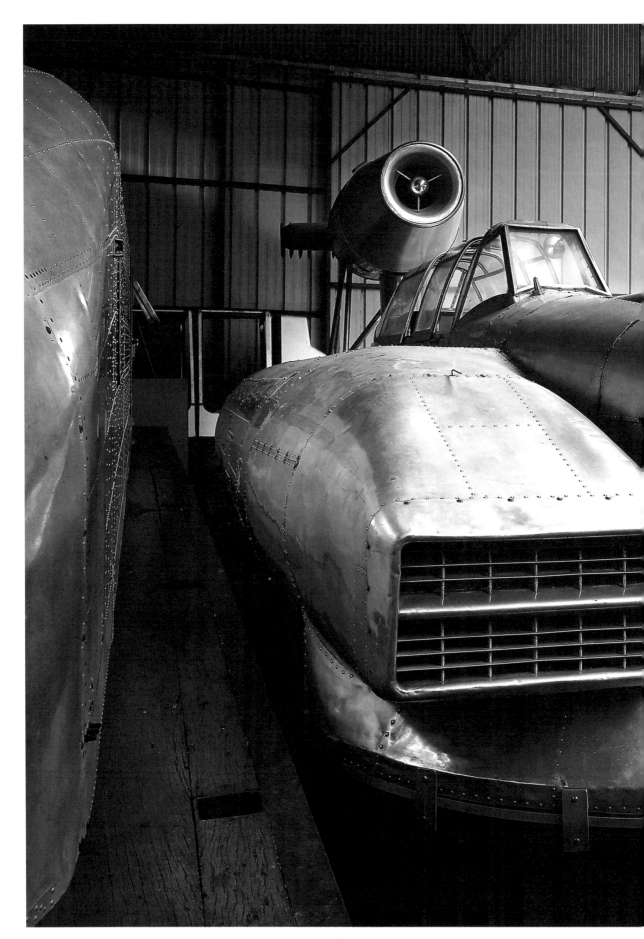

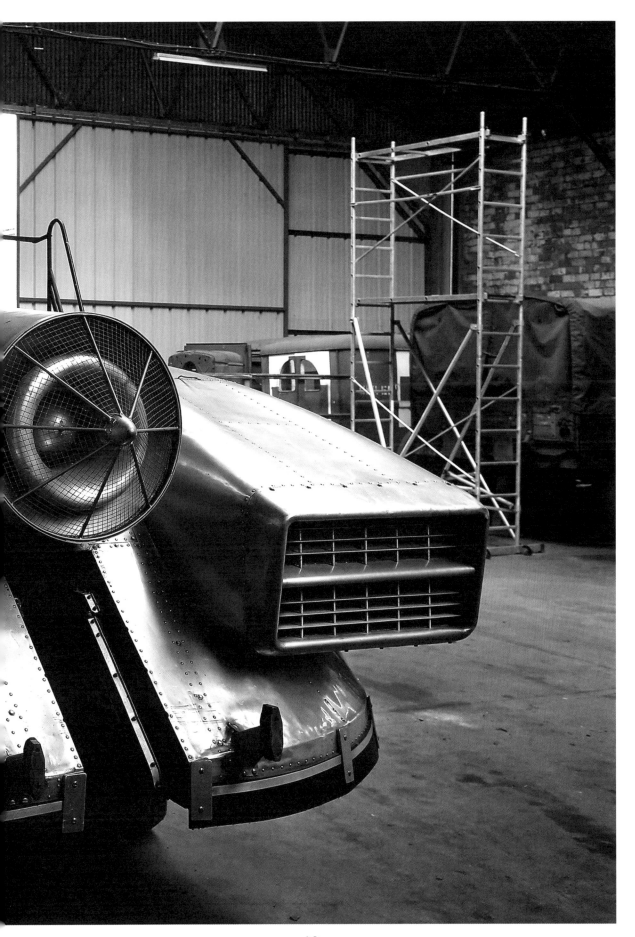

UNITED-KINGDOM

NETHERLAND

North Sea

BELGIUM

GERMANY

Lille o

English Channel

o Amiens

LUX.

Cherbourg
o

Reims o

o Metz

Paris
■

Nancy
o

Strasbourg o

Brest
o

Belfort o

Dole

Rennes
o

Orléans
o

Dijon o ⊚

o Besançon

Nantes
o

FRANCE

SWITZERLAND

Poitiers o

Limoges
o

Clermont-
Ferrand
o

Lyon o

*Atlantic
Ocean*

ITALY

Bordeaux
o

Nice o

MONACO

Toulouse o

Montpellier
o

Marseille o

Perpignan o

Ajaccio o

SPAIN

*Mediterranean
Sea*

N

100 km

The Theatre of Dole · Dole, France

The city's first permanent theatre was built in 1754 in a military building adjacent to the stables. After the stables collapsed, the idea emerged to build a new performance venue that would contribute to the development of musical art in the region. The ambitious project was carried out in the upper part of the city, where there were many private mansions and the more distinguished citizens lived. The construction work lasted from 1840 to 1844, according to the plans of the engineer-architect Jean-Baptiste Martin. The aristocracy of the whole region came to the inauguration.

Classified as an historic monument since 1996, the theatre is remarkable. Although it has endured through the ages, it remains practically intact with its superb Neoclassical facade featuring a central forecourt supported by columns. The theatre is an Italian-style hall, shaped like a horseshoe to magnify the space between the stage and the large foyer. Six hundred seats are spread over five levels in boxes and balconies originally in duck blue with gold features. The decor, painted on wood and marouflaged canvas by the decorators Och and Chenillon, still glistens. In 2015, the building was closed to the public for a complete renovation. The building reopened in 2021 in a welcoming and impressive setting. By adopting a soft and tempered approach to the renovation and restoring its original colours, it was possible to work around the constraints of the existing Italian-style building to adapt it without disturbing its very special atmosphere. This new, modern venue regularly hosts concerts, plays and dance performances.

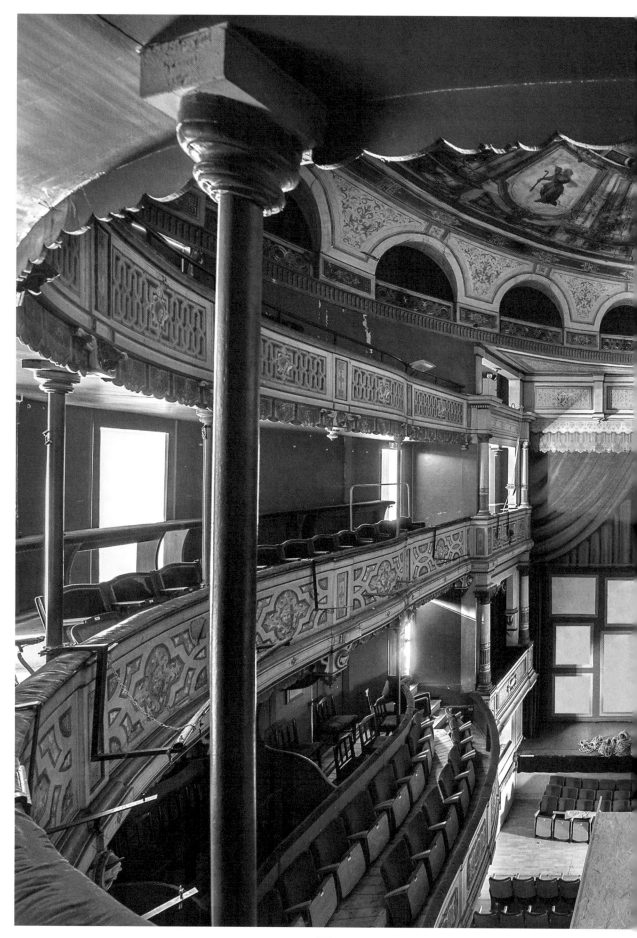

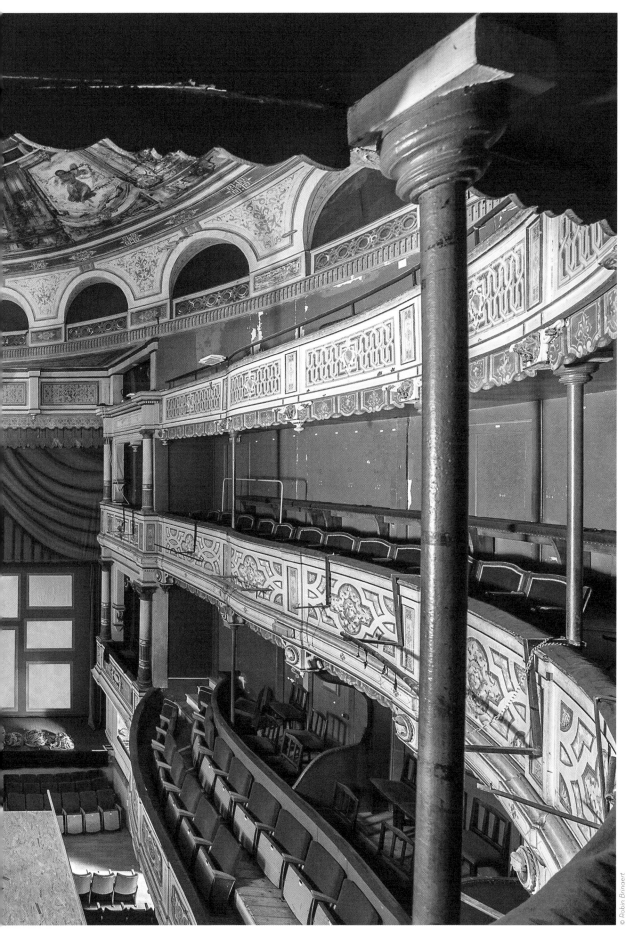

UNITED-KINGDOM

NETHERLAND

North
Sea

BELGIUM

Lille ○

GERMANY

LUX.

English Channel

Brest
○

FRANCE

SWITZERLAND

Atlantic
Ocean

ITALY

MONACO

San Sebastián
○

Bilbao
○

ANDORRA

SPAIN

Girona ○

**Cement Factory
Dome** ◉

Barcelona

Mediterranean
Sea

○
Tarragona

N

Valencia ○

**BALEARIC
ISLANDS**

100 km

Alicante ○

Cement Factory Dome · Catalonia, Spain

The Catalonian coast is dotted with dozens of cement factories, several of which have been abandoned for various reasons, the most common being complaints from local residents about particle emission, their proximity to towns, or the deposits running out.

One of these disused factories is well known to urban explorers, though its precise location will remain undisclosed. Over the last few years it has been used as a backdrop for various advertising spots and videos. Its large, dome-shaped warehouse stands in stark contrast to the more muted appearance of the other warehouses, kilns, and silos.

In addition to this site, evidence of stone extraction can still be found in the vicinity. Buried in the undergrowth, the rusting remnants of this industry have been sorely neglected, despite the valuable heritage they represent. They are testimony to a bygone era, a time when the mining industry clung on to survival thanks to material extracted from other quarries, until the day it was finally abandoned.

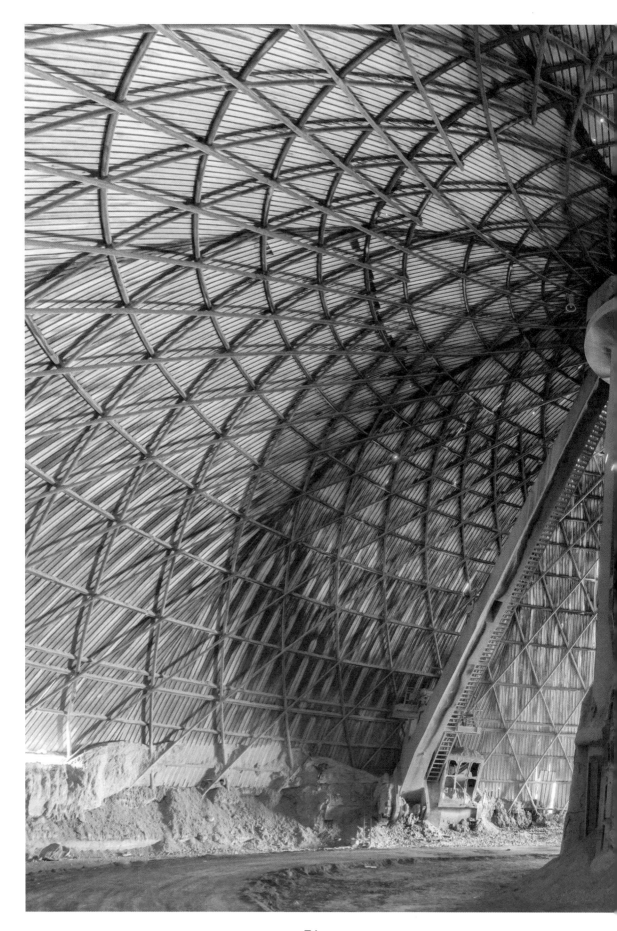

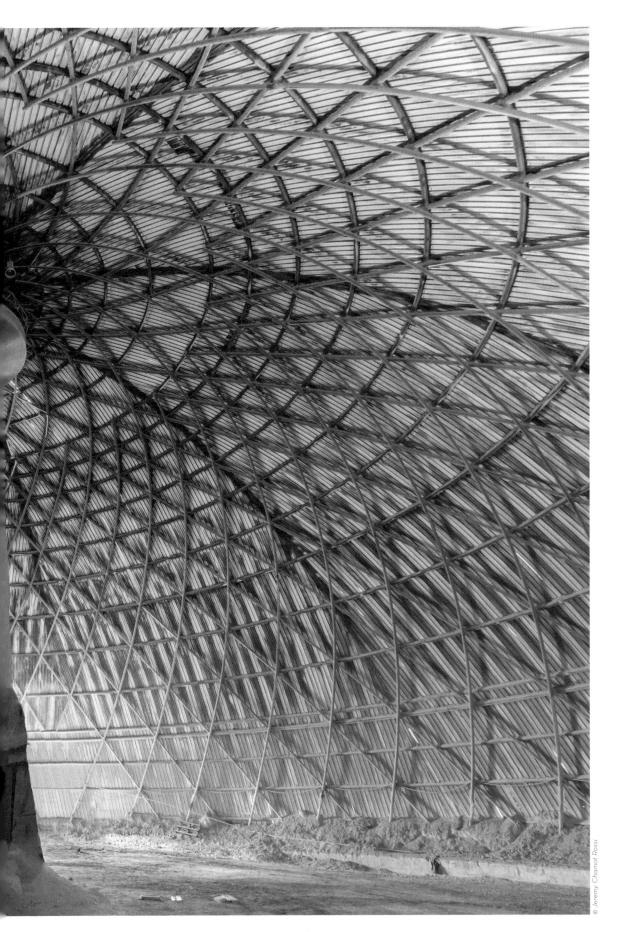

Porto

PORTUGAL

N

500 km

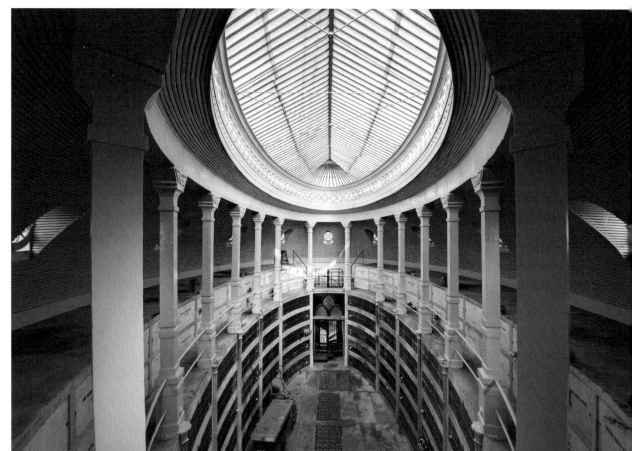

21st-century Crypt · Porto, Portugal

Hundreds of numbers, bouquets of glass and ceramic flowers, glazed metal, wood and marble: this is the industry dedicated to the transport from one body to another, from one place to another, turned wheels, springs and cranks, raised steps and trays, in the delicate palm of the Deposition, where nothing less elaborate than a dwelling served as a final resting place. Everything was joined together in an ordinary, anchored building. One slides, lifts, hoists, pushes, places horizontally. The bar that neither holds nor turns requires the necessary strength for the last stance, and it is an elbow that bends under the weight of the deceased.

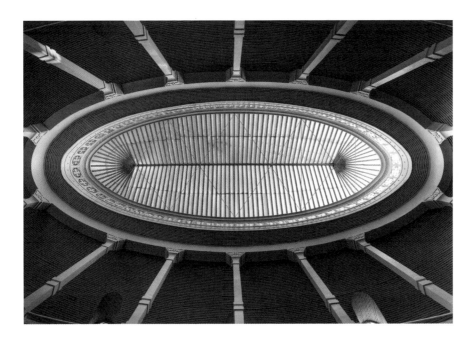

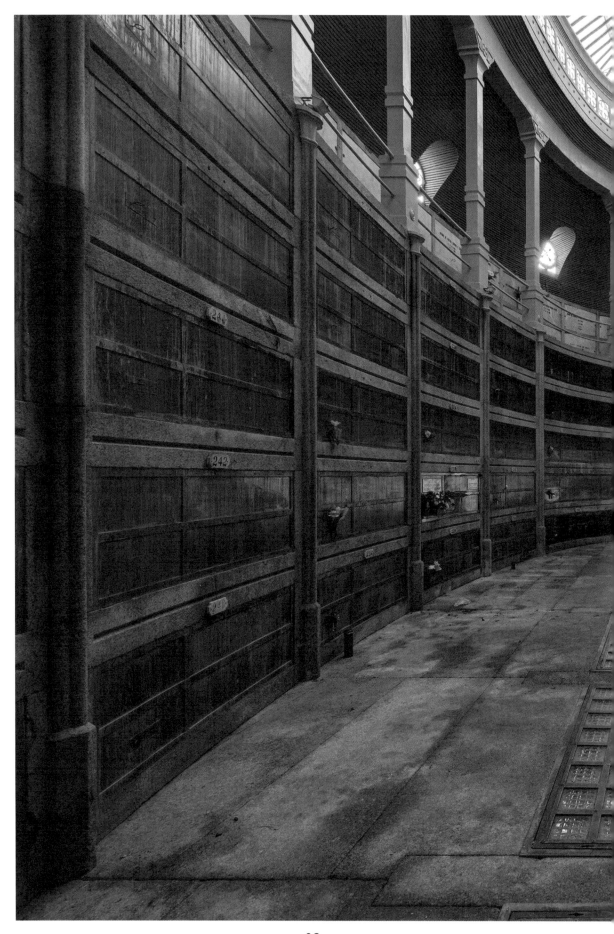

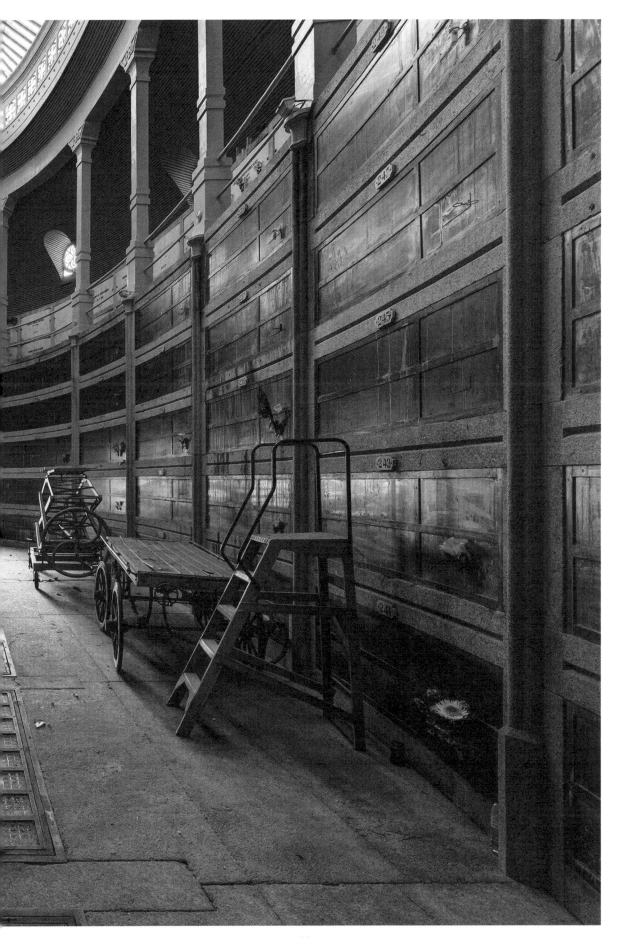

The Crespi d'Adda Power Plant · Lombardy, Italy

In 1869 a wealthy Italian textile manufacturer named Crespi bought a piece of land near the Adda River and set up a production plant: spinning, weaving, dyeing and administration.

A hydroelectric plant was built in 1909 to facilitate the operation of the growing business.

It was the time of enlightened industrialists and philanthropists who, inspired by the current social doctrine, wanted to satisfy the needs of their workers by taking care of their living conditions both inside and outside the factory. A complete city was built around the plant in addition to houses it included a hospital, church, school, cultural centre, theatre, stadium, public baths, a washhouse, fire station, and a cemetery.

Unfortunately, in 1929 the Great Depression hit Italy and the plant slowed down until it closed.

Today the magnificent 'black turbines' are still there, overhung by their old control desk. A Francis turbine and two other powerful Kaplan turbines provided a total power output of 858 kW. They occupy the entire hall.

The power plant is the smallest of those created along the Adda River, but certainly the most beautiful: The Liberty Lombard-style decorations, the original wooden floor, the marble control panel, and the head of the turbines make it a real jewel of industrial archeology.

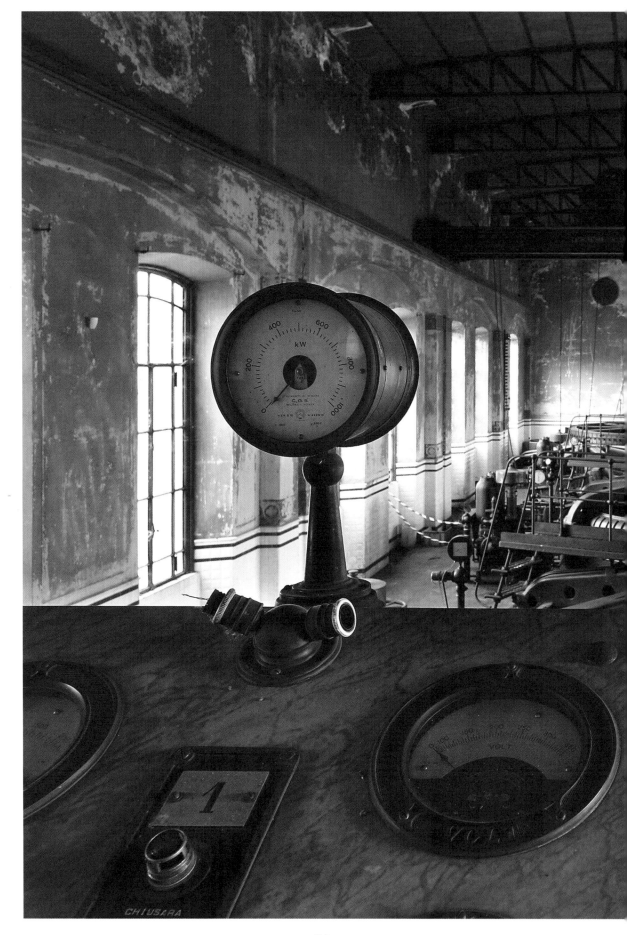

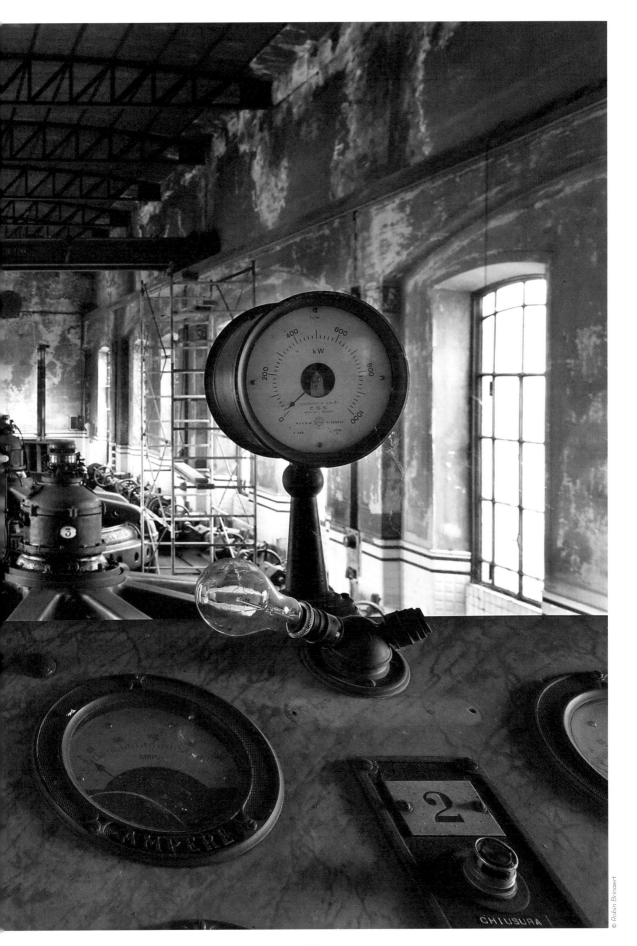

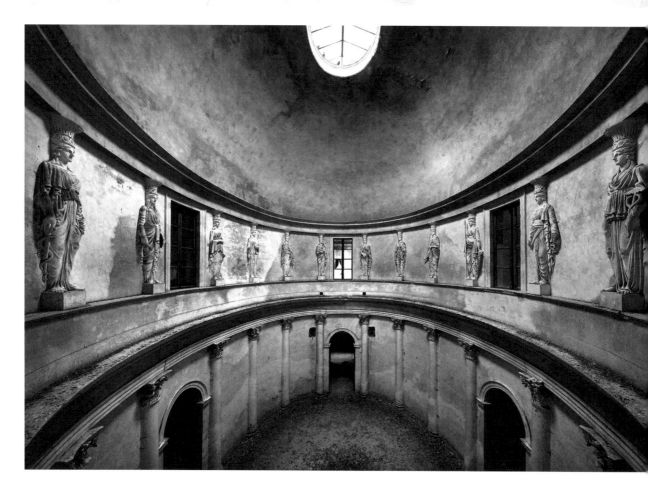

Palazzo Athena · Lombardy, Italy

Purchased at the beginning of the 20th century by Silvio Strumia, an entrepreneur in the silk industry, this old Neoclassical house is surprising. In the centre of the building a large elliptical room extends over two floors, crowned by a dome with a skylight. The dome is decorated with caryatids in white stucco and is supported by 16 Corinthian
columns. Each column bears the insignia of an art or a profession – perhaps a subtle reminder of the workers the industrialist employed between 1920 and 1950.
Recognisable by its characteristic high chimney, the spinning mill that Strumia built in the gardens adjacent to his palace also gave work to many women of the region.

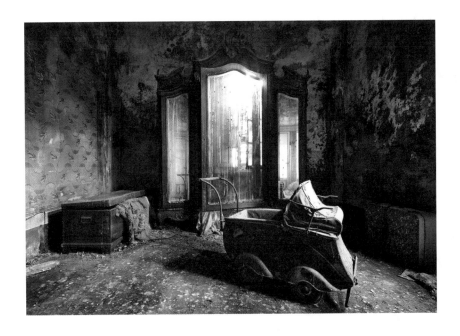

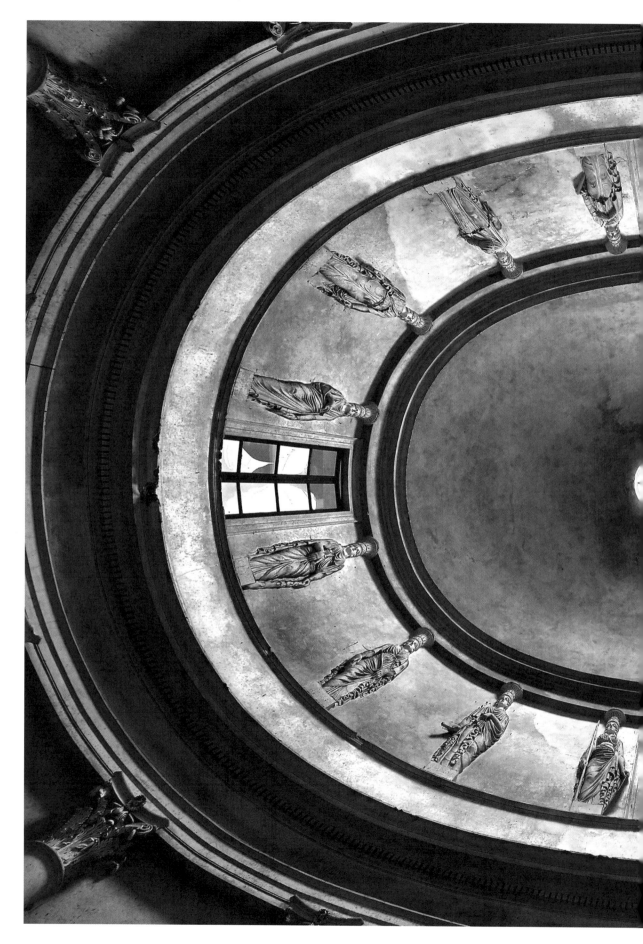

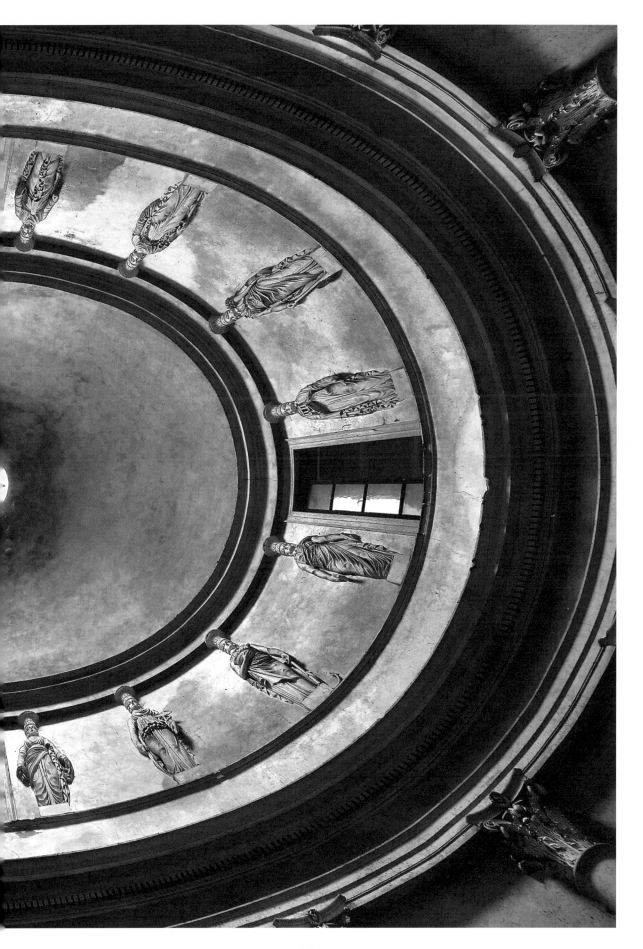

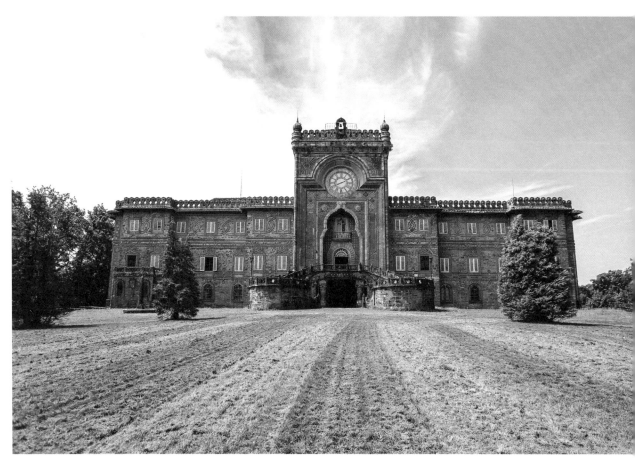

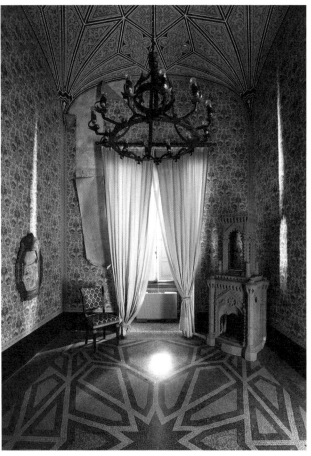

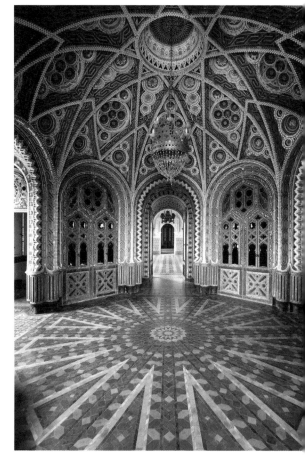

Castello Non Plus Ultra · Tuscany, Italy

The castle of Sammezzano is a masterpiece of excess and refinement. This proud place has hosted many personalities — Charlemagne himself stayed there while his son was baptised by the pope in 780 CE. But the one who had the most remarkable impact was Ferdinando Panciatichi Ximenes, the owner who transformed it between 1843 and 1889.

A politician, patron, lover of architecture, engineering and botany, this man of immense culture undertook to make the castle a true work of art reflecting his complex, tormented and megalomaniac personality. The magical atmosphere that permeates this labyrinth of myriad colours, the Moorish-inspired sculptures and grandiose salons (including the Peacock Room, with its majolica-decorated walls), leaves no visitor indifferent.

The gardens are equally impressive: Ximenes conceived the 'Historical Park' — 65 hectares of exotic plants, fountains and oaks that would prepare the visitor for the splendours waiting at the end of the path. But the castle was deserted by his descendants, looted during the Second World War, and transformed into a luxury hotel in the 1970s.

Now awaiting the realisation of a project to transform it into a luxury resort with spa and golf courses, the building and its park remain once more abandoned.

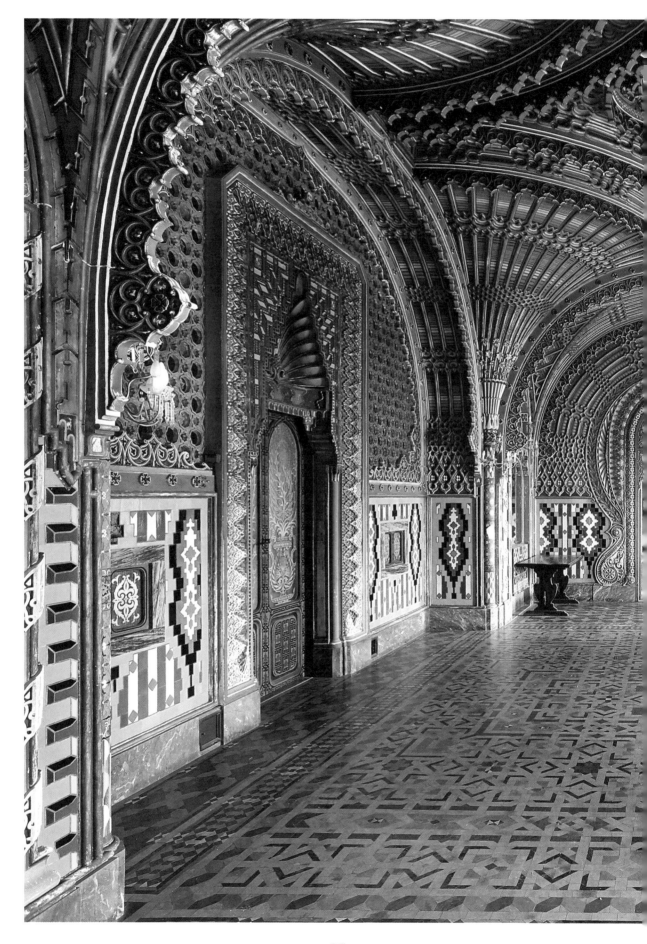

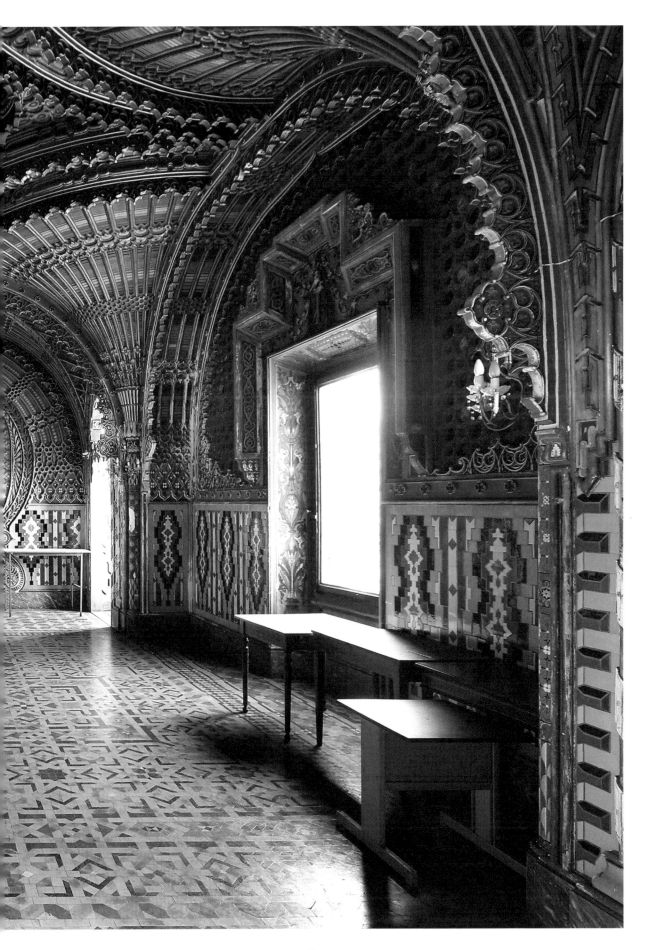

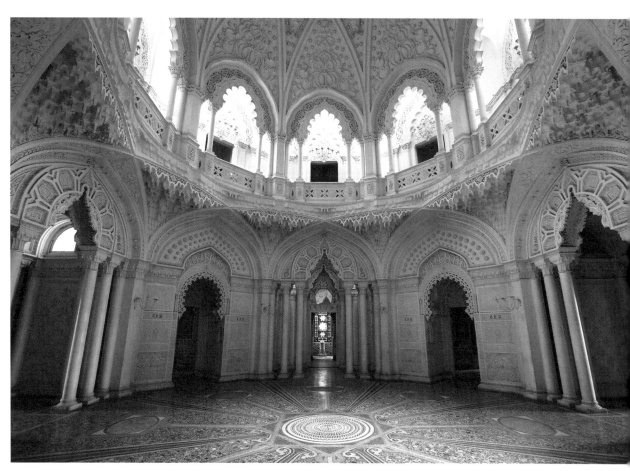

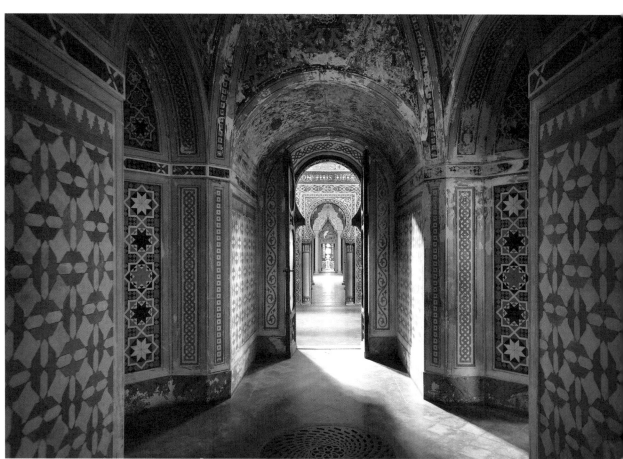

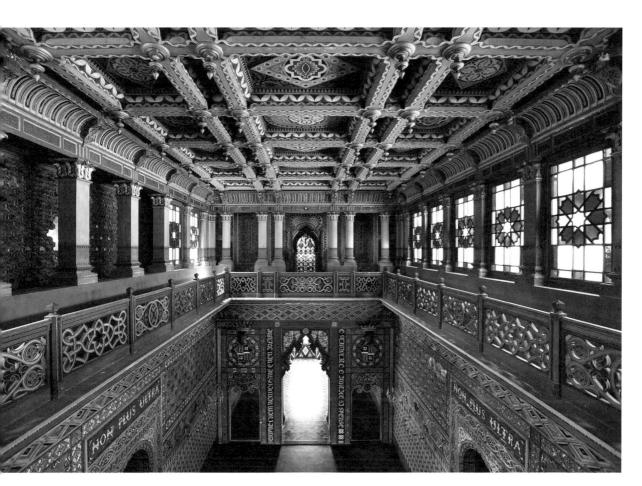

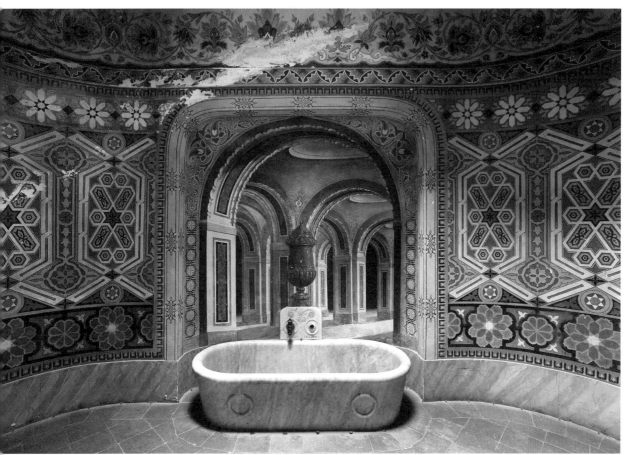

95

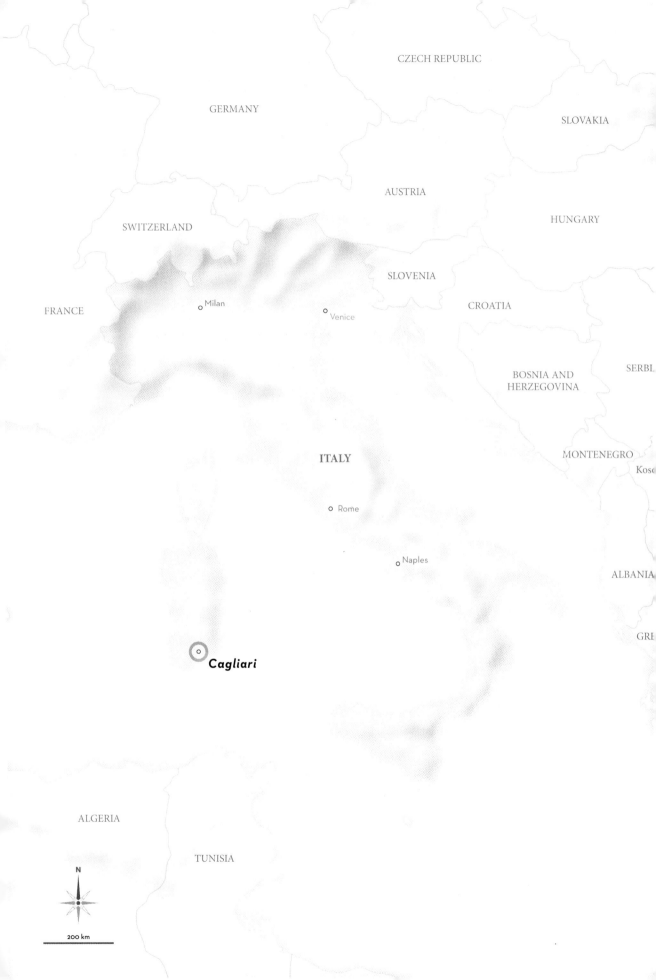

Sant'Elia Stadium · Cagliari, Italy

Completed in 1970 in the town of Cagliari, Sardinia, the Sant'Elia Stadium was designed as a showcase for the rising stars of Italian football in the 1960s: Cagliari Calcio (formerly US Cagliari). The icing on the cake for this outstandingly successful club was the fact that the stadium was completed in the very year that Cagliari won the Italian championship, justifying an investment of 1.9 billion lire (almost €1 million) covered by the municipality and a national sports loan. Built of reinforced concrete with uncovered oval stands, the stadium was considered a real work of art at the time. It could hold up to 20,000 spectators, a number that soon proved problematic.

The resources invested in the construction of the building did not extend to the infrastructure needed to support the huge numbers of *tifosi* (supporters): the access roads to the stadium were far too narrow for the number of spectators that some matches attracted – such as the three matches in 1990 as part of the FIFA World Cup – and the car park had only 200 spaces.

The stadium itself soon suffered from a number of problems: Its proximity to a nearby fuel depot caused a fire when one of the underground pipes ruptured, causing the fuel to rise to the surface, and a worker's cigarette butt accidentally set the building alight. Subsequent repairs failed to halt the stadium's decay – it also became less well attended as the club fell down the league ranks, attracting fewer and fewer spectators. As the concrete became more brittle and further problems arose (the athletics track and stands were in poor condition, the lighting was faulty, etc.), numerous renovations were undertaken until it became clear that the stadium was not fit for purpose and it closed its doors for good in 2012.

The club then moved to the Unipol Domus, also known as the Sardegna Arena, a temporary structure that it hoped to vacate in a few years' time. The project for a new stadium, approved in 2017, moved ahead in 2023 with a €50 million plan unveiled by the city council for the demolition of the Sant'Elia Stadium and the construction, on the same site, of a 30,000-seat arena as part of a vast complex including hotels and restaurants. It was hoped that the new structure (expected to cost around €160 million, including investment from the club and several commercial partners) would become Sardinia's main stadium and give a new lease of life to Cagliari Calcio, who are eager to prove themselves once again in a stadium worthy of their status.

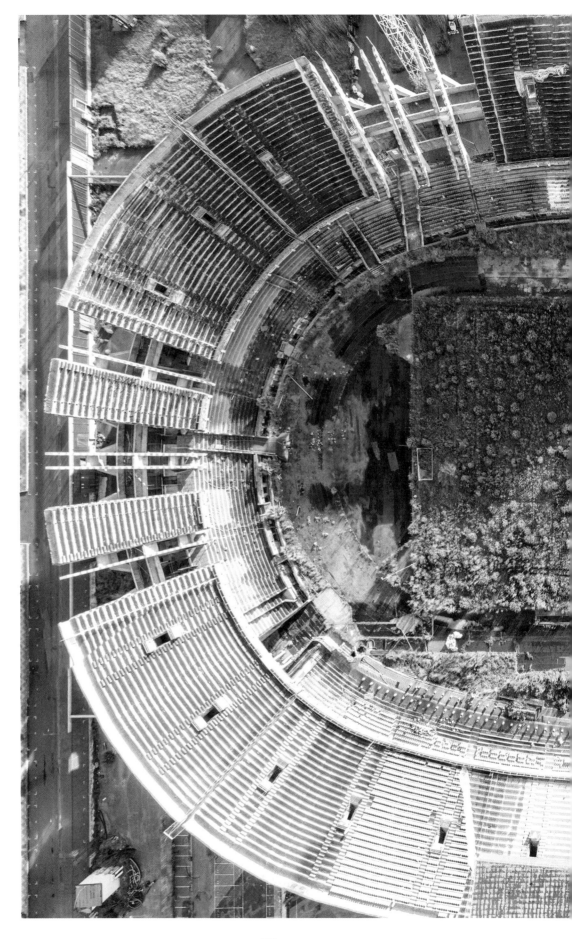

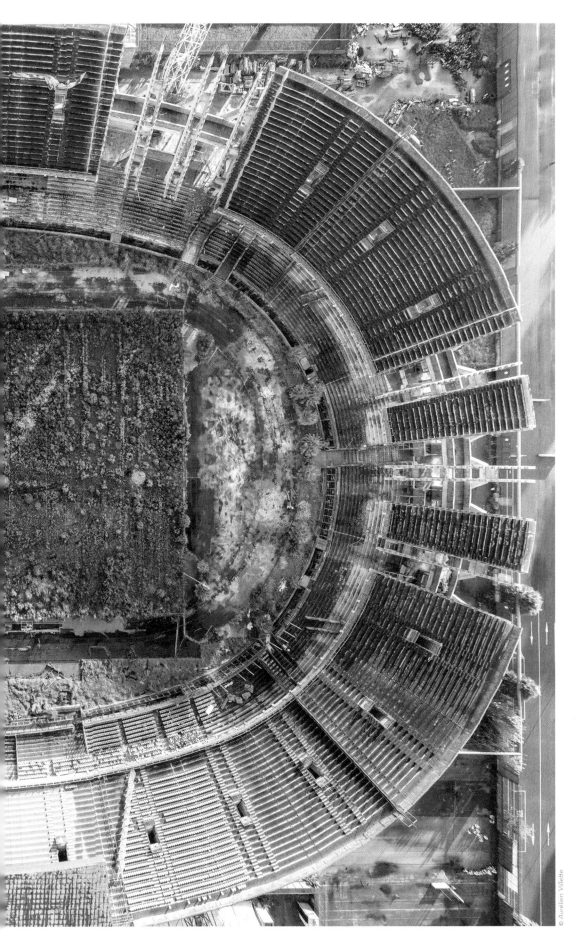

Hugo Mine Hangman's Room 2 · Gelsenkirchen, Germany

The particular geomorphology of its coal-rich subsoil has given the Ruhr Basin a first-rate mining and iron and steel heritage. The advent of the Industrial Revolution led to rapid change in the landscape and widespread development, with the formation of mining companies. In 1873, Hugo Honingmann, a wealthy businessman from Essen, took over the management of the 'Hugo Mining Union' in Gelsenkirchen.

As the mining network developed, the exhaustion of certain pits reduced them to mere communication or ventilation routes in order to supply the subsoil with fresh air. New shafts were opened, others deepened, headframes erected and coking plants created to process the coal directly.

All the surface buildings were also rationally designed, including the miners' changing room. It was named the 'hanging room' because of the way clothes were hung on a sort of cage connected to a locked chain identified by a code. It was raised to the ceiling to save space and protect against theft.

At the beginning of the 20th century, Gelsenkirchen swallowed up all the surrounding villages, becoming Europe's most important mining and industrial town, making it a prime target for the bombing raids of the Second World War.

Once renovated, the complex continued to expand in the 1950s, but all the improvements and investments made to modernise it did not prevent resources from running out. The social movements of the 1980s and the efforts made in the 1990s were unable to halt its decline, and the mine finally ceased operations on 28 April 2000.

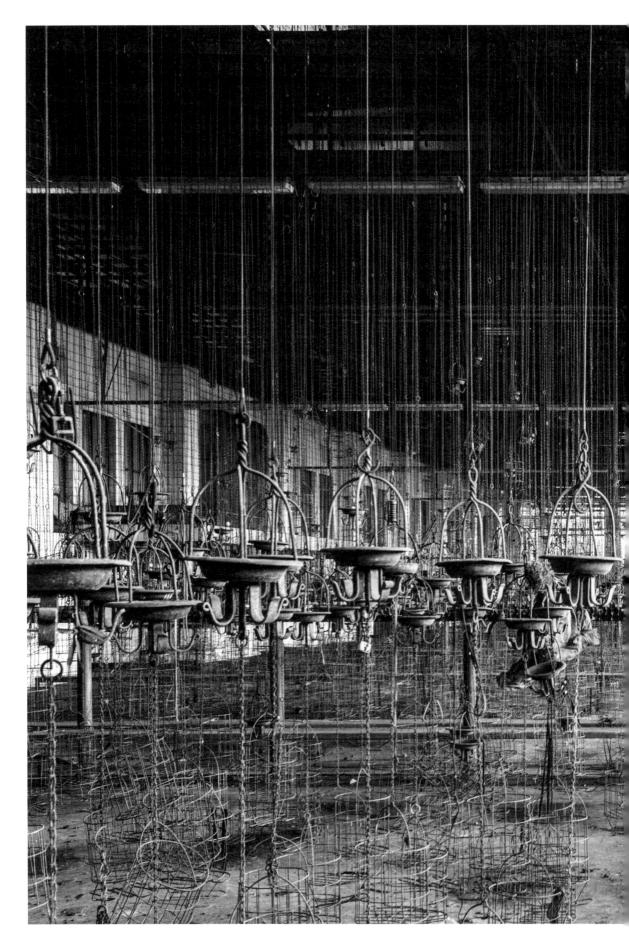

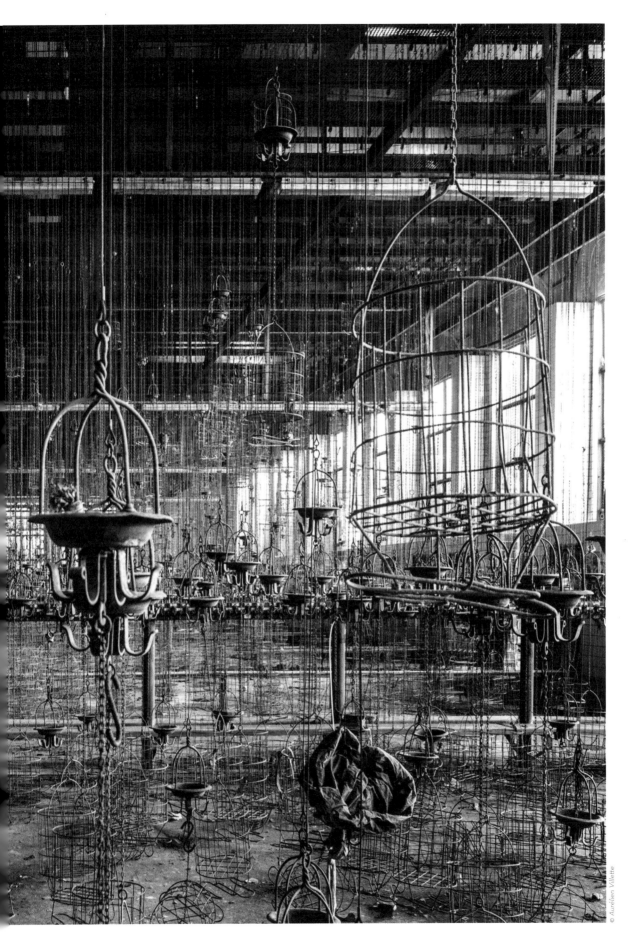

DENMARK

North
Sea

Baltic
Sea

POLAND

NETHERLANDS

Kiel

Rostock

Lübeck

Schwerin

Bremerhaven

Hamburg

Bremen

Elbe

Oder

Berlin

Osnabrück

Hannover

Potsdam

Weser

Magdeburg

⊙ **Vockerode**

Dortmund

Göttingen

Halle

Düsseldorf

Kassel

GERMANY

Leipzig

Görlitz

Köln

Erfurt

Dresden

Aachen

Bonn

BELG.

Koblenz

CZECH
REP.

Frankfurt-
am-Main

Main

LUX.

Mainz

Bamberg

Trier

Würzburg

Nürnberg

Mannheim

Rhein (Rhine)

Sarrebruck

Regensburg

FRANCE

Stuttgart

Donau (Danube)

Passau

Inn

Ulm

Augsburg

Munich

Freiburg-
Briesgau

Ravensburg

AUSTRIA

N

SWITZERLAND

LIECH.

100 km

Kraftwerk Vockerode · Saxony-Anhalt, Germany

At such a political turning point as that of 1989, it was only a matter of time before this complex closed down, incapable as it was of competing against modern power stations. A large number of buildings were subsequently demolished, but those that were still standing in 1996 have been registered on the list of Historical Monuments in Saxony-Anhalt.

Vockerode's unique architecture continues to intrigue, and was the source of many artistic interventions exploring the relationship between the history of the cultural landscape and industrial growth, such as the 1998 'Mittendrin – Sachsen-Anhalt in der Geschichte' exhibition, for example. In 2001, the dynamiting of four chimneys in the vicinity finally put an end to the place's visual identity, referred to by the locals as 'the Titanic of the Elbe'.

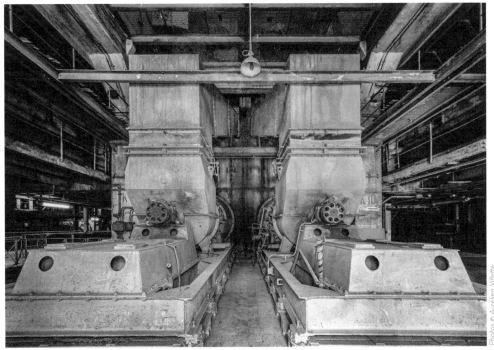

Photos © Aurélien Villette

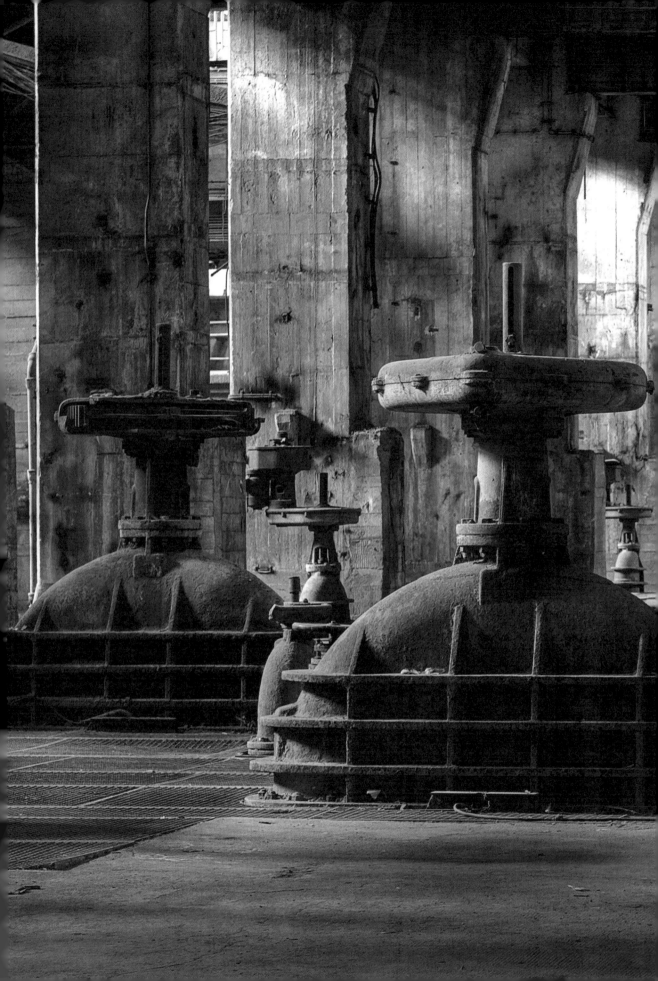

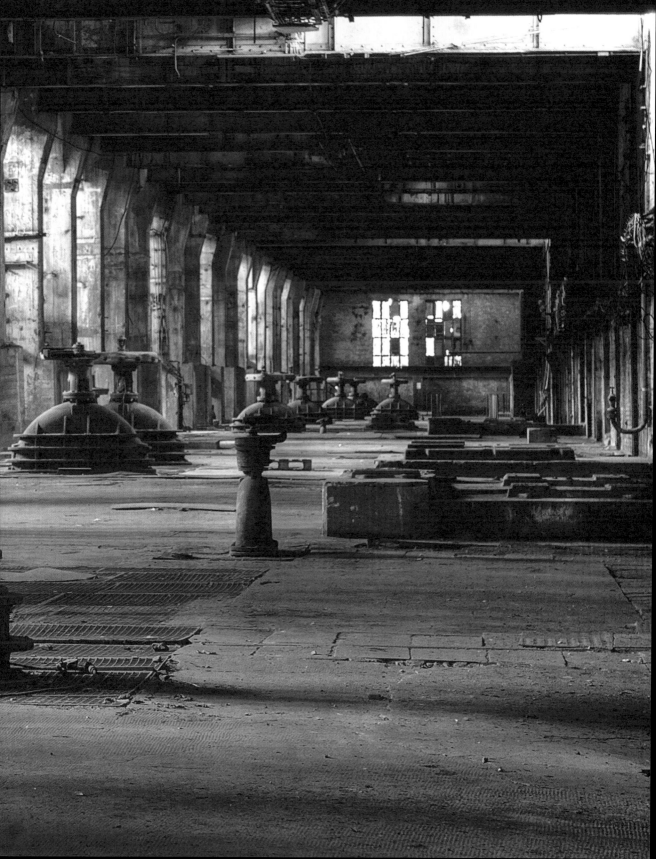

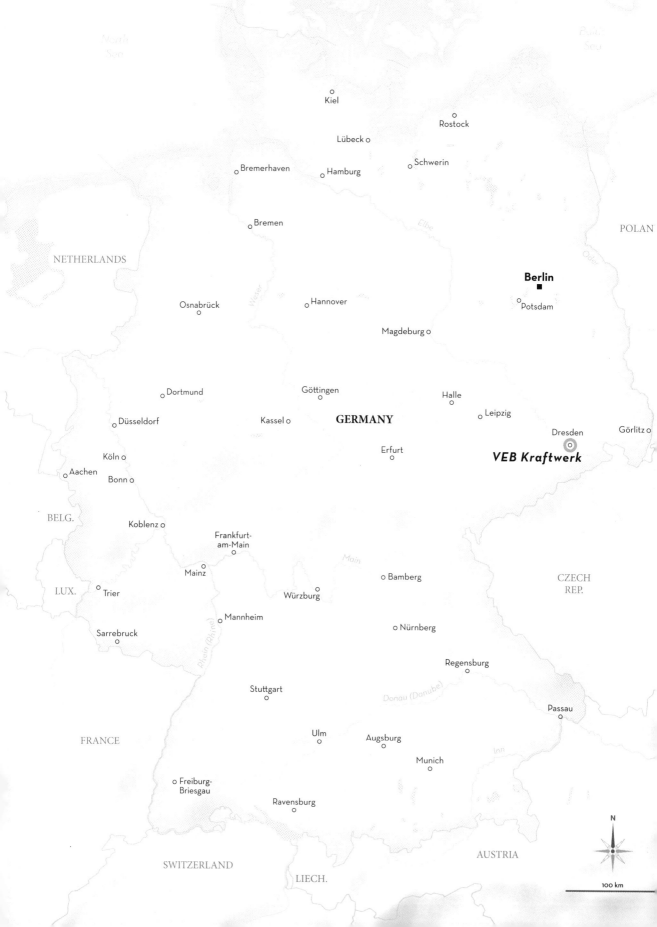

VEB Kraftwerk · Germany

This was the largest power station in East Germany. It was built by VEB BMK in 1966 and the first unit started working in 1971. The two 'factories' are located in the same hall with 12 210-Mw turbines stretching over a distance of 600 metres. During reunification, non-compliance with environmental norms meant that the filters could not be adapted. Werk 1, with its 6 units, ceased production in 1996, followed in 1998 by Werk 2 and the remaining 6 units. The power station, despite being an industrial wasteland, remained a lively place: For several years, it hosted cultural events, both in the open air and in the turbine hall. Today, the turbines have vanished from the main hall, as they have all been dismantled, but the structure of the power station has survived.

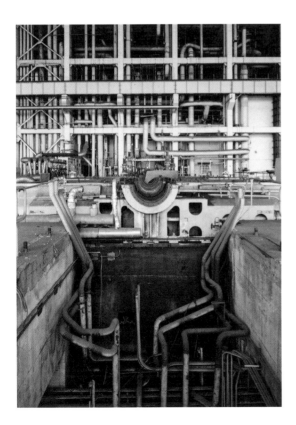
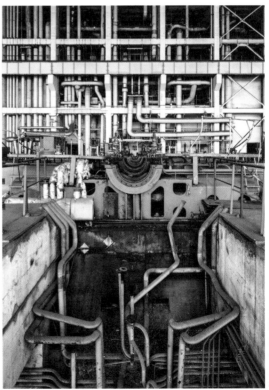

Photos © Aurélien Villette

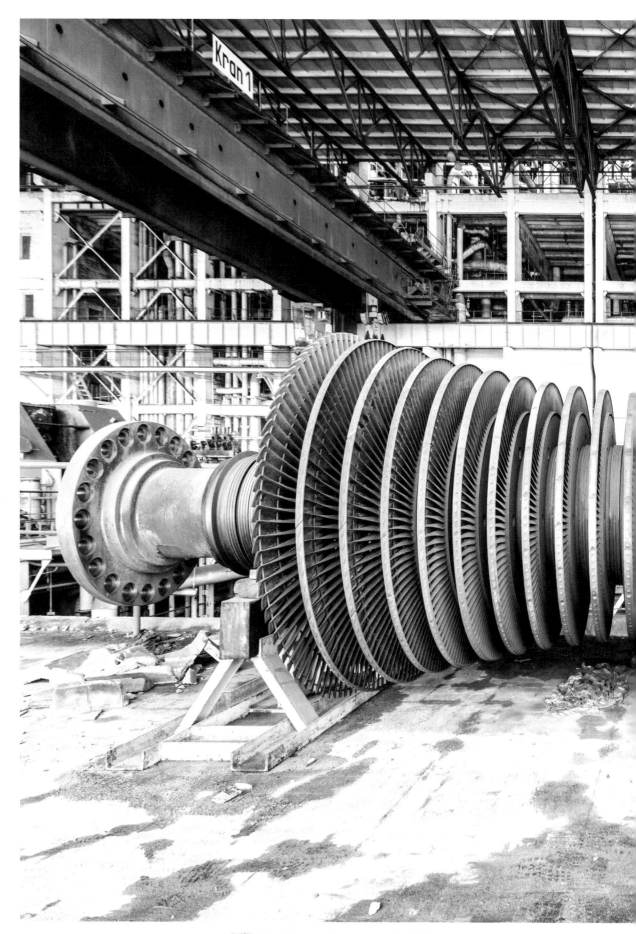

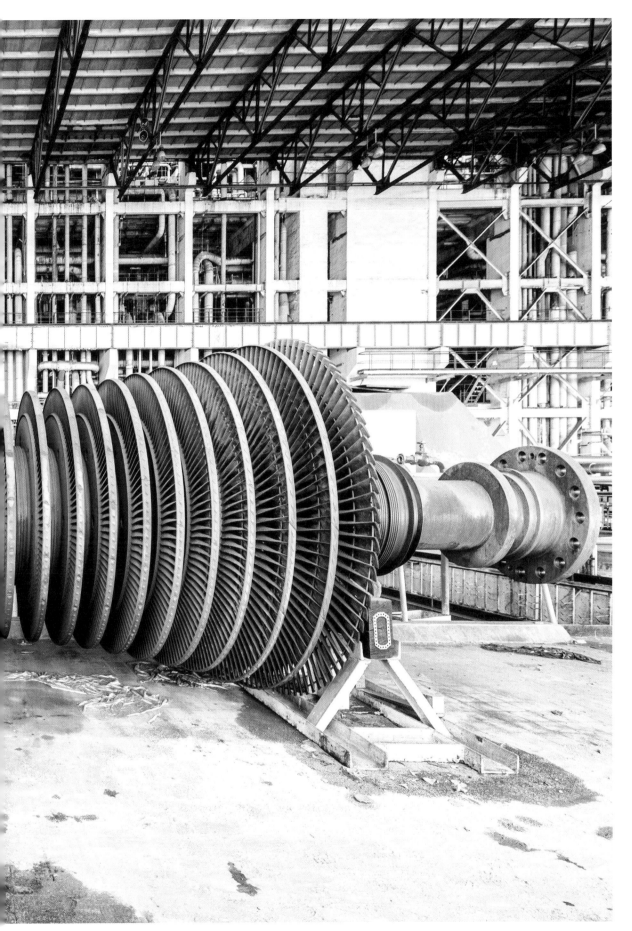

CZECH
REPUBLIC ○ *Luková*

N

500 km

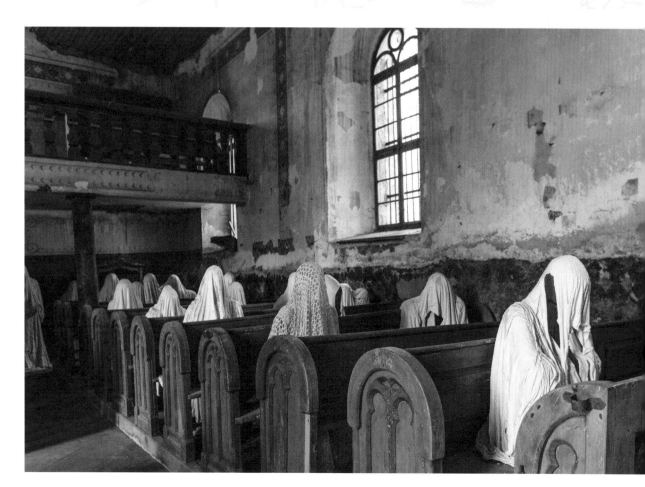

Church of Saint George · Lukovà, Czech Republic

The Catholic church of Saint George clings to the hill overlooking Lukovà, a village in the north-west of the Czech Republic.

Although the original construction dates back to 1352, its architecture has been modified many times over the course of history. In the early 15th century, the Hussite Wars pitting Catholics against the followers of Jan Hus, a Czech religious reformer, led to its partial demolition. The Gothic presbytery was preserved when it was restored a century later. In 1796, a violent fire again seriously damaged the small church. The church was rebuilt in a neo-Gothic style, using stone, brick, lime and slate for the roof.

Saint George retains this exterior appearance today. The two doors of the main entrance open onto a Romanesque interior housing three altars richly decorated with paintings and sacred sculptures. During restoration work in the 19th century, the sandstone baptismal font was moved to a nearby church.

During the First World War, the church bells were melted down to make weapons. The rest of the furnishings, church accessories and liturgical ornaments were looted. In 2012, stripped bare and deserted, Saint George's church threatened to collapse. A student from Bohemia's Faculty of Design and Art decided to use it for his thesis. Hadrava placed 32 life-size plaster silhouettes representing the shadows of a bygone world where faith shaped a large part of people's personalities.

The installation was a great success, and the money raised from donations was used to try and restore the church, which is still accessible.

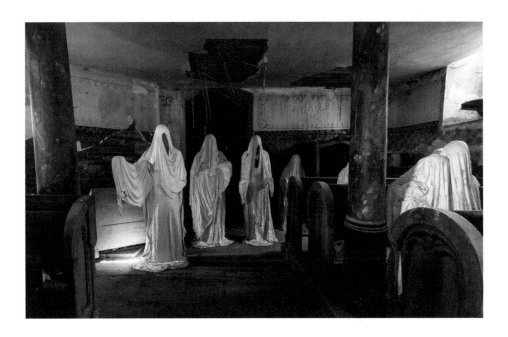

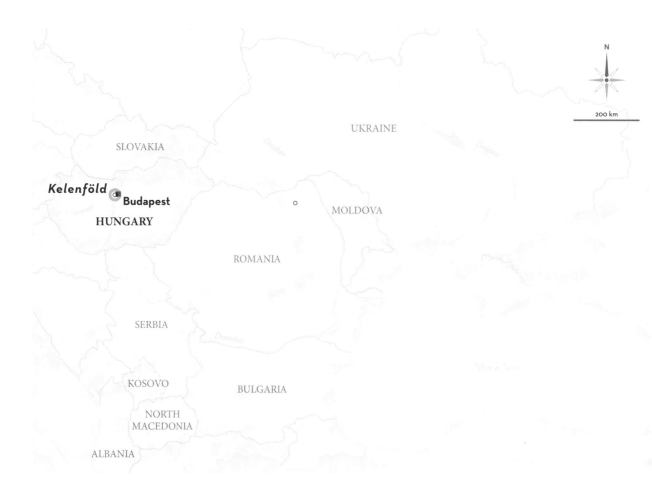

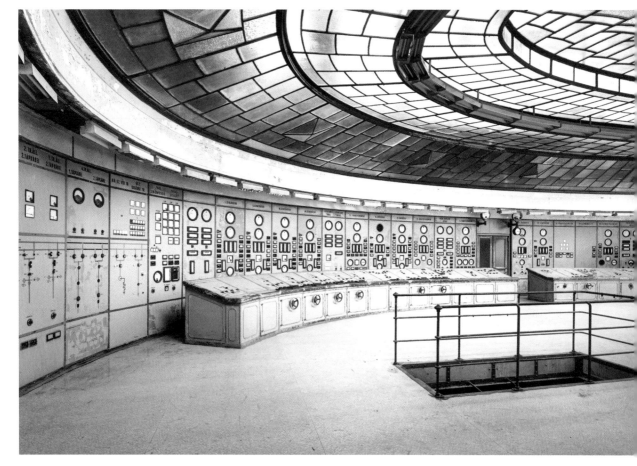

Kelenfold Power Plant • Hungary

This semi-abandoned power station located in Hungary, named Kelenfold, is a true gem among industrial locations. It was once Europe's most advanced power station. The control room itself has been abandoned for quite some time, but most parts of the site are still used to provide power to Budapest.

The control room is located in a power station that is over 100 years old. As mentioned above, the power station is only semi-abandoned, as most parts of it are privately owned and still in use. On a regular day, it supplies Budapest with 60% of its heating and hot water and provides 4% of Hungary's total energy supply. The main gas supply to this power station comes from Russia through Ukraine. In case it is shut off for whatever reason, the station has a liquid fuel-oil reserve on site that can last for eight days.

In its early days, the station was actually the first boiler house, the first regional electricity supplier, and Europe's first electricity exchange.

The most precious feature of the station is the amazing Art Deco control room with a huge glass ceiling, which was closed around 2005. It was designed by two architects, Kálmán Reichl and Virgil Borbíro, around 1927. Construction took two years. The control room is protected against demolition by Hungarian law. Unfortunately, this also means the control room is not touched at all, and thus no restoration is taking place. The box-like building, which looks like a small house, was built as a shelter for the workers in case the station was bombed during the Second World War. Fortunately, that did not happen.

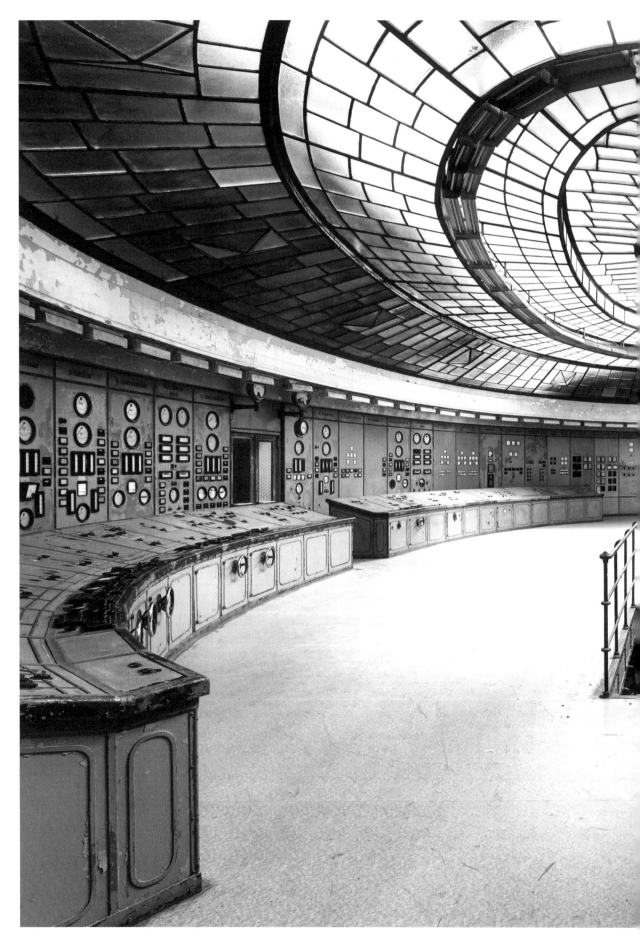

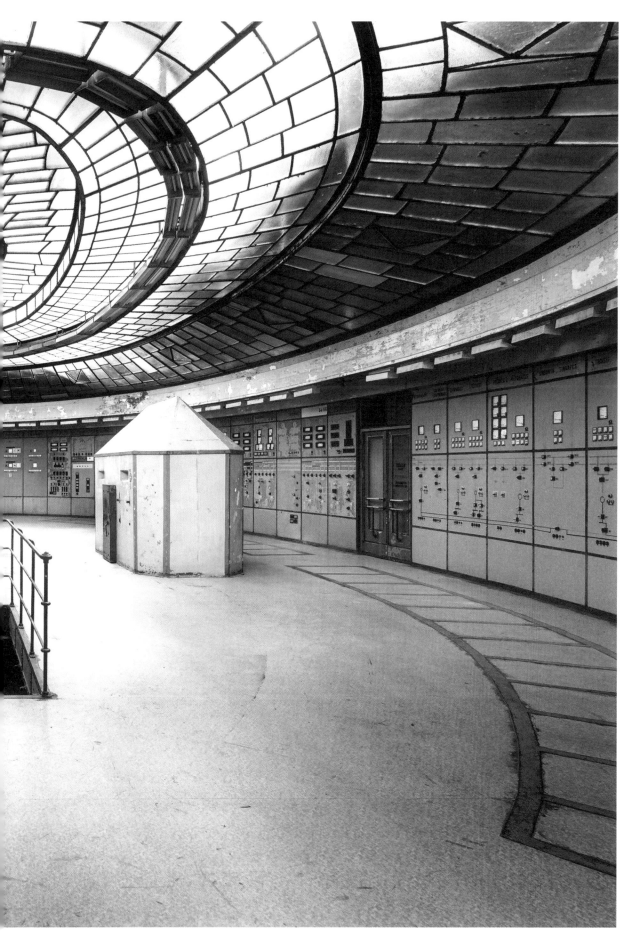

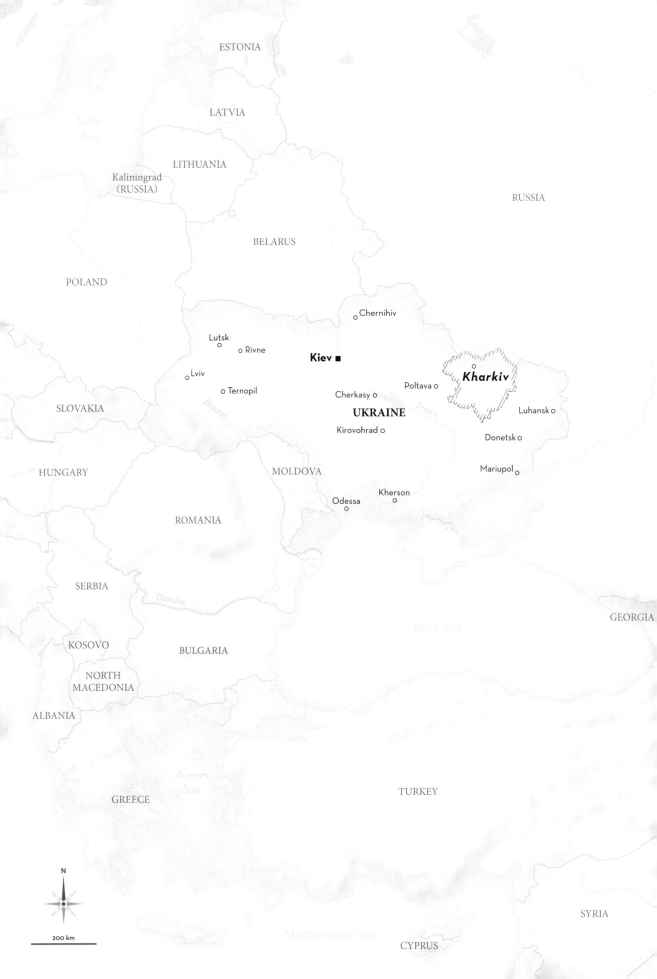

Sharovsky Castle · Kharkiv region, Ukraine

In this abandoned castle in the Kharkiv region – once one of several castles belonging to the wealthy Sharovsky family – dust now reigns supreme. Built in the mid-19th century, the castle is a blend of neo-classical and Russian Baroque, evoking the magnificence of the past. At the rear of the building are the remains of a botanical garden, a haven of greenery that led to the castle (as well as its vast halls) being converted into a tuberculosis clinic for many years.

The residents have now disappeared and no one has trodden the endless floors of the castle for many years.

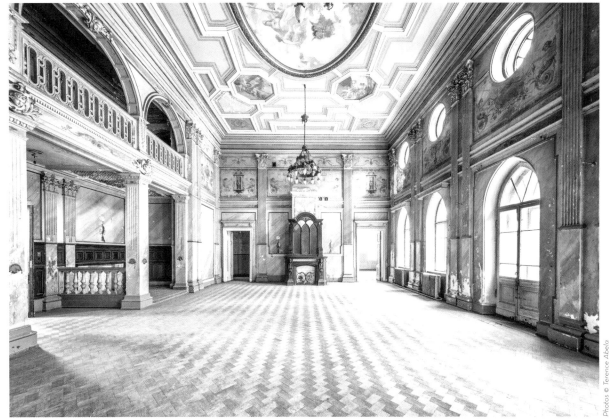

Photos © Terence Abela

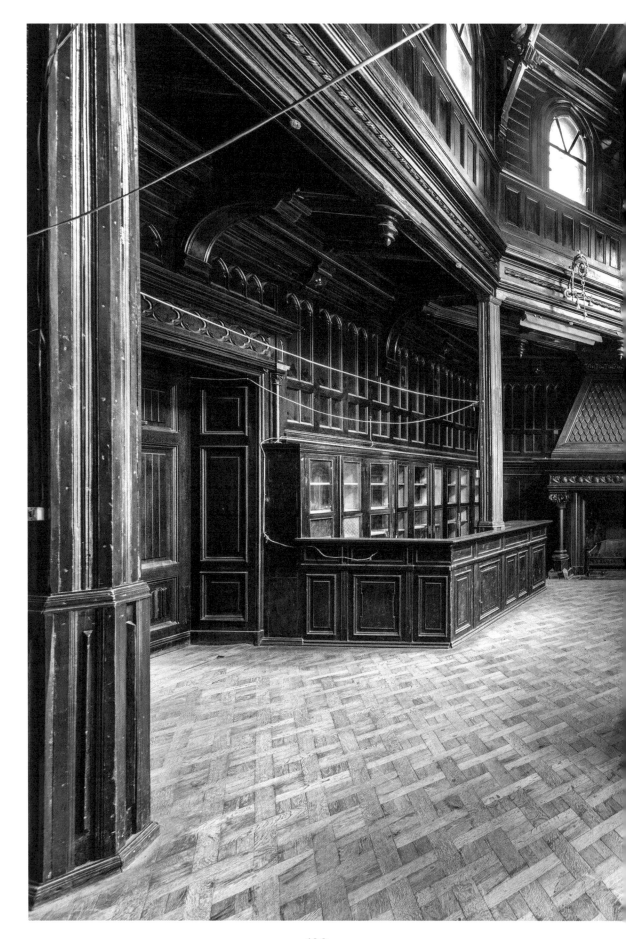

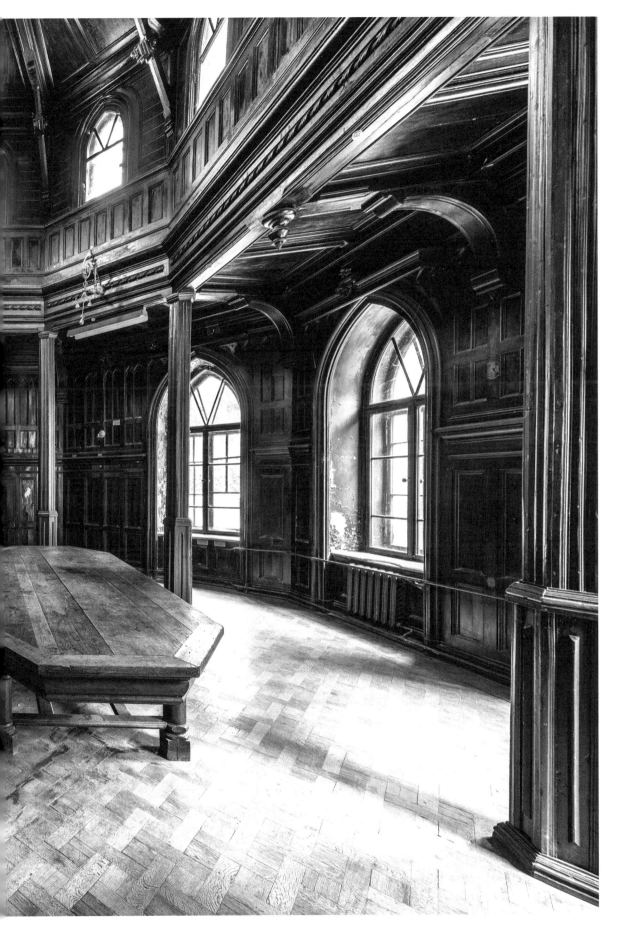

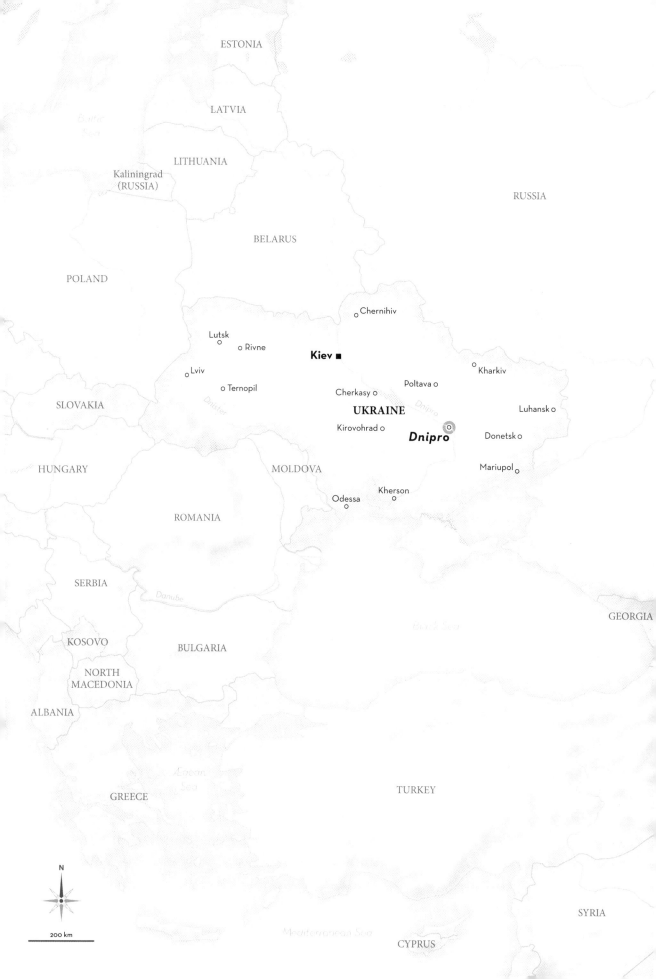

Lenin Palace of Culture · Dnipro, Ukraine

At the heart of the gigantic Lenin Palace of Culture in the city of Dnipro, the silence was briefly disturbed by the welcome sounds of renovation: The monument, one of the country's most impressive Soviet relics, was due to be refurbished. Unfortunately, the war with Russia put an end to the project and the site will probably end up suffering the same fate as the statue of Lenin that once stood in the city and was dismantled in 2014.

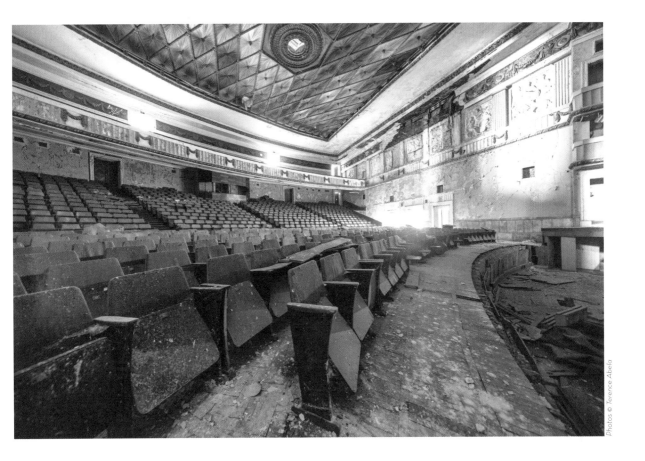

Photos © Terence Abela

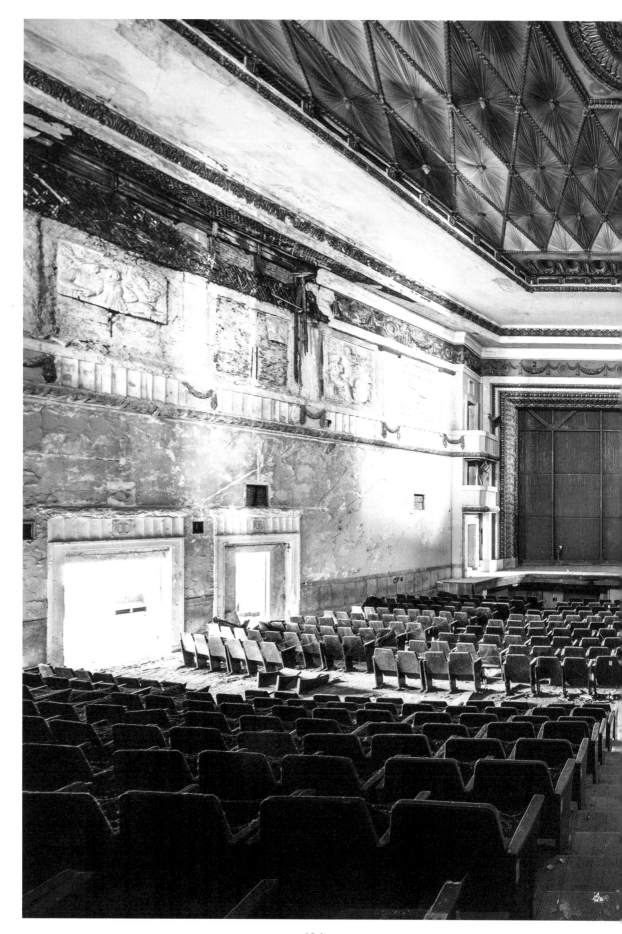

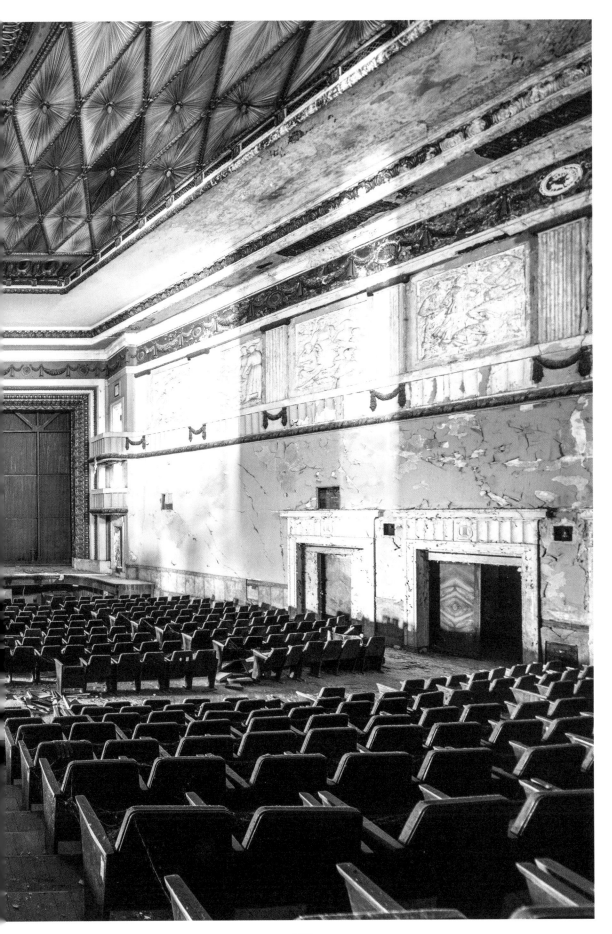

Abandoned Town of Pripyat · Chernobyl, Ukraine

Pripyat became infamous on 26 April 1986, when reactor number 4 at the Chernobyl nuclear power station, just 3 km away, exploded. Tens of thousands died as a result of the radiation and the effects on flora, fauna and people will continue to be felt for millennia to come. Today, this irradiated zone can only be visited in the company of guides.

From the leisure area with its café and abandoned bumper cars to the ruined Palace of Culture, from the rows of ghostly beds in the maternity ward to the piles of gas masks in the local school, everything is a reminder of the tragic fate that befell this once prosperous little town.

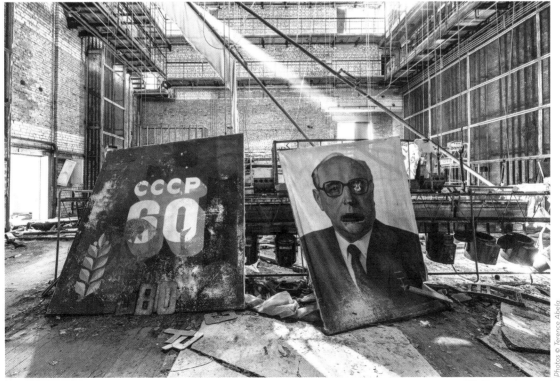

Photos © Terence Abela

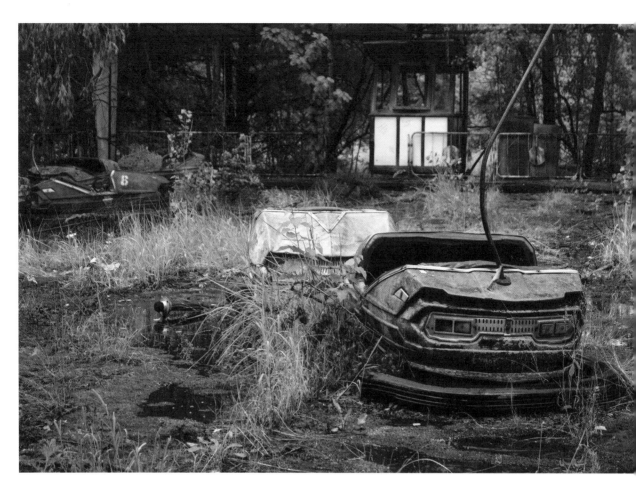

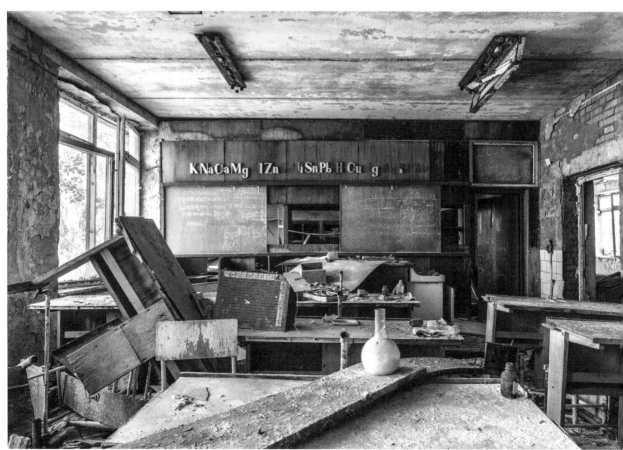

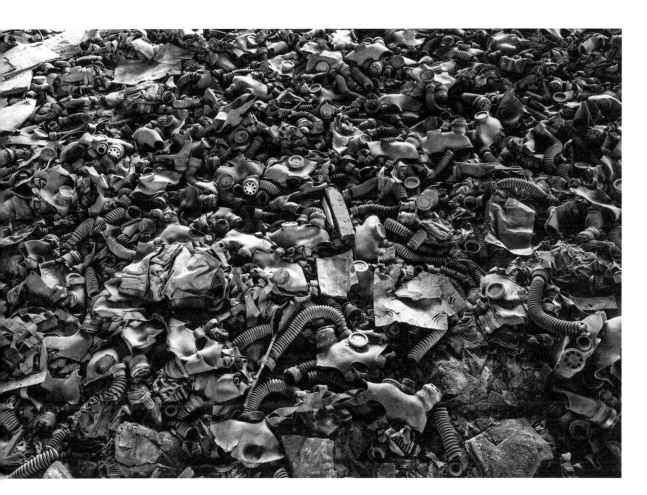

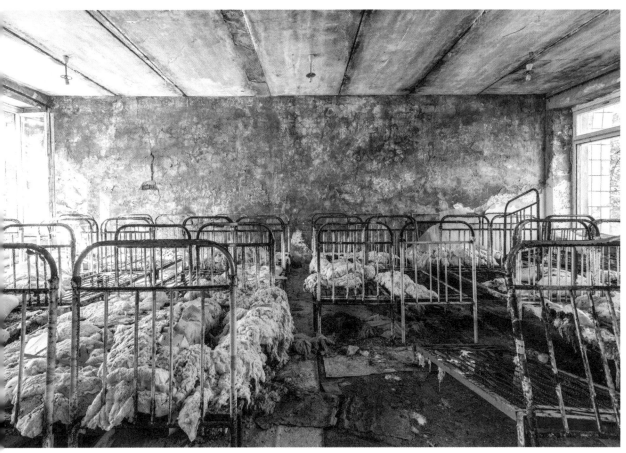

ESTONIA

LATVIA

LITHUANIA

Kaliningrad
(RUSSIA)

RUSSIA

BELARUS

POLAND

SLOVAKIA

UKRAINE

HUNGARY

Suceava o

MOLDOVA

o Cluj-Napoca

Timisoara o

ROMANIA

Hunedoara

Brasov o

Galati o

o Tulcea

SERBIA

Craiova
o

Bucharest ■

o Constanța

GEORGIA

KOSOVO

BULGARIA

NORTH
MACEDONIA

ALBANIA

TURKEY

GREECE

SYRIA

N

CYPRUS

200 km

Hunedoara Station · Romania

The Romanian Communist Party rose to power in 1945. Nicolae Ceaușescu's totalitarian government finally collapsed in December 1989 following a coup. The communist regime in the country drew its inspiration largely from the practices of its Soviet neighbour. It continued to support the USSR throughout the time it was a member state of the Warsaw Pact.

Hunedoara station, like hundreds of others across the country, still bears the scars of communist propaganda. In this large industrial town, where many sites have shut down since the fall of the totalitarian regime, a gigantic fresco in a closed-off area of the station depicts themes like 'the glorification of labour' and 'the worker at the service of the nation'.

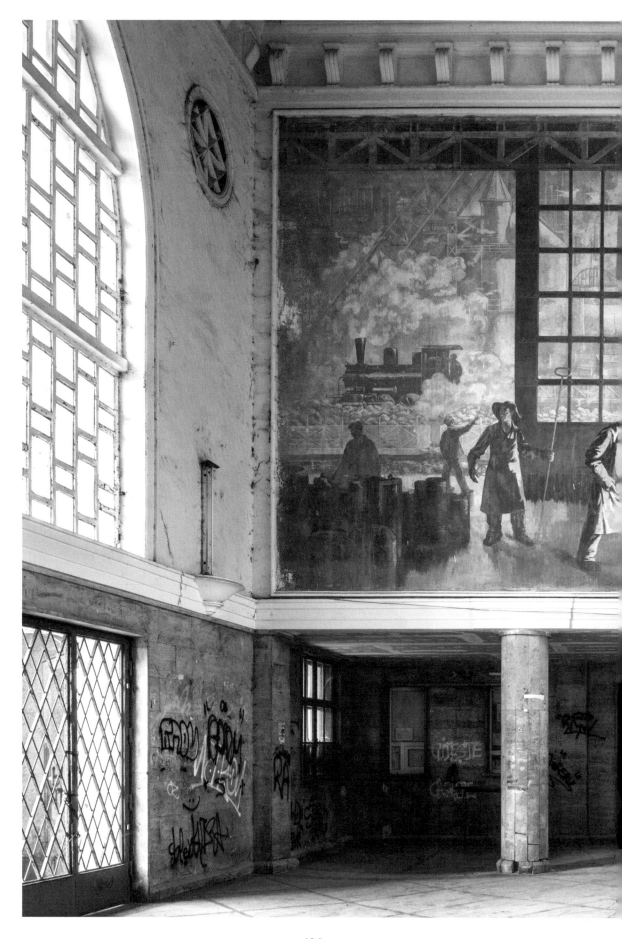

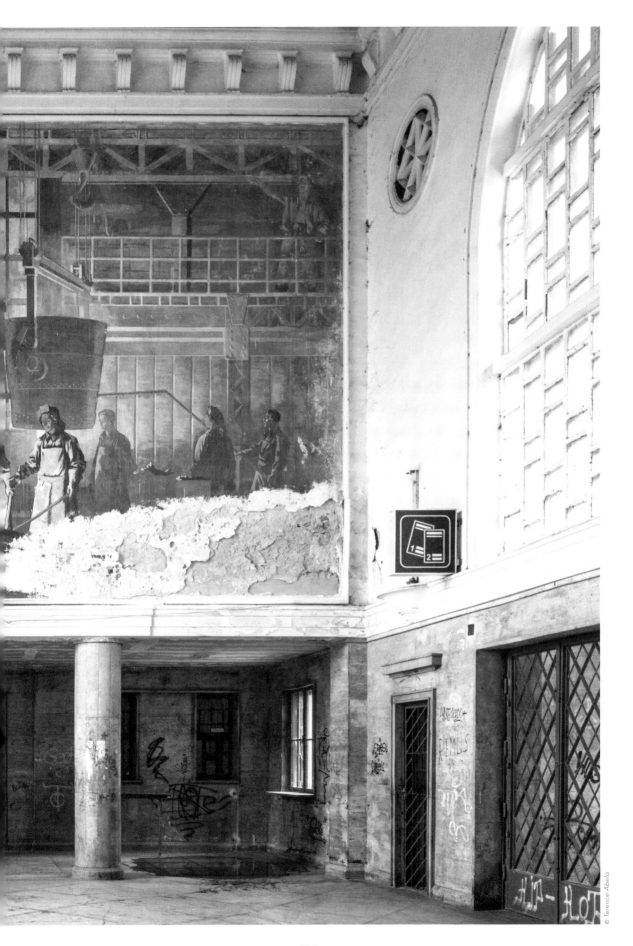

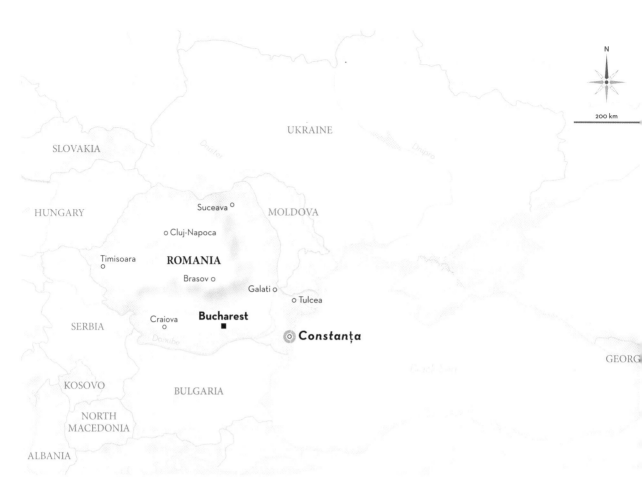

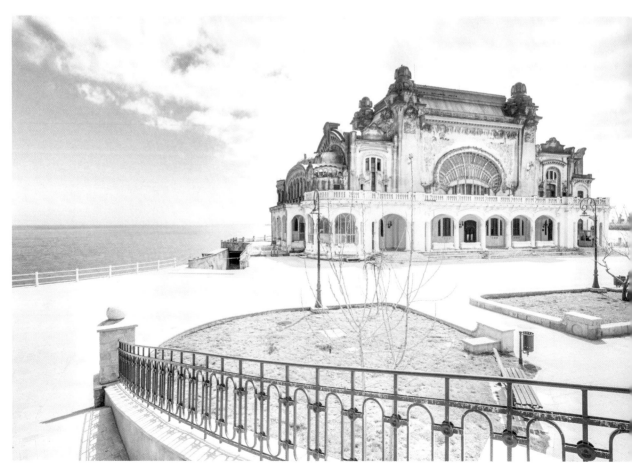

Casino Constanţa · Romania

Once this was the most glorious building in Romania, but since 1990 it has been abandoned and is slowly falling apart. The building is listed as an historic monument by the Ministry of Culture and Religious Affairs of Romania. The casino was built in Constanţa (formerly known as Tomis), Romania. The name of the city comes from the half-sister of the Roman emperor Constantine the Great. Constanţa is the oldest continuously inhabited city in Romania. It was founded in approximately 600 BCE, is located on the Black Sea and is the largest city in the region. The city itself has nearly 300,000 citizens and attracts a lot of tourists in summer because of its large beaches and warm climate. The casino used to be the main attraction near the port of the city, which is the largest port on the Black Sea, and also one of the largest ports in Europe. The pedestrian area around the casino is a popular destination for couples and families because of its romantic and friendly atmosphere.

Daniel Renard and Petre Antonescu designed the Art Nouveau building with stunning 18th-century Baroque accents, commissioned by the Romanian King Carol I. It was first opened to the public in 1910, and public money funded its construction. The original plan was to pay homage to Romania's artistic traditions, but while construction was in progress, it turned into an Art Nouveau palace for the Belle Epoque. Many wealthy travellers enjoyed their time playing games and dancing in this symbol of the city. The restaurant right across from the casino, which has now been renovated and given another purpose, was the place to enjoy dinner.

The iconic building survived two World Wars. During the 1914 visit of the Russian Imperial Family, the casino played host to a royal gala. Despite diplomatic negotiations, Grand Duchess Olga rejected the proposed marriage to Prince Carol of Romania and the Russians sailed away. Olga and the rest of her family were later killed by the Bolsheviks. During the Second World War, the building was used as a hospital. Under the post-war communist regime, it even operated as a restaurant for a time. Maintaining the structure quickly became too expensive, and in 1990 the building was closed and has remained so since then.

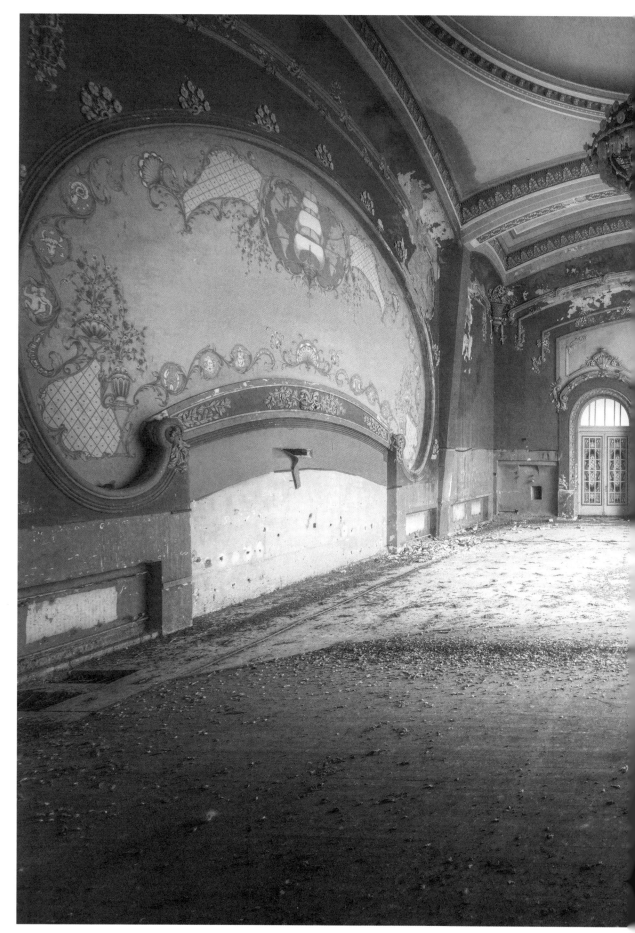

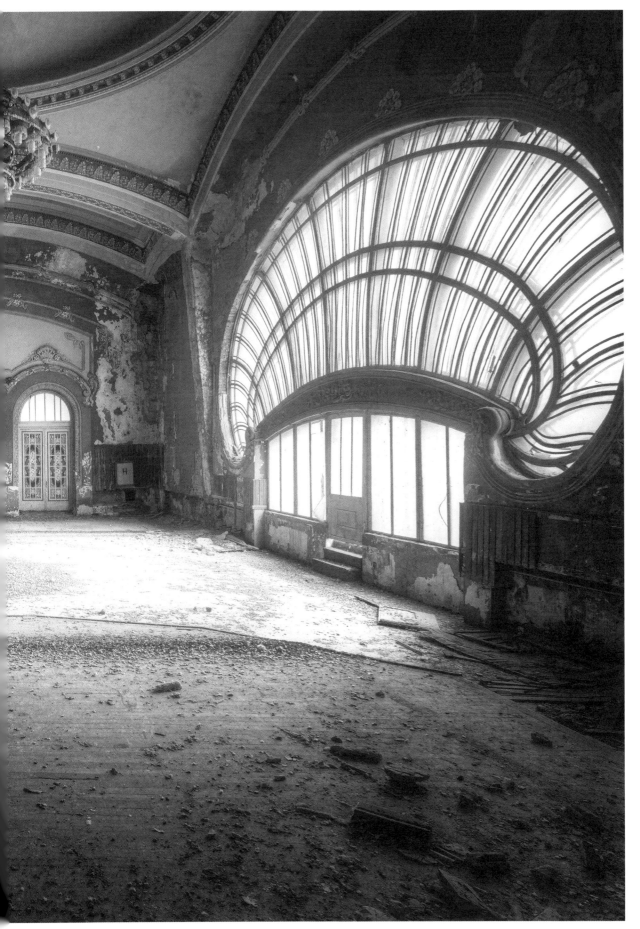

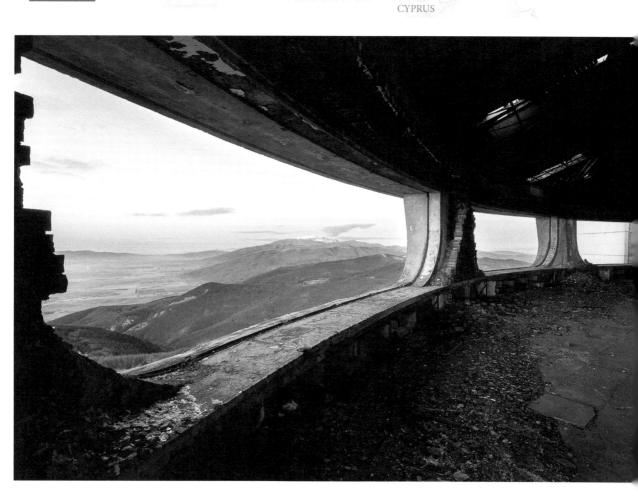

Buzludzha · Bulgaria

This building is located on the peak of Mount Buzludzha at an altitude of 1,432 metres. The building was opened in 1981 to celebrate both Bulgarian liberation from Ottoman rule (1891) and the 1944 victory over Hitler's domination of Bulgaria. Russia played a key role in both events. The monument also served as the symbolic headquarters of the Bulgarian Communist Party.

Over 60 different Bulgarian artists collaborated to design the murals you can see in the picture, and thousands of volunteers were involved in the construction process. Some of the murals show the faces of Engels, Marx, and Lenin, while others depict labourers and the construction of the monument itself. The construction project cost about 14 million Bulgarian Lev, which is approximately $8 million. Citizens donated money to construct the monument, as they were told it was a monument for the people, by the people.

The huge tower you see in the picture is over 100 metres high. It has a huge red star on it, three times as large as the stars on the Kremlin. Some claimed that the red light which used to be emitted from the star could be seen from as far away as Greece and Romania.

Bulgarian Communism ended around 1989, at which time the Buzludzha monument was inherited by the state. About six years later in the mid-90s, the process of decay began and the building surrendered to the elements of nature. Rumour has it that the building was protected by security guards until the mid-90s. The roof of the building used to consist entirely of copper and would have made extremely heavy. Just one night after security guards left, looters would have made off with the entire copper roof.

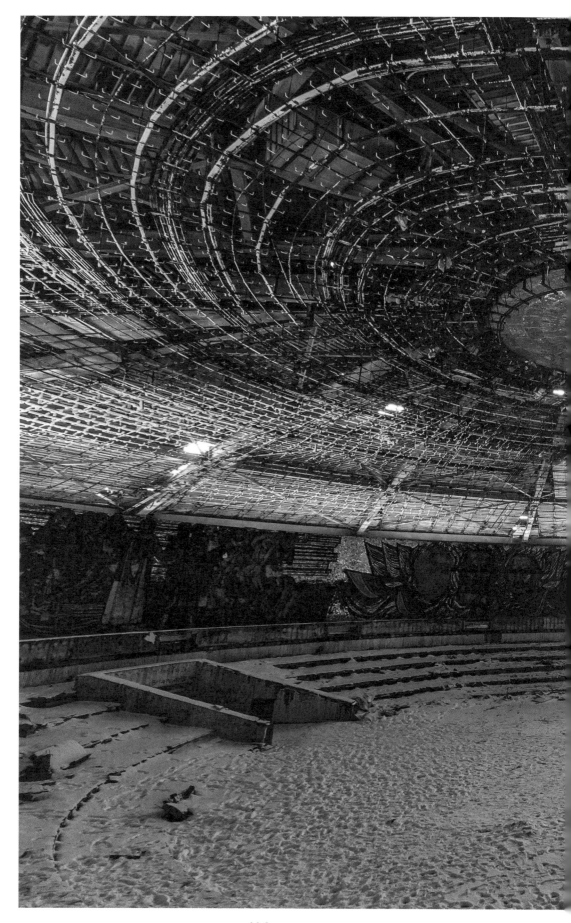

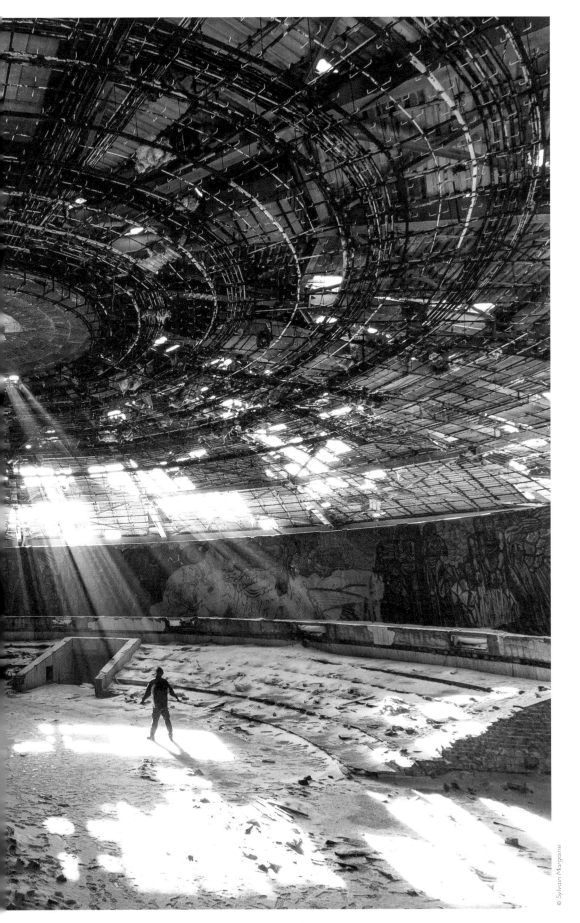

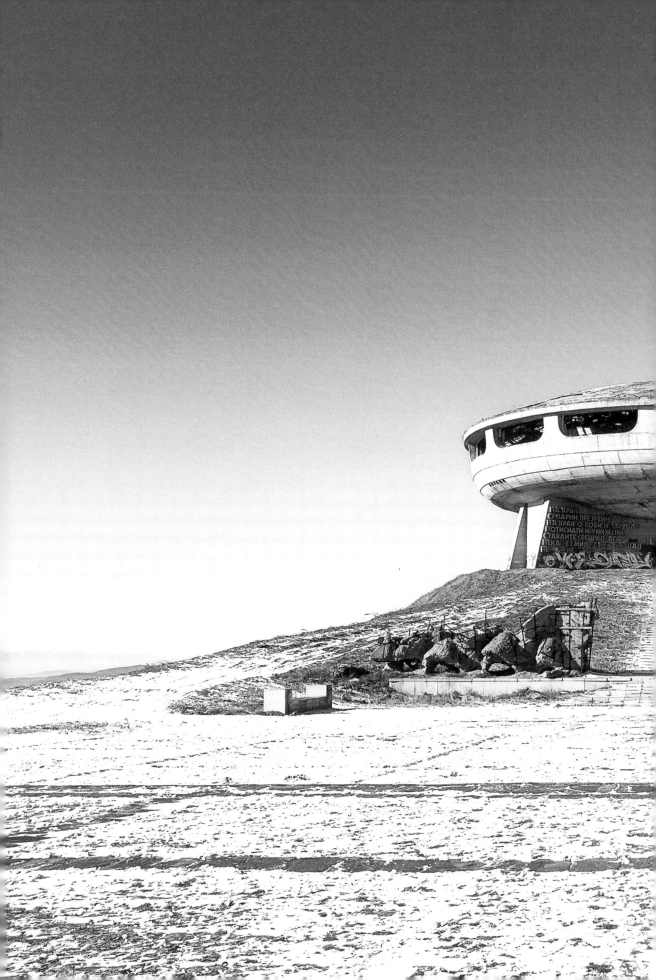

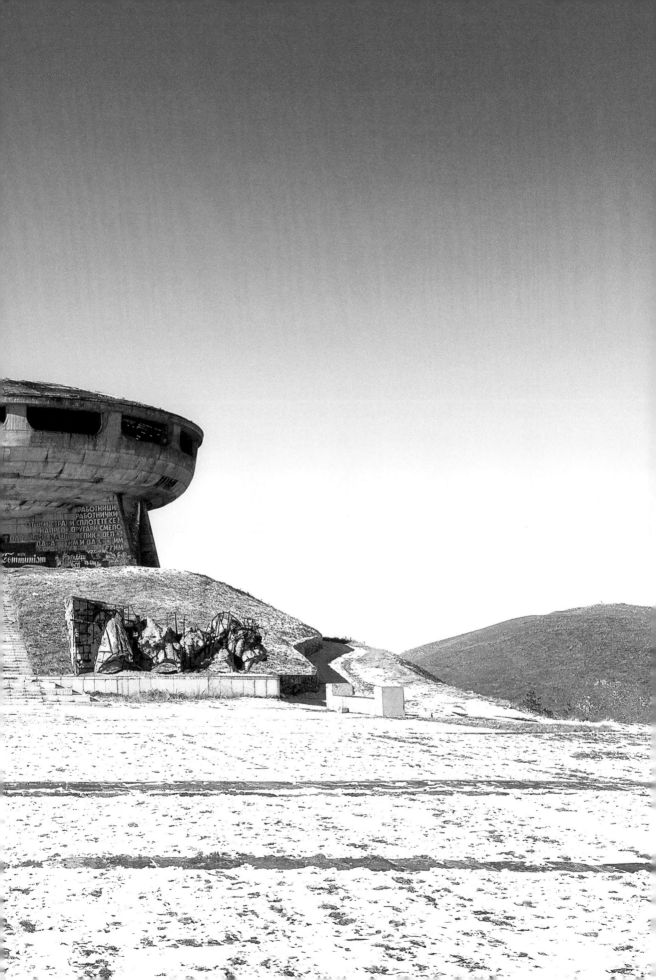

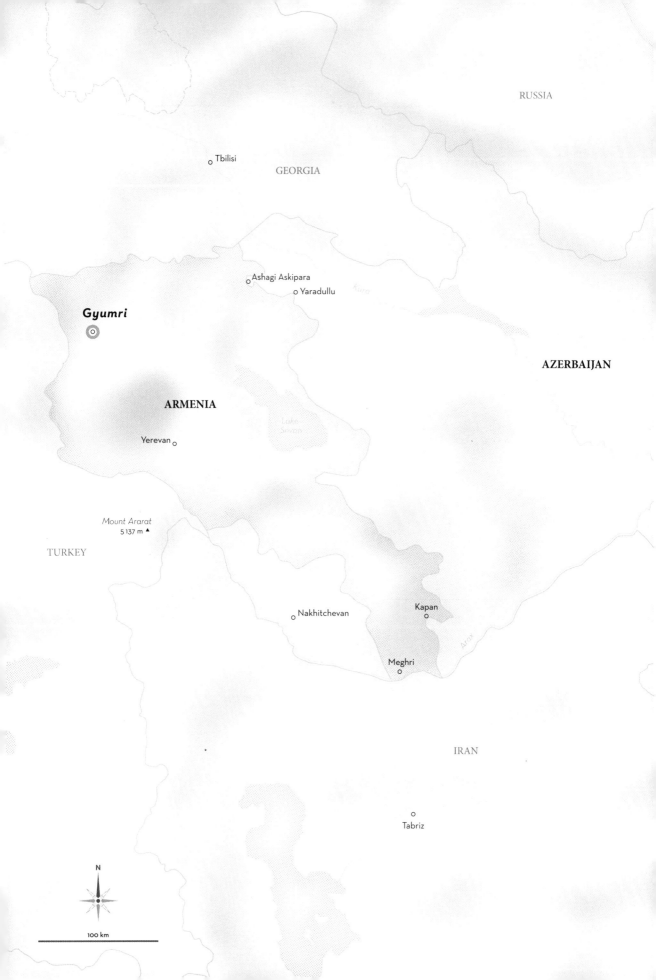

RUSSIA

Tbilisi

GEORGIA

Ashagi Askipara

Yaradullu

Kura

Gyumri

AZERBAIJAN

ARMENIA

Lake
Sevan

Yerevan

Mount Ararat
5 137 m ▲

TURKEY

Kapan

Nakhitchevan

Arax

Meghri

IRAN

Tabriz

N

100 km

Polytechnic University of Gyumri · Armenia

In 1918 following the Russian revolution, Armenia, like its neighbours, ceased to be part of the former Empire and in 1920 became the Armenian Soviet Socialist Republic. Later, in 1922, it became part of the Republic of Transcaucasia, one of the founding members of the USSR. After Transcaucasia broke up in 1936, questions remained regarding the annexation of certain territories, in particular Nagorno-Karabakh which was annexed to Azerbaijan. However, things remained unchanged for the duration of Soviet domination, until the demonstrations of 1988. When independence was proclaimed in 1991, Armenia remained on good terms with Russia, and this is borne out by the many statues and frescos which remain dotted around the country. Nevertheless, conflict with its neighbour flared up even more fiercely, and despite a ceasefire being established in 1994, the issue remains unresolved. The country that has never forgotten the United Armenia of the old days must be content to dream as it looks at the abandoned railway lines which cross the borders erected by history.

Some of the remains still bear witness to the Soviet era. The former Polytechnic University of Gyumri, for example, is a sad symbol of the country's opening up to the international community during the Soviet period. This fountain, standing in a desolate landscape, is one of the few survivors of the devastating earthquake of 1988, which caused almost 50,000 deaths. The USSR had no choice but to turn to the international community for help in rebuilding the country.

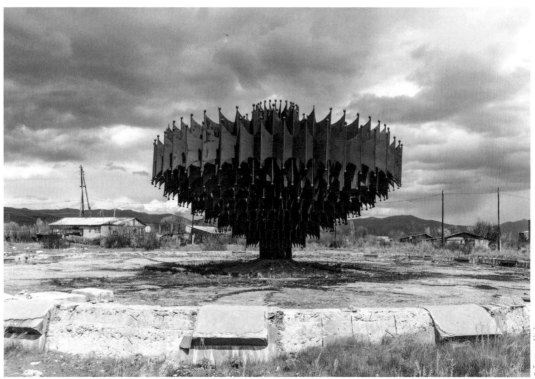

© Terence Abela

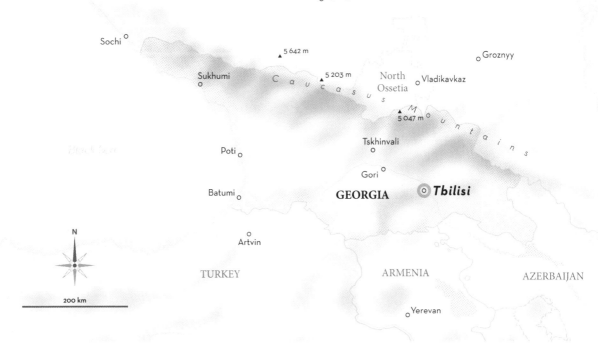

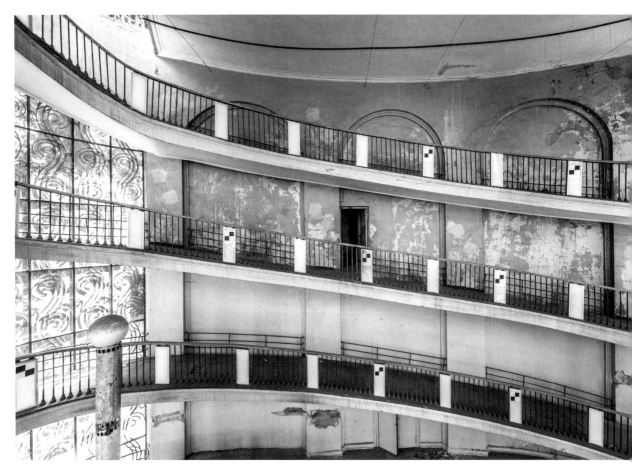

Tbilisi Funicular Station·
Tbilisi, Georgia

Georgia came under Soviet influence in 1921, and later joined with neighbouring countries to form the Soviet Republic of Transcaucasia.

As the birthplace of Joseph Stalin, this land enjoyed a privileged status following his rise to power. Members of the Russian intelligentsia in search of entertainment and relaxation were welcome guests there, and Georgia became synonymous with the pursuit of pleasures such as dancing and fine cuisine. Some of its once majestic establishments still retain a vague aura of their former grandeur, despite having fallen into a state of disrepair, such as the sanatoria of Tskatulbo, which are nowadays largely occupied by refugees fleeing the fighting in Abkhazia. Khrushchev paid particular attention to Georgia after the death of 'The Father of Nations', enthusiastically dismantling Stalin's personality cult. The country was emancipated in April 1991, but conflicts quickly arose between the central authorities and certain regions seeking independence, namely Abkhazia and South Ossetia.

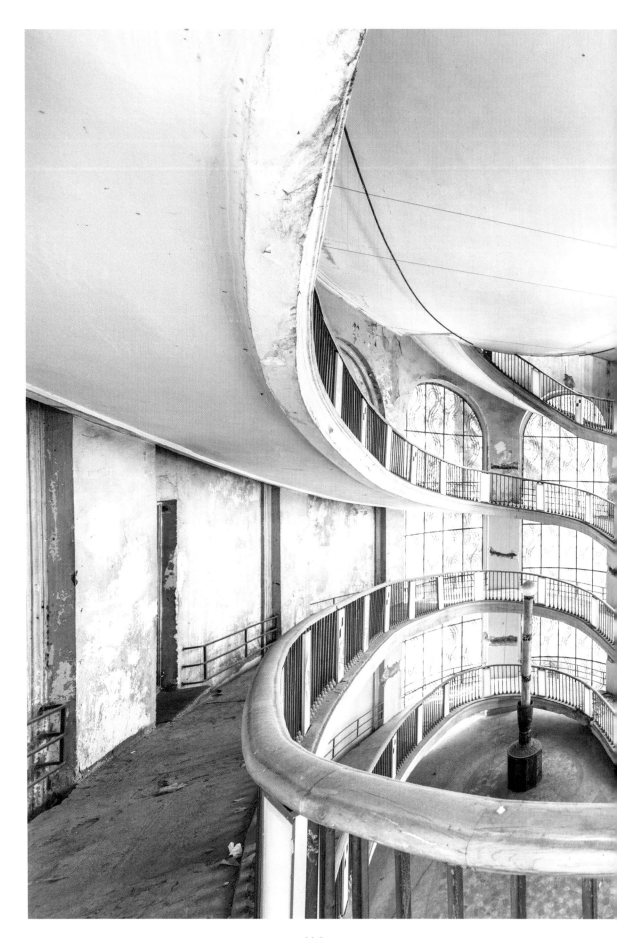

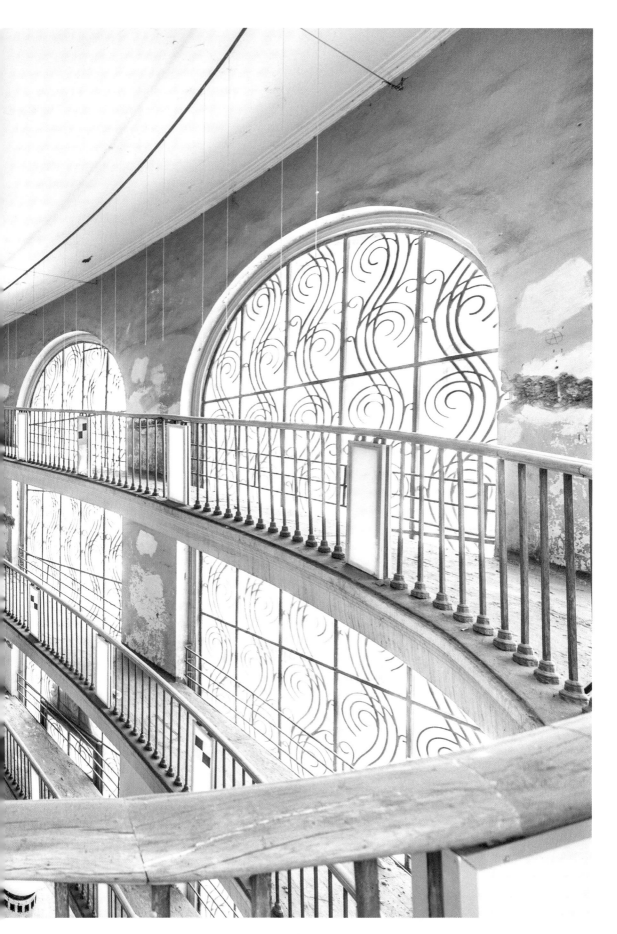

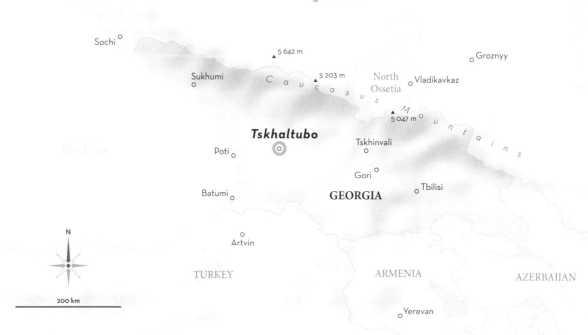

Novorossiysk

RUSSIA

Pyatigorsk

Sochi

Groznyy

▲ 5 642 m

Sukhumi

Caucasus
▲ 5 203 m
North
Ossetia
Vladikavkaz

Mountains
▲ 5 047 m

Tskhaltubo

Tskhinvali

Poti

Gori

Batumi

Tbilisi

GEORGIA

N

Artvin

TURKEY

ARMENIA

AZERBAIJAN

200 km

Yerevan

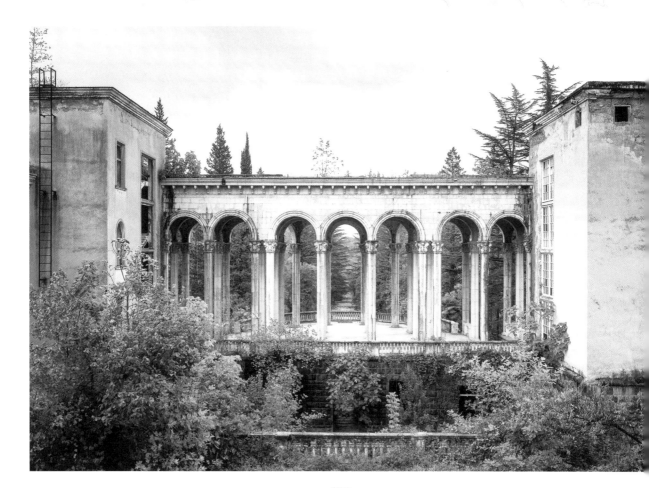

Tskaltubo · Georgia

Tskaltubo is a city in western Georgia with around 17,000 residents. The city is famous for its thermal springs, also called the 'Waters of Immortality'. The water in Tskaltubo is known for its therapeutic effects due to the presence of radon chloride and magnesium.

People from all over the world visit the city to get help with a variety of disorders or imbalances: cardiac and vascular, nervous system, endocrine system, and skin conditions. The area is unique due to the fact that the bathing process involves constant running water, and this means it maintains its 33-35 degree Celsius temperature.

Between the 12th and 13th centuries, Georgian residents loved to take guests to the city to relax and have a treat. In the early 20th century, after chemical analysis had taken place and revealed the uniqueness of the water, the city was officially declared a medical spa resort. Construction of the resort started about five years later. In the 1950s Soviet era, Tskaltubo was an important spa resort. At different times, nine bathing houses and 19 sanatoria were built. Bathing house 6, which is the largest still functioning thermal bath today, was built exclusively for Joseph Stalin in the 1950s. In 2015 a new medical thermal centre was erected. The new construction contrasts with a lot of buildings in severe decay elsewhere in the rest of the city.

Many of the sanatoria that were thriving 50 years ago are now abandoned, in significant disrepair, and are crumbling. However, some of the former sanatoria and hotels are now home to IDPs (Internally Displaced Persons). These are people who were mostly displaced from their homes in Abkhazia due to the war at the end of the 20th century. Abkhazia declared de facto independence at that time, and nearly all Georgians were forced to flee.

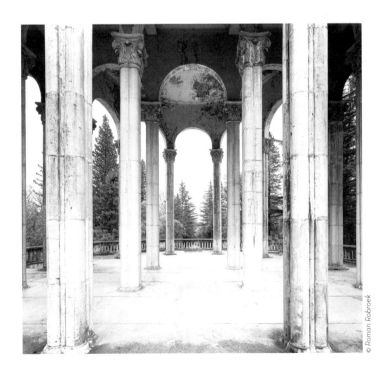

© Roman Robroek

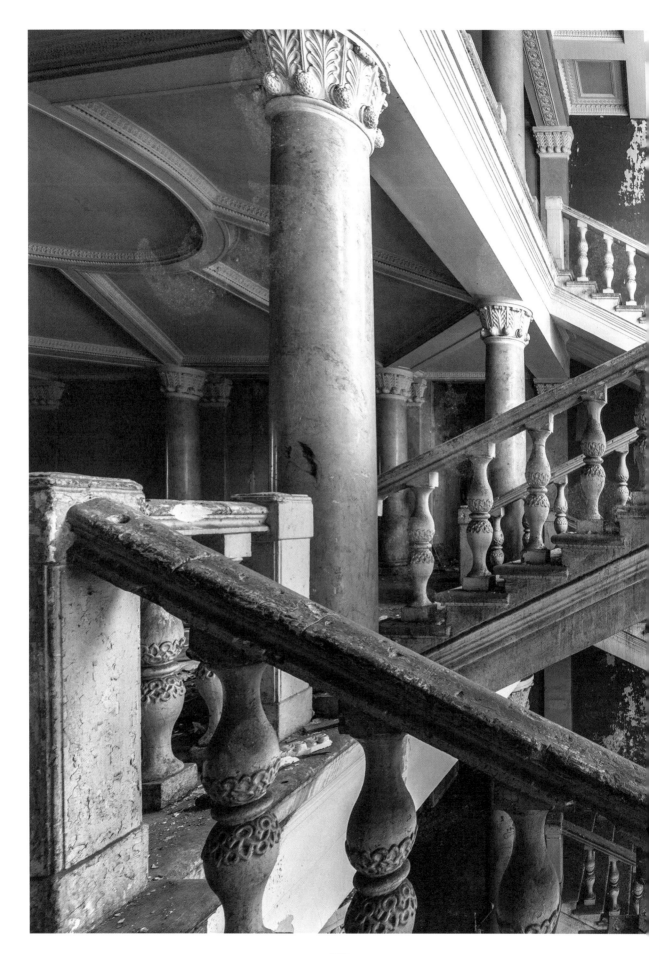

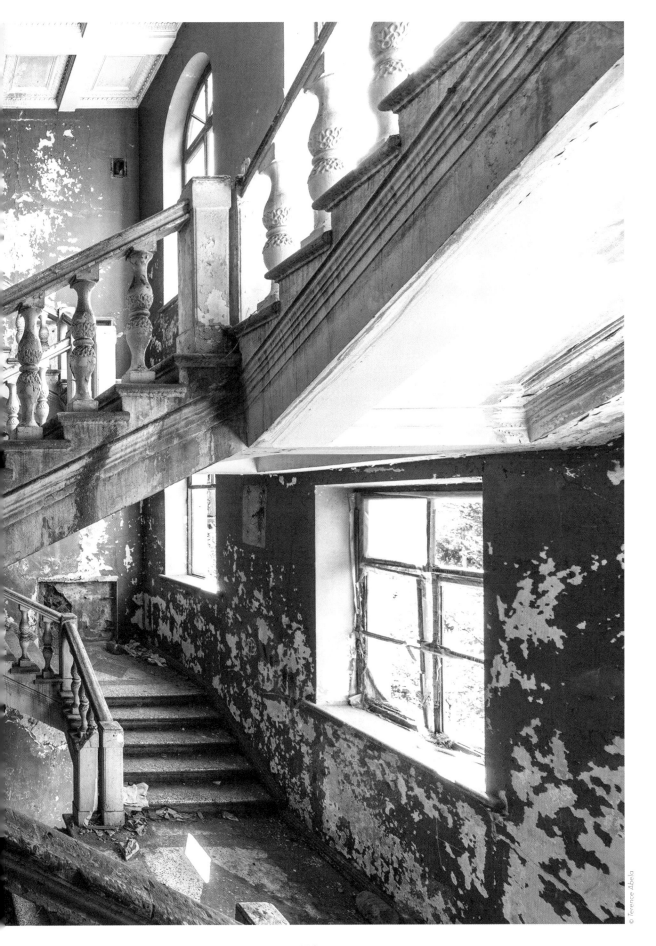

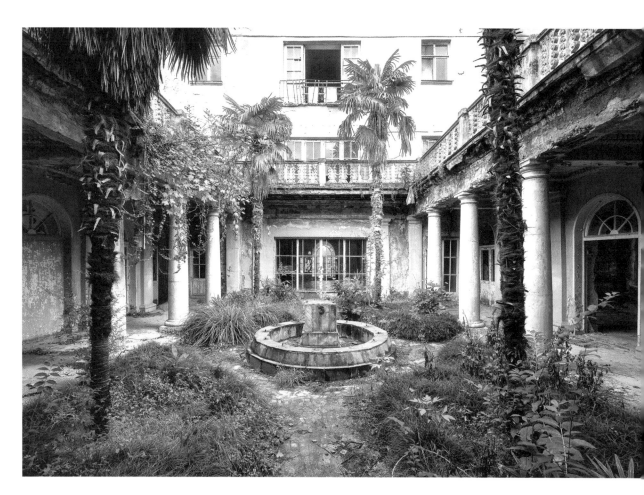

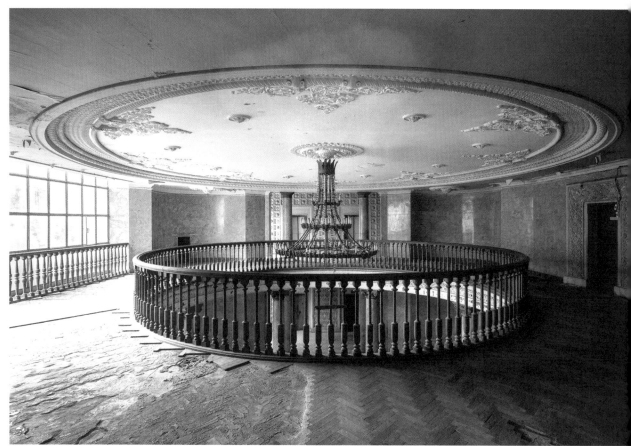

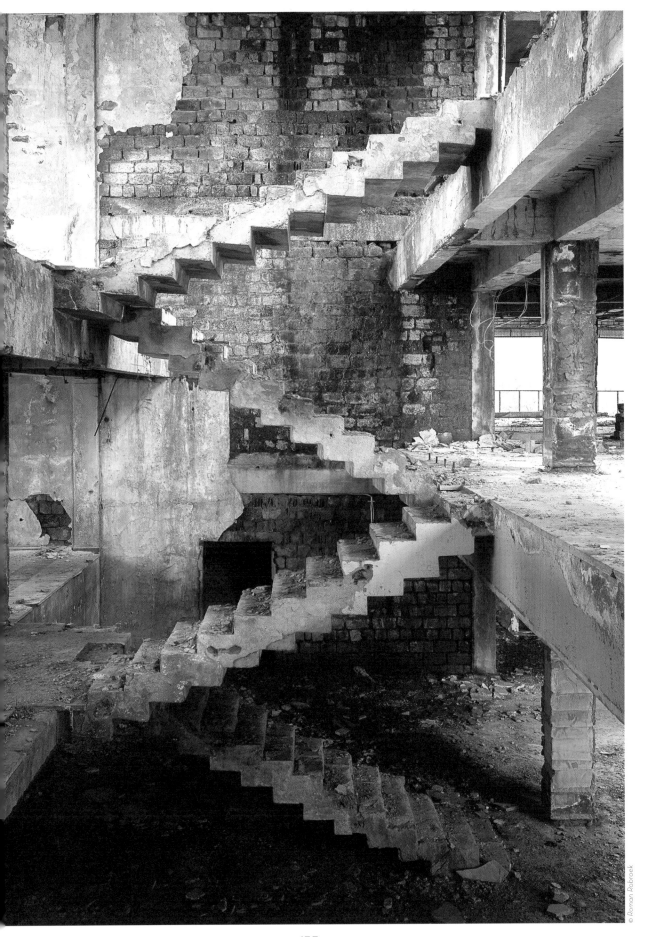

Baïkonur

KAZAKHSTAN

Almaty

Bishkek

Shymkent

UZBEKISTAN

Tashkent

KYRGYZSTAN

CHIN

Bukhara Samarkand

Kashgar

TAJIKISTAN

Dushanbe

N

TURKMENISTAN

Mary

Bactria

Pamir

500 km

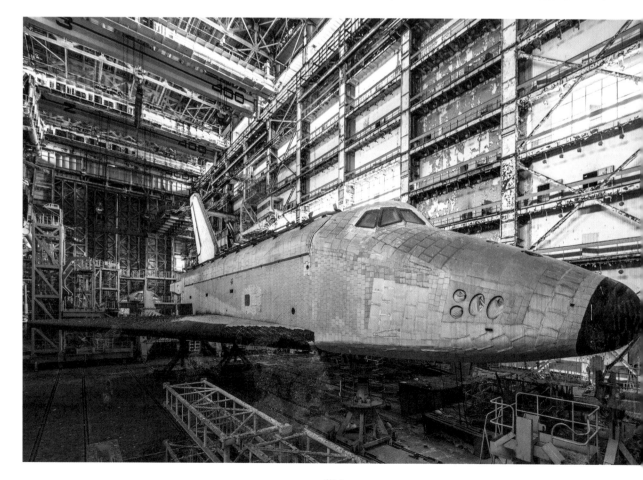

Baikonur Cosmodrome · Kazakhstan

The Soviet space programme was born in the early 1920s out of the communist regime's desire to make its mark through advances in industry. The ensuing research made the government aware of the military potential of rockets, and new funds were released to accelerate developments in this field.

In the midst of the Cold War, the conquest of space was of particular importance: Over and above the technical challenges, its avowed aim was to prove the superiority of Soviet ideology. It was in this context, when the Americans had already won the race to the Moon and the Apollo mission had proved successful, that the *Buran* project emerged, launched by the Soviet government in 1974 – two years after NASA announced that it was developing a Space Shuttle programme.

It was the Baikonur Cosmodrome, built in the 1950s in Kazakhstan, which hosted all the test flights of the various Shuttle prototypes throughout the 1980s. Finally, on 15 November 1988, Baikonur was the launch site for the one and only flight of the first operational Shuttle model, the *Orbiter K-1 Buran*: launched by an Energia booster, it covered 84,000 km in 3 hours and 25 minutes without a human crew. At least four other flights should have followed this initial victory, but the fall of the Berlin Wall in 1989, and the break-up of the USSR two years later, put an end to the Buran programme, which was officially abandoned in 1993.

The *Orbiter K-1 Buran* was destroyed on 12 May 2002 when the roof of its hangar collapsed. However, you can still see the *Orbiter K-2 Ptichka*, a Shuttle destined for the next stages that was almost finished when the programme was interrupted, as well as the model of another prototype, the *Orbiter OK-4M*, and the Energia launcher.

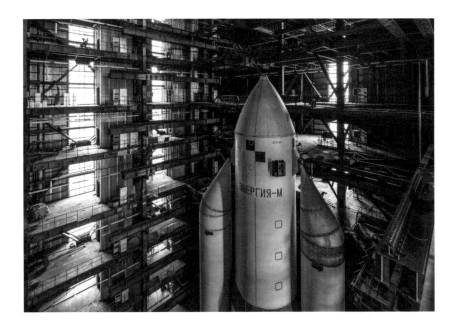

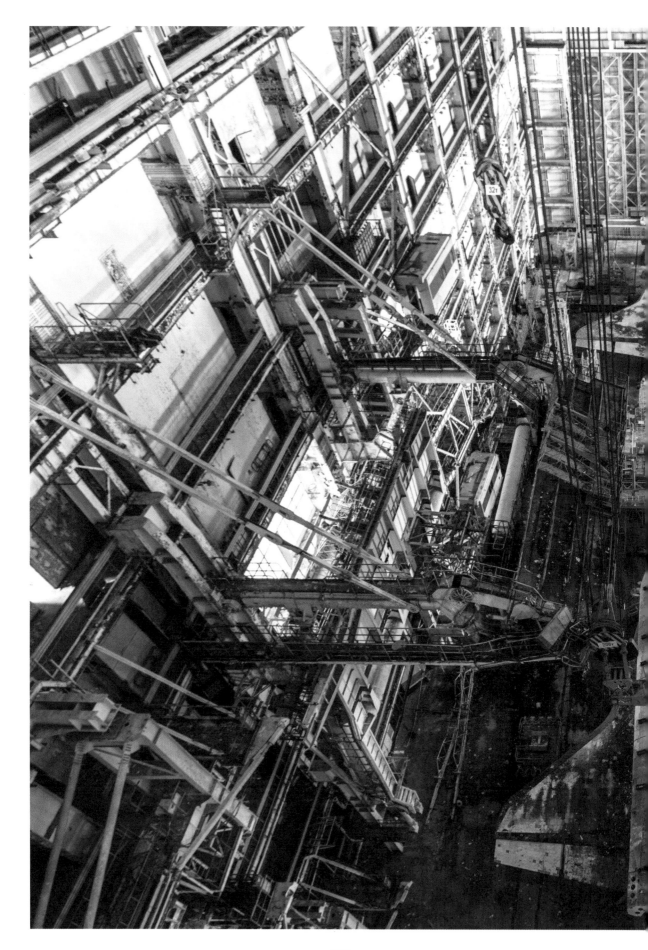

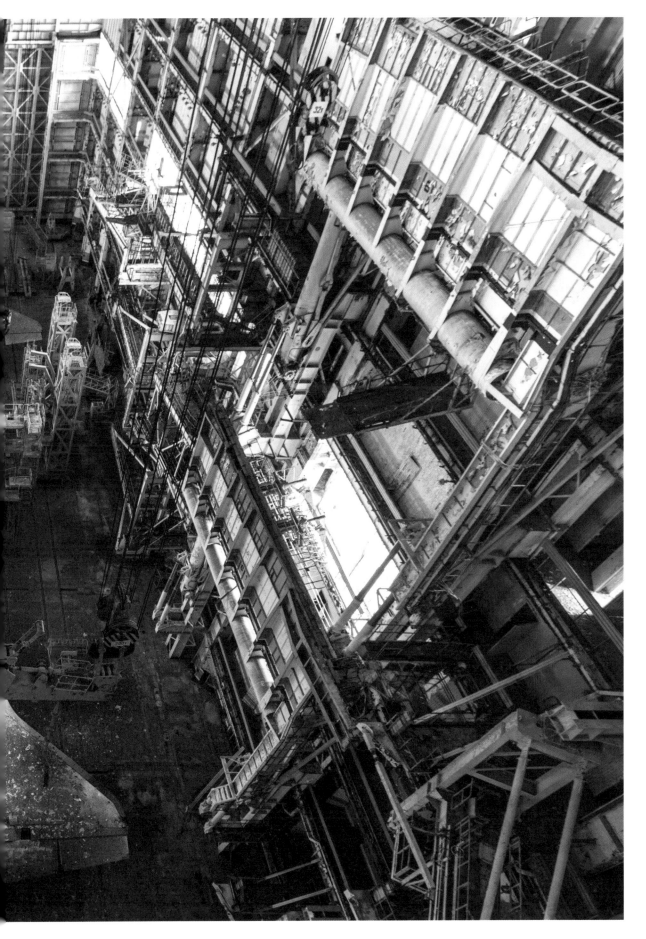

KAZAKHSTAN

Almaty
○

Bishkek
○

Shymkent
○

UZBEKISTAN

Tashkent
○

KYRGYZSTAN

Bukhara
○

Samarkand
○

Kashgar
○

TAJIKISTAN

Dushanbe
○

CHINA

TURKMENISTAN

Mary
○

Bactria

Pamir

Kabul
○

AFGHANISTAN

Islamabad
○

Uch Sharif
◎

PAKISTAN

New Delhi
○

IRAN

INDIA

N

500 km

Tomb of Bibi Jawindi · Pakistan

The tomb of Bibi Jawindi, at Uch (frequently referred to as Uch Sarif) in southern Punjab, is one of the most spectacular monuments in this richly endowed region: Uch, said to have been founded by Alexander the Great, is reputed to be the home of 'shrine culture'. Included on UNESCO's Tentative List of World Heritage Sites, the tomb was built c. 1494 by an Iranian prince, Dilshad, for Bibi Jawindi, the great-granddaughter of a famous Sufi saint.

The main building, only half of which is still standing, is richly decorated, both inside and out: Carved wood, coloured earthenware, delicate ornaments and Islamic inscriptions can still be admired at the mausoleum both on its superb dome and within its enclosure, itself largely destroyed. All around, there are numerous reliefs in the ground, indicating the presence of tombs.

The derelict state of the site can largely be explained by the harsh climatic conditions: Torrential floods in 1817 washed away half the structure of the tomb and part of the enclosure.

Conservation measures have been undertaken, notably in 1999 at the initiative of the Pakistan Conservation and Rehabilitation Centre, which invited various bodies (including numerous international organisations) to help protect the site. Unfortunately, flooding is not the only environmental hazard in the region. Moisture, salt infiltration and erosion have gradually taken their toll on the monument and the remains of its walls, which continue to crumble, slowly but surely.

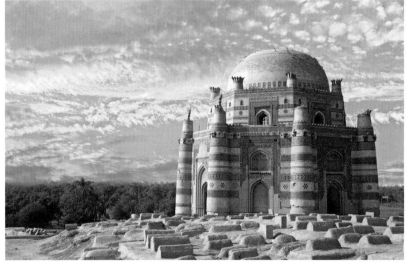

© Usamashahid433

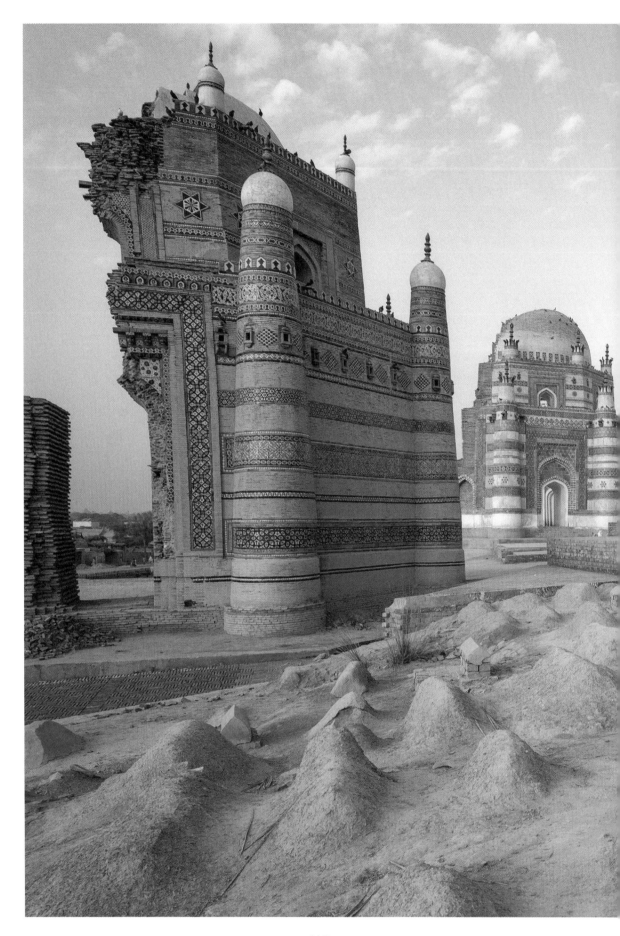

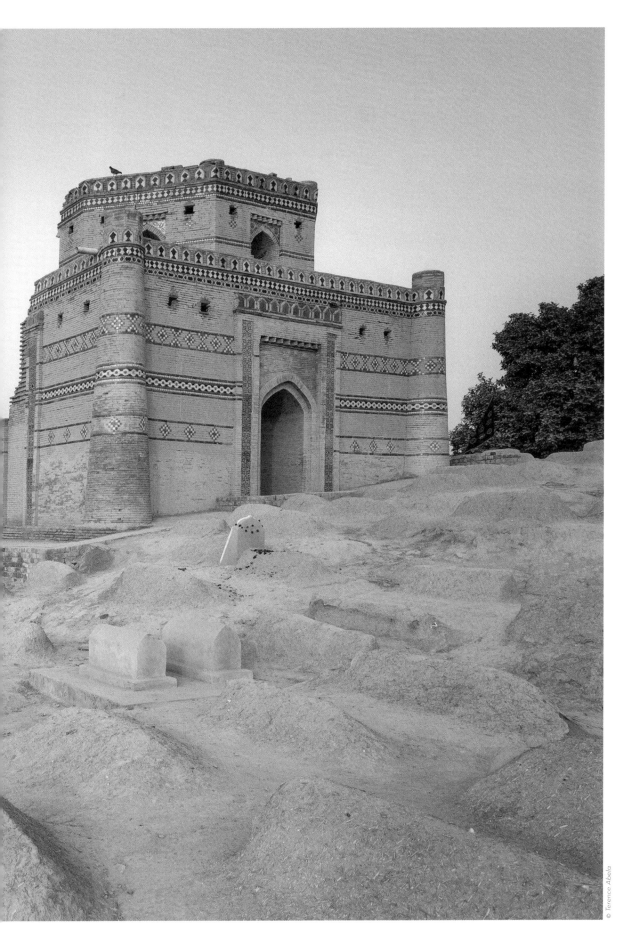

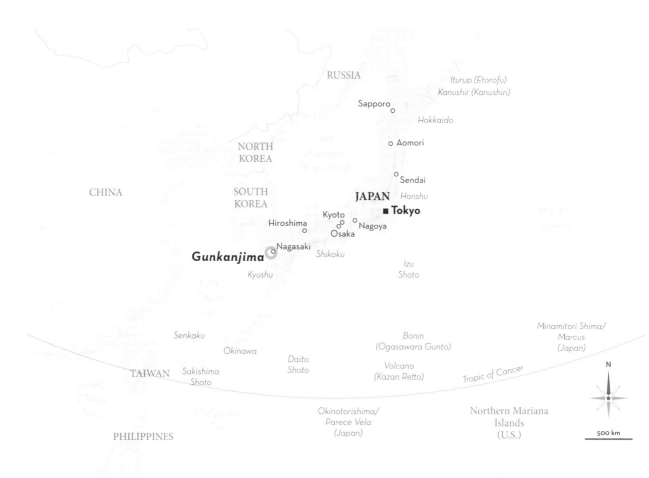

RUSSIA

Iturup (Etorofu)
Kanushir (Kanushiri)

Sapporo

Hokkaido

NORTH
KOREA

Aomori

Sendai

CHINA

SOUTH
KOREA

JAPAN Honshu

■ **Tokyo**

Kyoto
Hiroshima Nagoya
Osaka

Gunkanjima Nagasaki

Shikoku

Izu
Shoto

Kyushu

Senkaku

Bonin
(Ogasawara Gunto)

Minamitori Shima/
Marcus
(Japan)

Okinawa

Daito
Shoto

Volcano
(Kazan Retto)

N

TAIWAN Sakishima
Shoto

Tropic of Cancer

Okinotorishima/
Parece Vela
(Japan)

Northern Mariana
Islands
(U.S.)

500 km

PHILIPPINES

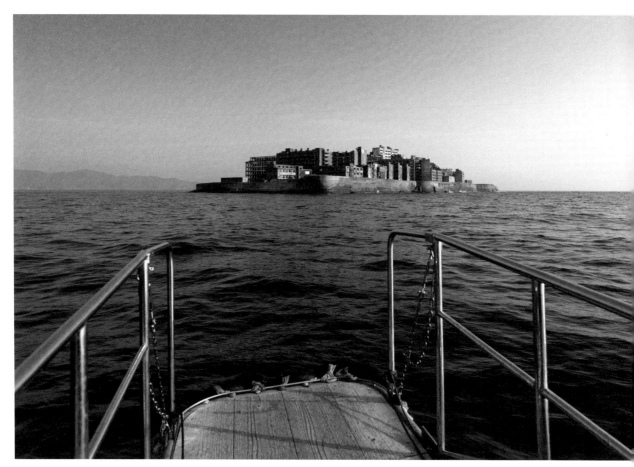

Gunkanjima · Japan

Hashima, better known as Gunkanjima – Battleship Island – because it looks like a military warship, hides a completely abandoned city behind its huge sea wall.

Coal was discovered on Hashima in 1810, but it was only in 1890, when Mitsubishi bought the island, that mining began in earnest. Workers moved to the island with their families and by 1959 Hashima was a working city, with 5,300 residents and the highest population density in the world. The island was completely covered with apartment blocks, schools, hospital, gym, cinema, shops, shrine, pachinko parlor, bath houses, bars, even a brothel.

The mine closed in 1974 – petroleum had become cheaper and easier to produce – and the island was abandoned by its inhabitants.

The island remained empty until the early 2010s, when access was once again permitted. Used as a film location or inspiration for several films, including the 23rd in the James Bond series, *Skyfall*, and Christopher Nolan's *Inception*, the island is now a popular destination for film buffs and photographers as well as adventure-seeking tourists. The city of Nagasaki, just 5 kilometres away, offers official tours so that visitors can discover a small part of the 'ghost island'.

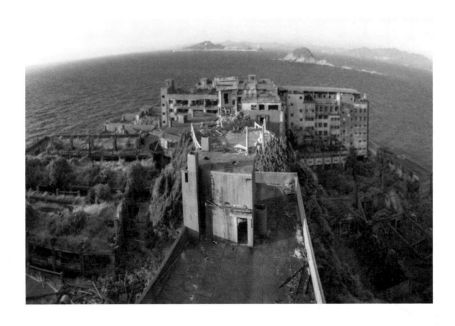

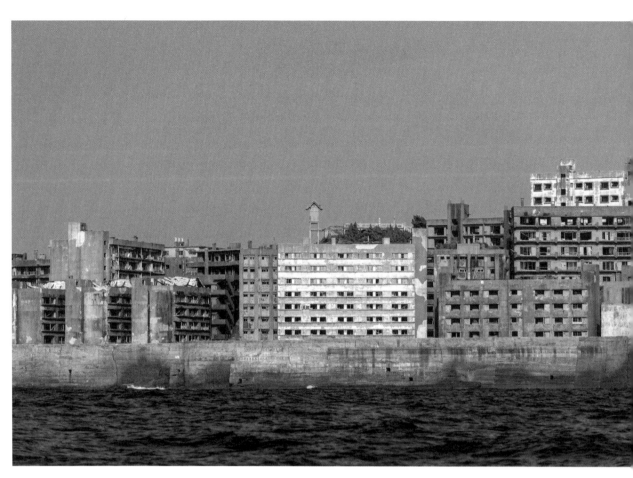

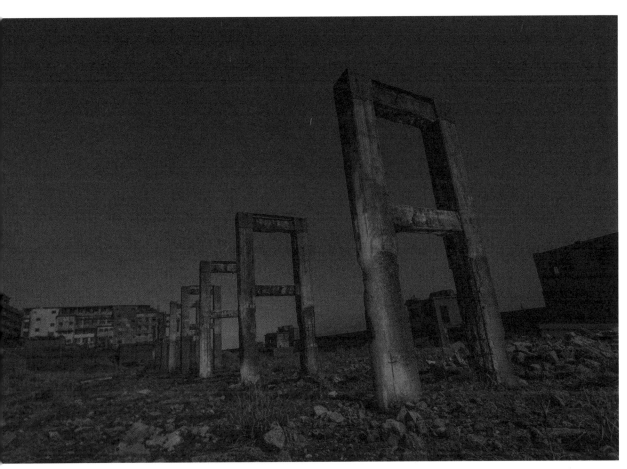

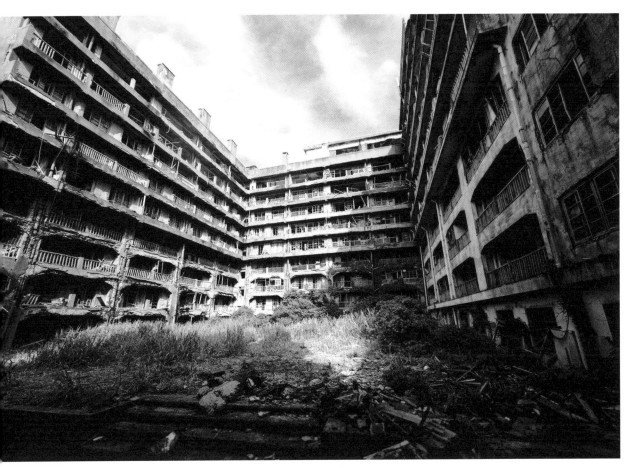

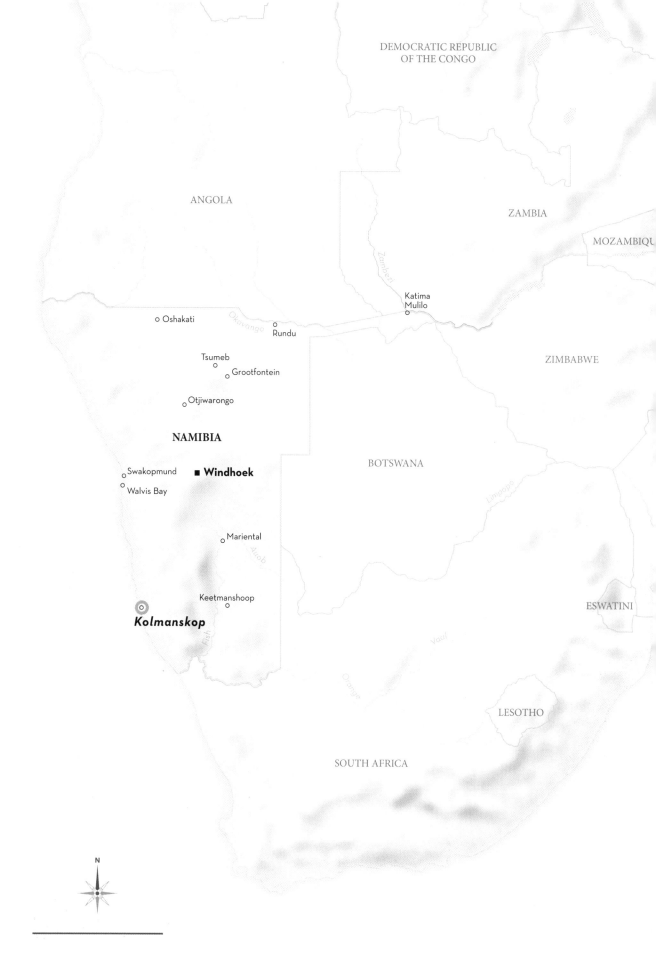

DEMOCRATIC REPUBLIC
OF THE CONGO

ANGOLA

ZAMBIA

MOZAMBIQU

Katima
Mulilo

Zambezi

ZIMBABWE

o Oshakati

Okavango

o Rundu

Tsumeb
o

o Grootfontein

o Otjiwarongo

NAMIBIA

BOTSWANA

Limpopo

o Swakopmund
o Walvis Bay

■ Windhoek

o Mariental

Auob

Keetmanshoop
o

Kolmanskop

ESWATINI

Vaal

Fish

Orange

LESOTHO

SOUTH AFRICA

N

Kolmanskop · Namibia

Kolmanskop, a ghostly oasis built on the burning sands of the Namib Desert, offers a poignant vision of human excess in the face of nature's unyielding grandeur. This village was once the jewel of Namibia, a prosperous anomaly rising from the arid dunes, built on a sea of diamonds. Today, Kolmanskop is little more than a sandy memory, its buildings colonised by the golden dust of the desert, mute relics of a bygone mining era.

At the dawn of the 20th century, a German railway worker, August Stauch, discovered a glittering stone during the construction of the railway line crossing the desert. This chance find triggered a diamond rush, attracting a host of adventurers, miners and dreamers to this remote corner of Africa. Kolmanskop was born out of this diamond fever, standing proud against the desolate immensity of the desert. Within a few years, the village boasted incongruous luxuries in the middle of nowhere: a casino, a ballroom, a theatre and a hospital equipped with an X-ray machine, the first of its kind in Africa. The Germanic-style houses, with their ornate facades and pointed roofs, were havens of comfort for the colonists. Water, brought in at great expense from the port of Lüderitz, irrigated lush green gardens that contrasted with the surrounding red sand dunes. But the fortunes of Kolmanskop were closely linked to those of its mines.

With the deposits becoming exhausted, people's greed turned to other promising lands and the village began to decline. Mining was gradually abandoned and the inhabitants left, taking with them the memories of a dazzling but short-lived prosperity. Today, Kolmanskop is a vivid reminder of that past grandeur. The houses, swathed in sand, seem to be sinking slowly into the bowels of the desert, as if to blend back into the original landscape. The wind, time's silent accomplice, carries clouds of dust through the gaping windows, covering the floors in golden drapery. The furniture – still in place – barely emerges from this sea of sand, remnants of a time when life was in full swing. To walk through the sandy streets of Kolmanskop is to cross an invisible boundary between the present and the past. Each building tells a story, the story of men and women who came to seek their fortunes and found, for a time, an illusory paradise in the heart of the desert. The ballroom, once resonant with the echoes of magnificent parties, is now silent, its walls cracked by salt and time. The theatre, mute witness to plays performed before an enraptured audience, offers its stage to the shifting sands. The desert, patient and implacable, slowly reclaims its rights, burying Kolmanskop under an ever-thicker layer of its golden mantle.

And yet there is beauty in these ruins, a majestic melancholy that speaks of the transience of human glory in the face of the eternity of nature. Kolmanskop is a lesson in humility, a poignant reminder that wealth and prosperity are mirages, ephemeral like grains of sand in the wind. As you contemplate the remains of this village, you can't help but reflect on the tenacity of the human spirit, capable of building wonders even in the most unlikely places. But you're also aware of its fragility, because in the face of the immensity of the desert, Kolmanskop was no more than a brief illusion, a mere bubble of life, ready to burst at the slightest touch of time.

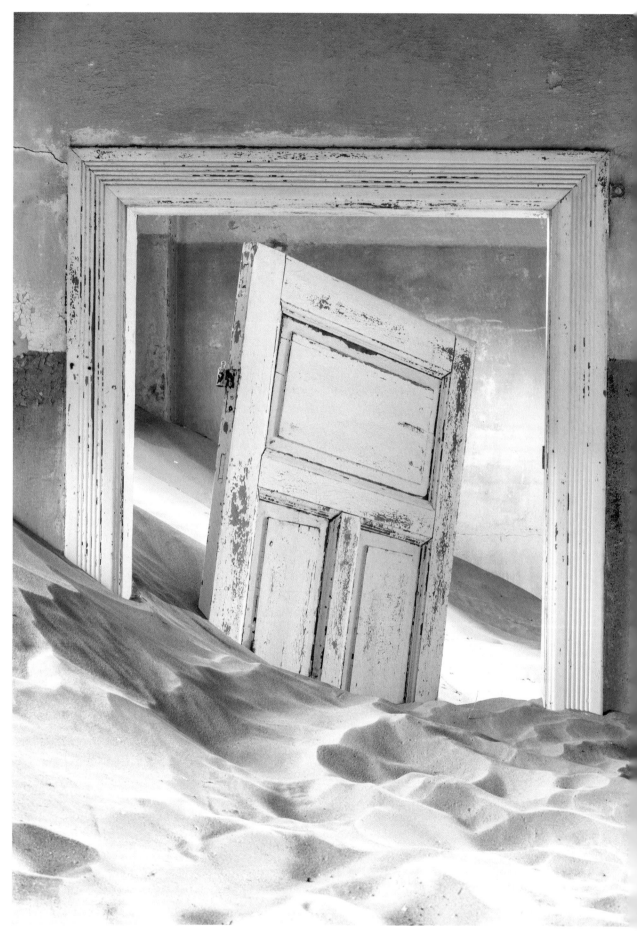

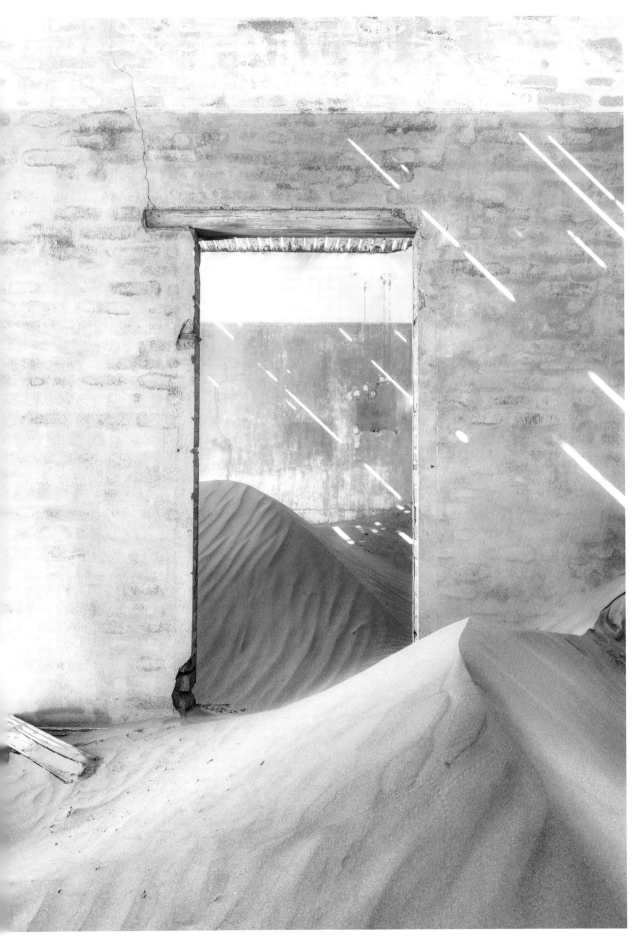

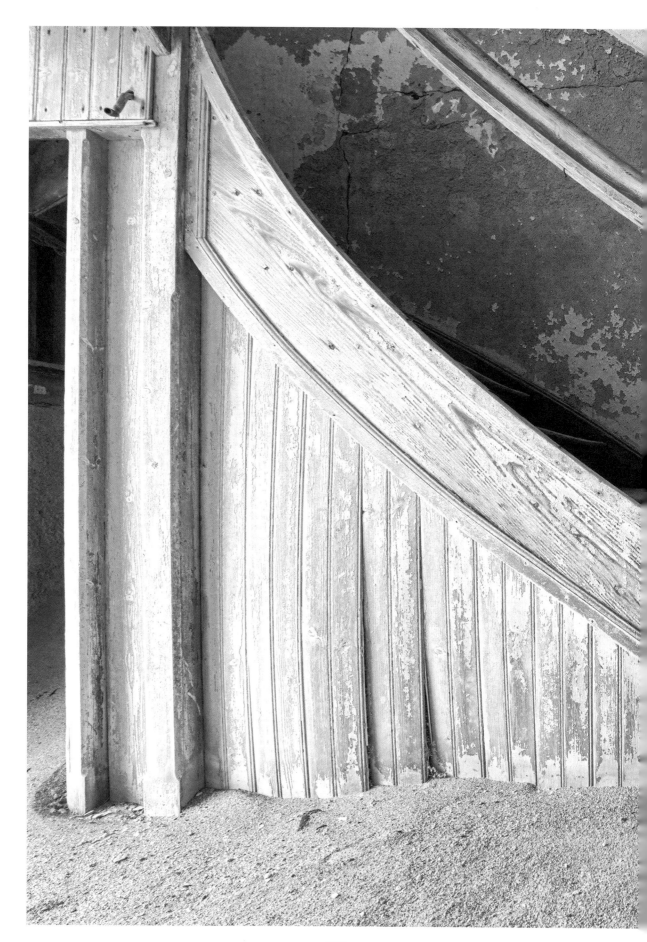

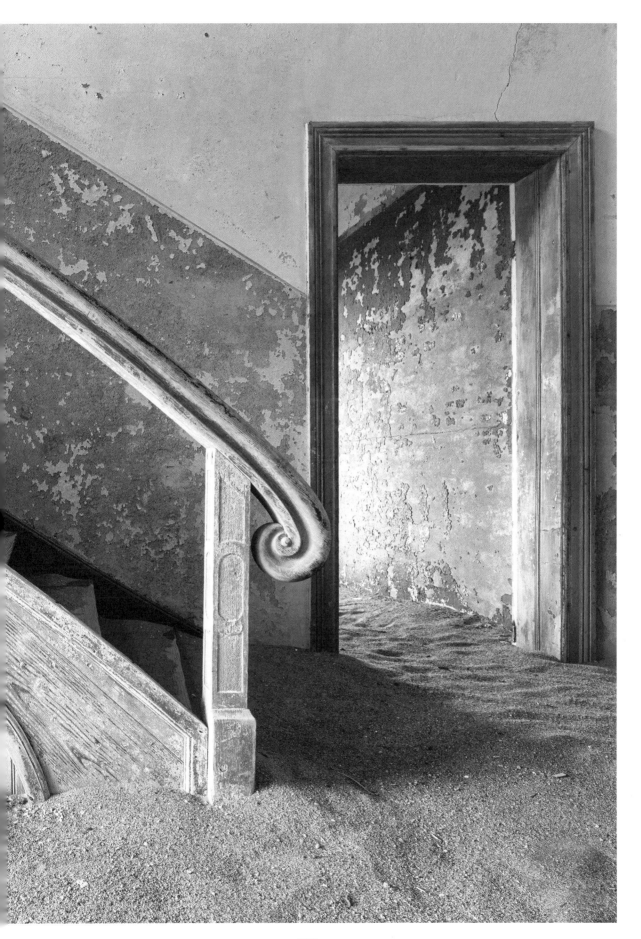

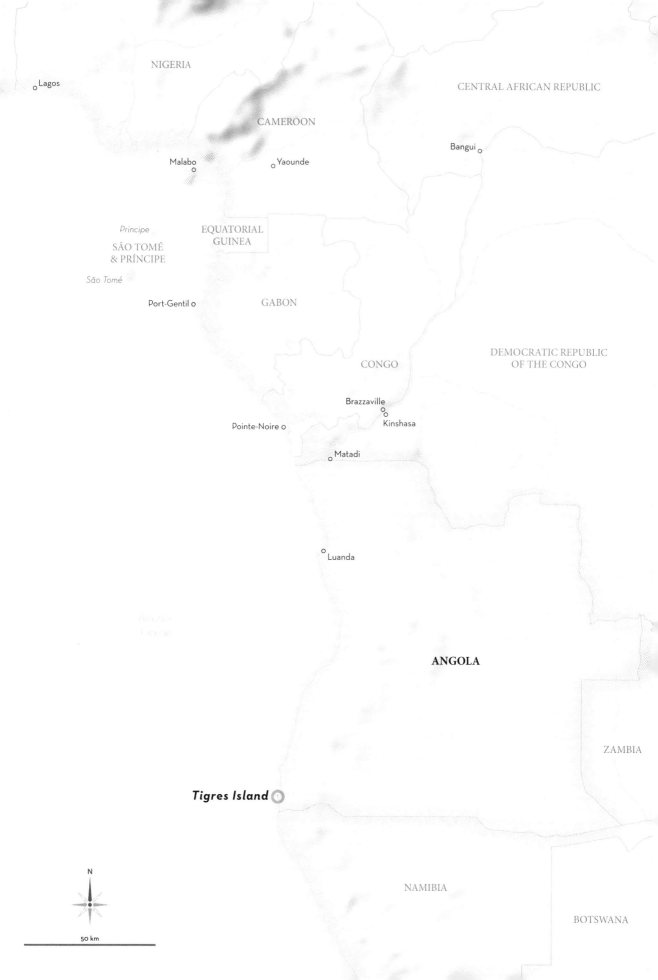

NIGERIA

Lagos

CENTRAL AFRICAN REPUBLIC

CAMEROON

Bangui

Malabo

Yaounde

Principe

EQUATORIAL
GUINEA

SÃO TOMÉ
& PRÍNCIPE

São Tomé

Port-Gentil

GABON

DEMOCRATIC REPUBLIC
OF THE CONGO

CONGO

Brazzaville

Kinshasa

Pointe-Noire

Matadi

Luanda

ANGOLA

ZAMBIA

Tigres Island

N

NAMIBIA

BOTSWANA

50 km

Saint Martin of the Tigers · Tiger Island, Angola

Tiger Island, located in Namib province, is Angola's largest island at 98 sq. km. It was once a peninsula bordering a wide bay, home to the fishing village of Saint Martin of the Tigers (São Martinho dos Tigres).

Founded in 1860, the village was to serve as a model for populating one of the country's most inhospitable regions: the Namib Desert. With the aim of making it an important demographic and economic centre, the Portuguese colonial government selected a large number of inhabitants from the Algarve (whose experience of sea fishing would be a valuable asset) to found the village and install the basic infrastructure. Saint Martin des Tigres proved a successful development: Thanks to the production of fish oil and all its byproducts, the village had become Angola's largest fishing centre by the beginning of the 20th century.

However, it bore the full brunt of the climate disaster that hit the bay in 1962: Huge waves swept across it, destroying the isthmus that linked the peninsula to the mainland. As a result, the peninsula became a particularly inhospitable island: It proved almost impossible to bring in supplies of water, food and basic necessities.

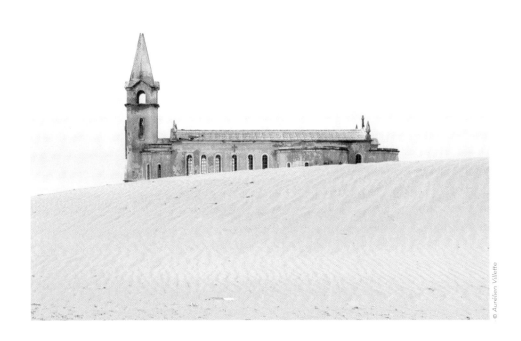

© Aurélien Villette

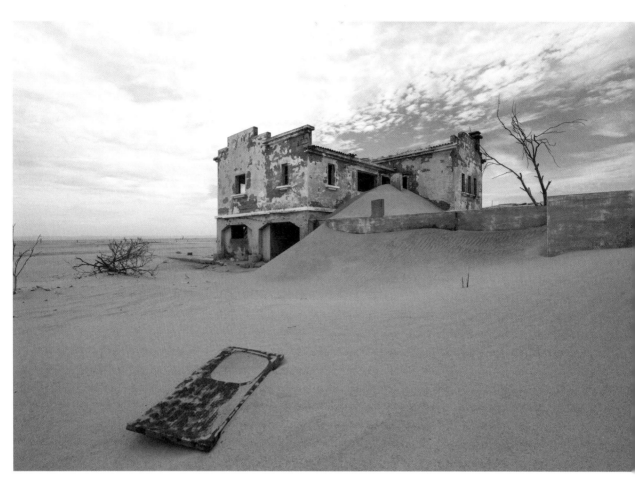

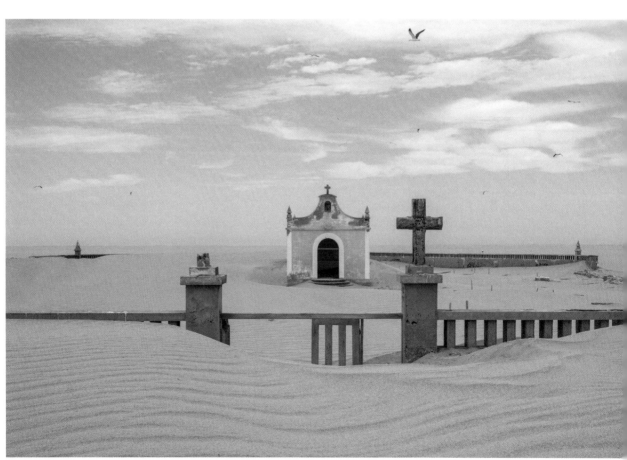

Between 1975 and 1976, a large part of the population, who had nevertheless adapted to the dire living conditions, decided to abandon the village: The civil war that was raging at the time made the inhabitants, most of whom were of European origin, fear reprisals from the various nationalist movements that were sweeping the country. Since then, the village has been uninhabited despite several attempts by the Angolan government to encourage new waves of migration in the 1980s and 1990s.

In 1996 the government appointed a municipal administrator for Saint Martin des Tigres, signalling its intention to repopulate the village and make it a thriving fishing port once again. The European Union supported the project but, almost 30 years on, it has still not got off the ground.

Today, the island is mainly occupied by seals and tourists, who come by car or on foot when the island is accessible by road at low tide. The tourists come to thrill at the sight of the ghost town and enjoy the beautiful scenery – they marvel at the coast shrouded in a mysterious fog and the red sand dunes whose colour and contours (reminiscent of a tiger's coat) have given the island its name.

© Aurélien Villette

SPAIN

Cádiz ○

Málaga ○

Marbella ○

Motril ○

Almeria ○

Algeciras ○

Gibraltar

Tarifa ○

Tanger ○

Tétouan ○

Nador ○

ALGERIA

MOROCCO

N

Meknès
○

50 km

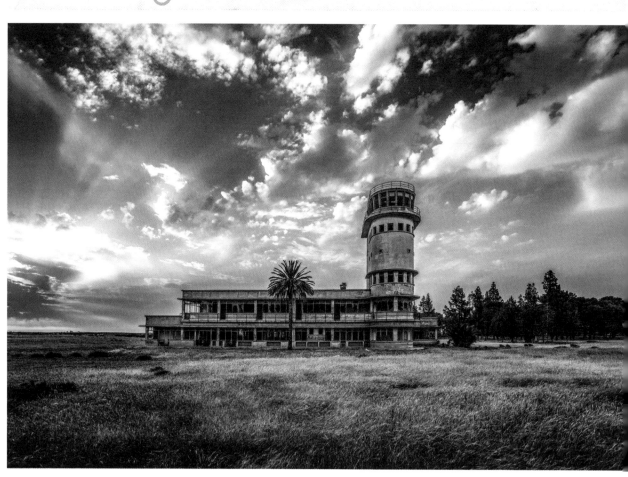

Meknes Aerodrome · Morocco

If you want to travel to Morocco, don't look for a flight to Meknes: it has never had a civilian airport. The only airport is a military one, located in the centre of the city.

In the late 1940s, the cities of Fes and Meknes tried to agree on a plot of land on which to build a joint airport. Unfortunately, negotiations dragged on and just as agreement was about to be reached, Fes changed its mind and announced that it was going it alone.

Meknes was forced to start looking for a plot of land on which to build its own airport. In 1950 a new site was identified 12 km from the city and in the middle of vineyards, various problems put paid to this second project. There was a third option, this time 14 km to the south. The terrain was hillier and required major earthworks. Nevertheless, the first calls for tenders for the future airport went out at the end of the year.

Although the building went ahead according to plan, the earthworks were bogged down. A workers' strike in 1952 further delayed the project. The following year, the head of the Moroccan Air Force came in person to inspect the site, which was still having problems ... and then radio silence. There are no records of the airport's service history but there is every reason to believe that it was never used – and probably never even finished.

More than 70 years later, the site is still there, abandoned. While the aircraft hangar has been converted into a farm building, the terminal remains virtually intact. You can still make out the airport lounge and ticket desks. The control tower overlooks a 2,500-metre-long runway that has never seen a plane, but where sheep like to graze.

SPAIN

Cádiz

Málaga

Marbella

Motril

Almeria

Algeciras

Gibraltar

Tarifa

Tanger

Tétouan

Nador

ALGERIA

MOROCCO

N

50 km

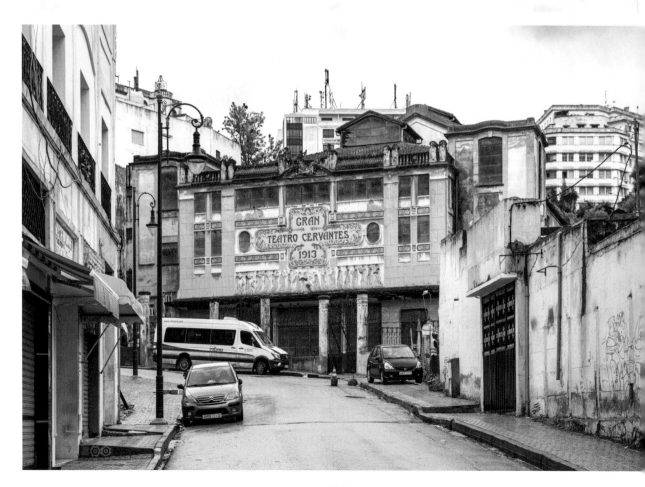

Gran Teatro Cervantes · Tangier, Morocco

In 1911 a Spanish emigrant couple, Don Manuel Peña and Doña Esperanza Orellana, decided to build a theatre near the Gran Socco in Tangier. Work lasted two years and the Gran Teatro Cervantes, with a capacity of 1,400 seats, opened in 1913.

The architect Diego Jiménez Armstrong, who had already designed several buildings in Tangier, created an Art Nouveau masterpiece, one of the first reinforced concrete buildings of its time and one of the largest, if not the largest, theatre in North Africa.

The Cervantes is the most Spanish of all Morocco's buildings. The materials used, the craftsmen, everything had to be Spanish in this artistic and architectural feat, whose ambition was to bring Iberian culture to a city occupied by both England and France. The programme also had to showcase Spanish culture. Artists from Spain were brought in at great expense.

But the Cervantes soon proved too expensive. The financial difficulties of this ambitious project became apparent during the First World War, and for fear of seeing the Gran Teatro fall into foreign hands, Manuel Peña resigned himself to handing it over to the Spanish government in 1924. But the government did not know what to do with the Cervantes. It rented it out to operators more concerned with their own short-term interests than with the upkeep of a building that was beginning to fall into disrepair.

The Spanish Civil War that broke out in 1936 did not help matters, as the Spanish community found itself divided. But it was above all the gradual disappearance of a Spanish-speaking audience that sealed the fate of the Cervantes. As a desperate measure, the theatre was even used for boxing and wrestling matches. The Cervantes closed in 1962 and lay dormant for decades, slowly deteriorating. Leased for a symbolic 1 dirham to the Moroccan state from 1972 to 1992, its doors have remained shut.

On the eve of its centenary, there was renewed interest in the Cervantes, however. In 2007 it was listed as a national heritage site, and in 2015 Spain handed it over to Morocco with the promise of restoring it and turning it into a cultural centre. Perhaps the Cervantes is finally preparing to turn a new page in its history.

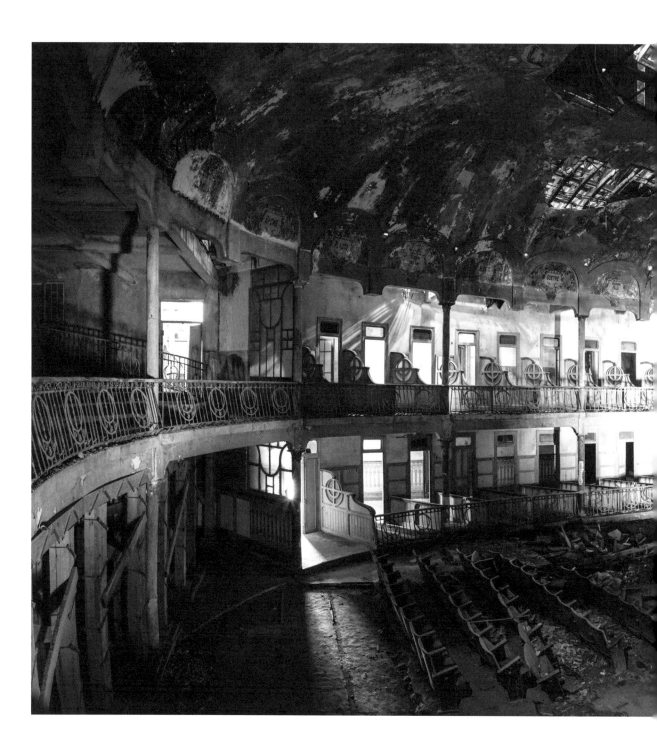

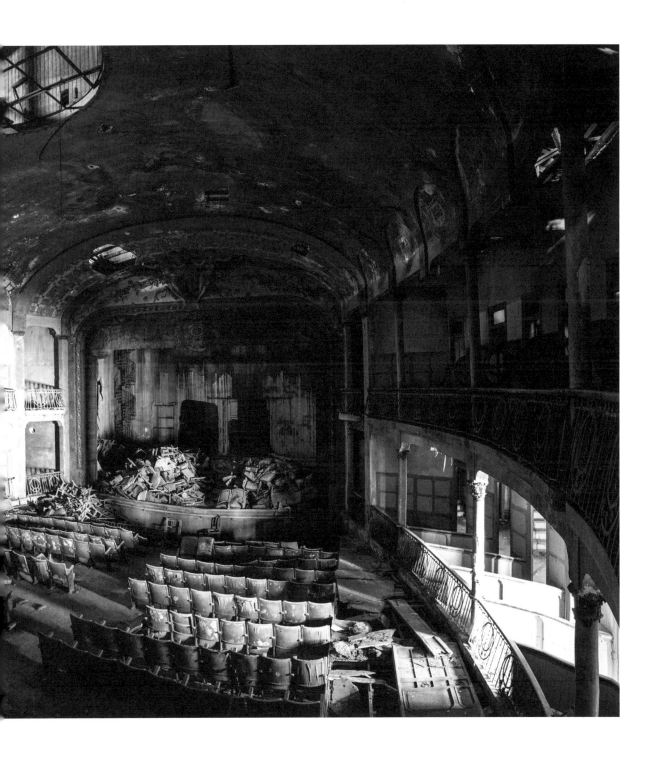

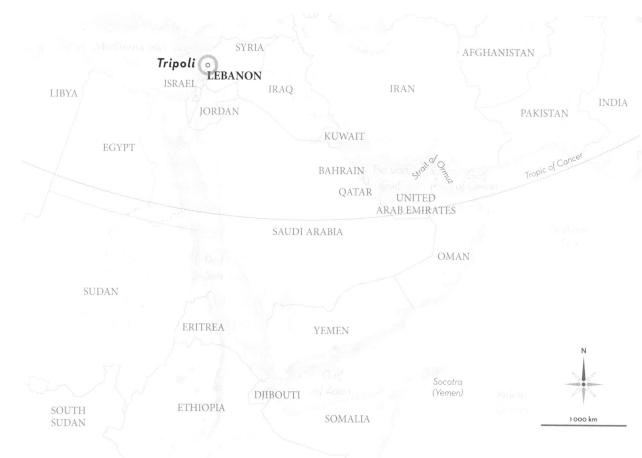

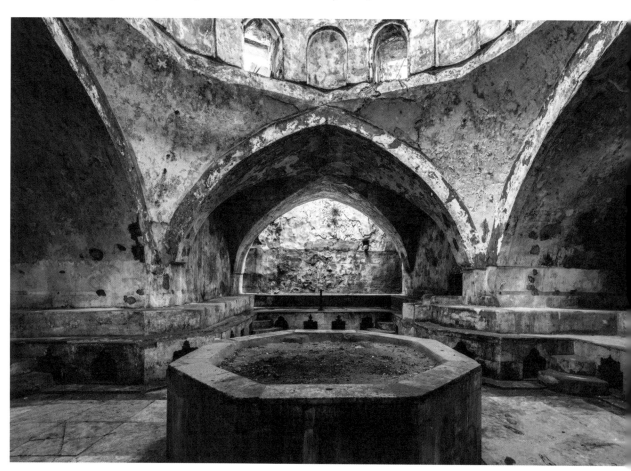

Hammam Al-Nouri · Tripoli, Lebanon

The Hammam al-Nouri was built in 1333 at the behest of the Mamluk governor Nur El-Din, and is located close to the Grand Mosque. It is still in good condition, but with its facade covered with modern shops it is extremely difficult to find the entrance. The dressing rooms, and the warm room known as a 'tepidarium', were built on a smaller scale than other baths in the city. However, the hot water steam hall is large and is surrounded by a series of private bathing alcoves.

The interior is decorated with multi-coloured marble paving, basins, and fountains, and from the exterior there is a view of its cluster of domes, perforated with light holes and protruding blue and green glass roundels.

The unique Hammam al-Nouri has been closed since the 1970s. Whilst it is clearly in need of restoration, it feels that time and neglect have added a strange charm and raw beauty. It is a cave of history which tells a story of eight centuries of bustling humanity.

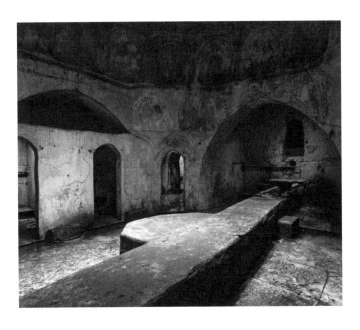

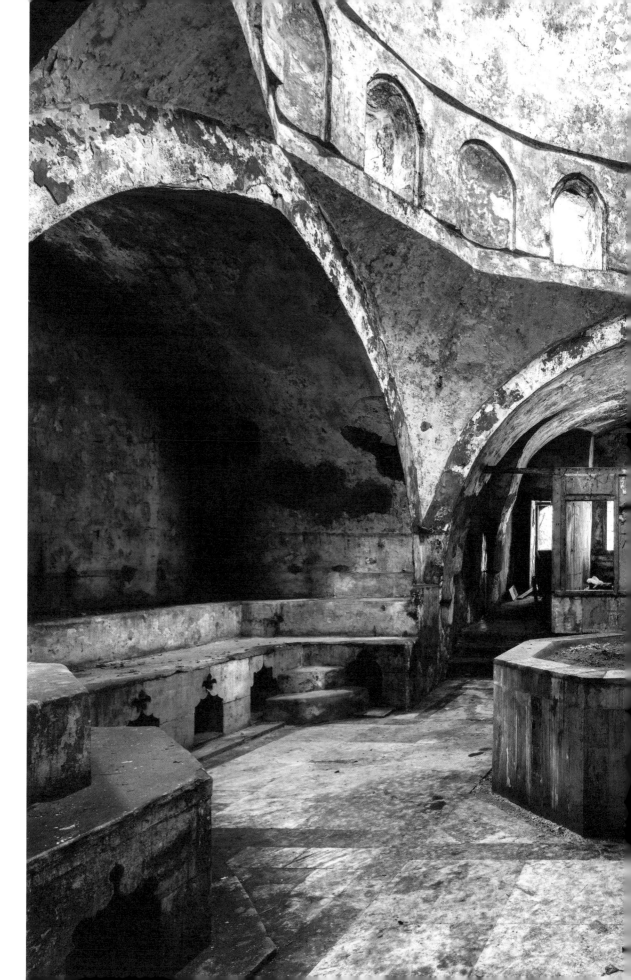

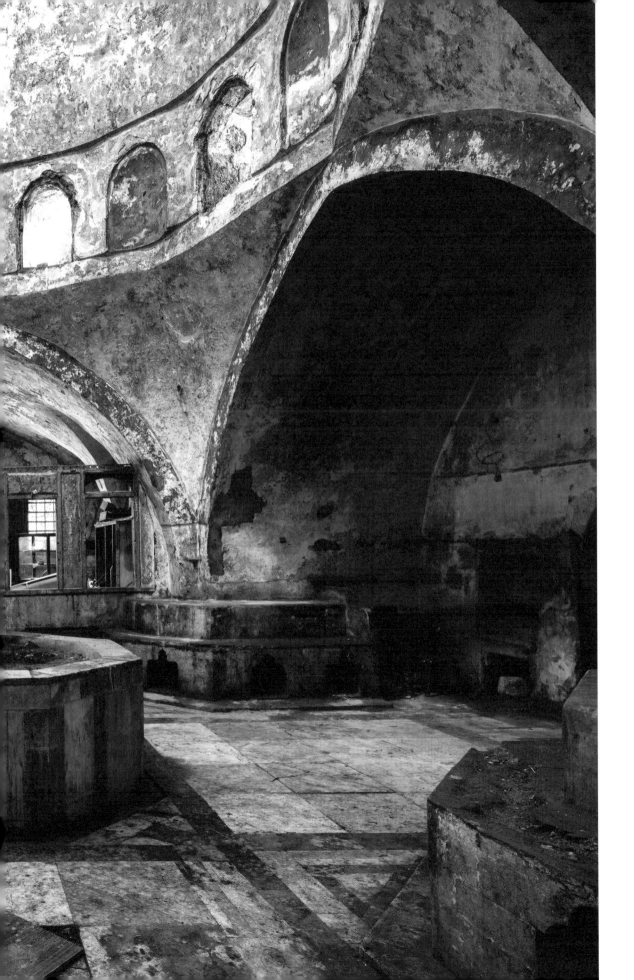

ABOUT JONGLEZ PUBLISHING

It was September 1995 and Thomas Jonglez was in Peshawar, the northern Pakistani city 20 kilometres from the tribal zone he was to visit a few days later. It occurred to him that he should record the hidden aspects of his native city, Paris, which he knew so well. During his seven-month trip back home from Beijing, the countries he crossed took in Tibet (entering clandestinely, hidden under blankets in an overnight bus), Iran and Kurdistan. He never took a plane but travelled by boat, train or bus, hitch-hiking, cycling, on horseback or on foot, reaching Paris just in time to celebrate Christmas with the family.

On his return, he spent two fantastic years wandering the streets of the capital to gather material for his first "secret guide", written with a friend. For the next seven years he worked in the steel industry until the passion for discovery overtook him. He launched Jonglez Publishing in 2003 and moved to Venice three years later.

In 2013, in search of new adventures, the family left Venice and spent six months travelling to Brazil, via North Korea, Micronesia, the Solomon Islands, Easter Island, Peru and Bolivia. After seven years in Rio de Janeiro, he now lives in Berlin with his wife and three children.

Jonglez Publishing produces a range of titles in nine languages, released in 40 countries.

CREDITS

PHOTOS

- **Sylvain Margaine:** Twelve Monkeys Power Plant, Church of Saint George, Buzludzha (p. 140-141).
- **Terence Abela:** Abandoned Buildings in Havana, Sharovsky Castle, Lenin Palace of Culture, Abandoned Town of Pripyat, Hunedoara Station, Polytechnic University of Gyumri, Tbilisi Funicular Station, Tskaltubo (p. 152-153), Tomb of Bibi Jawindi (p. 162-163), Saint Martin of the Tigers (p. 176).
- **Matt Emmett:** Subterranean Reservoirs and Cisterns, Crossness Pumping Station (except p. 24-25), Wilders Folly, Royal Aircraft Establishment, Stack Rock Fort, Satellite Communication Station, Cooling Tower.
- **Peter Scrimshaw:** Crossness Pumping Station (p. 24-25).
- **Francis Meslet:** Alla Italia Thermal Spa, Maidens School, Flood Castle, Lucky Castle, Top Grunge MIG, The Commodities Exchange, Crimson Earth, 21st-Century Crypt.
- **Robin Brinaert:** A Hovertrain 'Made in France', The Theatre of Dole, The Crespi d'Adda Power Plant, Palazzo Athena, Castello Non Plus Ultra.
- **Jeremy Chamot Rossi:** Cement Factory Dome.
- **Aurélien Villette:** Sant'Elia Stadium, Hugo Mine Hangman's Room 2, Kraftwerk Vockerode, VEB Kraftwerk, Kolmanskop, Saint-Martin des Tigres (p. 175 et 177).
- **Roman Robroek:** Kelenfold Power Plant, Casino Constanţa, Buzludzha (except p. 140-141), Tskaltubo (except p. 152-153).
- **Jonk:** Baikonur Cosmodrome.
- **Jordy Meow:** Gunkanjima.
- **François Beaurain:** Meknes Aerodrome, Gran Teatro Cervantes.
- **James Kerwin:** Hammam al-Nouri.
- **Usamashahid433:** Tomb of Bibi Jawindi (p. 161)

Texts

- **David Margaine:** Twelve Monkeys Power Plant, Hugo Mine Hangman's Room 2, Church of Saint George.
- **Matt Emmett:** Subterranean Reservoirs and Cisterns, Wilders Folly, Royal Aircraft Establishment, Stack Rock Fort, Satellite Communication Station, Cooling Tower.
- **Rachel Howard:** Crossness Pumping Station.
- **Francis Meslet:** Alla Italia Thermal Spa, Maidens School, Flood Castle, Lucky Castle, Top Grunge MIG, The Commodities Exchange, Crimson Earth, Kolmanskop.
- **Jeremy Chamot Rossi:** Cement Factory Dome.
- **Frédérique Villemur:** 21st-Century Crypt.
- **Robin Brinaert:** A Hovertrain 'Made in France', The Theatre of Dole, The Crespi d'Adda Power Plant, Palazzo Athena, Castello Non Plus Ultra.
- **Aurélien Villette:** Kraftwerk Vockerode, VEB Kraftwerk.
- **Roman Robroek:** Kelenfold Power Plant, Casino Constanţa, Bouzloudja, Tskhaltoubo.
- **Jonk:** Baikonur Cosmodrome.
- **Jordy Meow:** Gunkanjima.
- **François Beaurain:** Meknes Aerodrome, Gran Teatro Cervantes.
- **James Kerwin:** Hammam al-Nouri.

FROM THE SAME PUBLISHER

Atlas

Atlas of extreme weather
Atlas of geographical curiosities
Atlas of unusual wines

Photo Books

Abandoned America
Abandoned Asylums
Abandoned Australia
Abandoned Belgium
Abandoned Churches: Unclaimed places of worship
Abandoned cinemas of the world
Abandoned France
Abandoned Germany
Abandoned Italy
Abandoned Japan
Abandoned Lebanon
Abandoned Spain
Abandoned USSR
After the Final Curtain – The Fall of the American Movie Theater
After the Final Curtain – America's Abandoned Theaters
Baikonur – Vestiges of the Soviet space programme
Cinemas – A French heritage
Destination Wellness – The 35 best places in the world to take time out
Forbidden France
Forbidden Places – Vol. 1
Forbidden Places – Vol. 2
Forbidden Places – Vol. 3
Forgotten Heritage
Oblivion
Secret sacred sites
Venice deserted
Venice from the skies

'30 experiences' Guides

Soul of Amsterdam – A guide to the 30 best experiences
Soul of Athens – 30 experiences
Soul of Barcelona – 30 experiences
Soul of Berlin – A guide to the 30 best experiences
Soul of Kyoto – A guide to 30 exceptional experiences
Soul of Lisbon – 30 experiences
Soul of Los Angeles – A guide to 30 exceptional experiences
Soul of Marrakesh – A guide to 30 exceptional experiences
Soul of New York – A guide to 30 exceptional experiencess
Soul of Rome – A guide to 30 exceptional experiencess
Soul of Tokyo – A guide to 30 exceptional experiences
Soul of Venice – A guide to 30 exceptional experiences

'Secret' Guides

Follow us on Facebook, Instagram and X

Cartography: **Cyrille Suss** – Layout: **Emmanuelle Toulemonde Willard** –
Editing: **Jana Gough** – Proofreading: **Abigail Kafka** – Publishing: **Clémence Mathé**

Cover: © **Matt Emmett**

© JONGLEZ 2024
Registration of copyright: October 2024 – Edition: 01
ISBN: 978-2-36195-776-6
Printed in Slovakia by Polygraf